Flower
PORTRAITS IN
CROSS STITCH

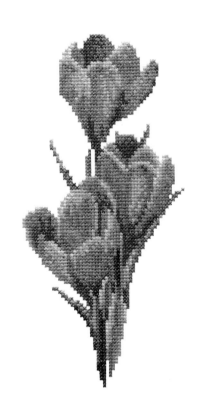

This book is dedicated to my parents for their love and support
throughout my childhood and art education.
My mother's warmth and generosity and my father's strength and positivity
have given me the perfect foundation for my work.

First published in 2001 by Murdoch Books UK Ltd

ISBN 1 85391 779 6

Text by Thea Gouverneur with Heather Haynes

Senior Commissioning Editor: Karen Hemingway
Project Editor: Dawn Henderson
Design: Alyson Kyles
Photography: Joe Filshie, Michelle Garrett and Dominic Blackmore

CEO: Robert Oerton
Publisher: Catie Ziller
International Sales Director: Kevin Lagden
Production Manager: Lucy Byrne

Colour separation by Colourscan, Singapore
Printed and bound by Tien Wah Press, Singapore

Murdoch Books UK Ltd
Ferry House
51–57 Lacy Road
Putney
London SW15 1PR
Tel: +44 (0)20 8355 1480
Fax: +44 (0)20 8355 1499
Murdoch Books UK is a subsidiary of
Murdoch Magazines Pty Ltd.

Murdoch Books®
Pier 8/9 23 Hickson Road
Millers Point
NSW 2000
Australia
Tel: +61 (0)2 8220 2000
Fax: +61 (0)2 8220 2020
Murdoch Books® is a subsidiary of
Murdoch Magazines Pty Ltd.

Flower
PORTRAITS IN
CROSS STITCH

THEA GOUVERNEUR

with Heather Haynes

MURDOCH
BOOKS

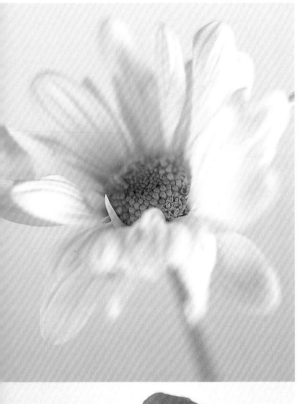

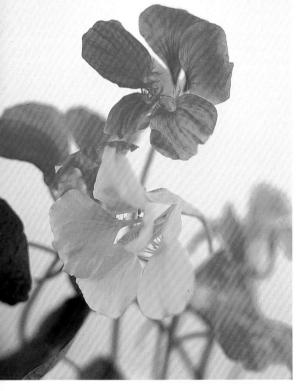

Contents

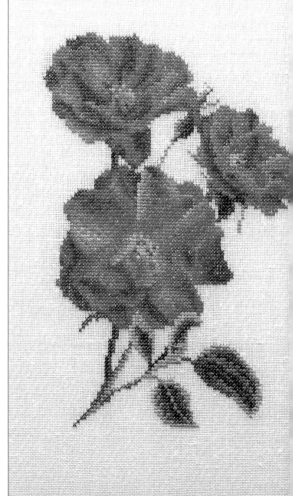

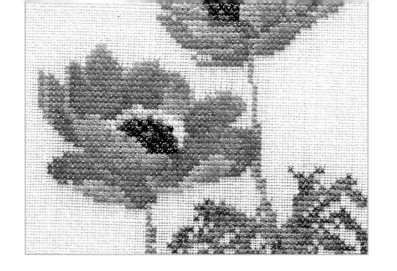

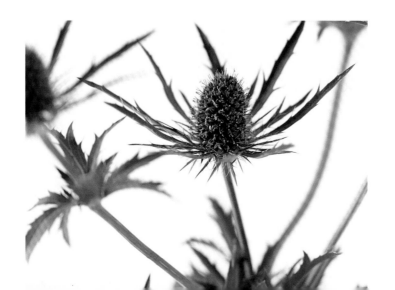

Introduction

I have loved flowers all my life. As a young girl, I was given an area of the garden to look after, and throughout the summer and when the weather was good, I worked in the garden every evening after dinner until it was dark. Over the years I learned a lot about plants and flowers, and my father even promised me that he would help me to open a florist shop. However, as I became first a teacher and then a designer, I never opened that florist shop, but I still work with flowers, of course – many of my cross stitch designs are of flowers.

I also still love to potter in the garden, to put my hand in the soil and smell it, to plant out my favourite flowers, to prune them and rearrange them time and again, and even to cut flowers in the summer and arrange them indoors in vases, or in bouquets for special friends.

Cross stitching is a passion equal to gardening for me. It has its advantages over gardening in that you can be cross stitching while warm and snug indoors – gardening can often leave you feeling cold and stiff. For me, it has the same pleasures as gardening –

the satisfaction of creating something beautiful on a blank canvas, but using coloured threads and stitches rather than plants and flowers. I also find it a tranquil and therapeutic activity – hours can pass when all I have been doing is quietly stitching.

This book of cross stitch designs came about because, after finishing my first book, I felt somehow bereft and wanted to start directly on another book. But where to begin? I knew I wanted to produce a book of flower designs but with so many flowers to choose from, it was very difficult to decide on which ones to include – so, I already have ideas for my third book!

The flowers I eventually settled on are my absolute favourites, the ones that hold particular memories for me. These flowers remind me of holidays, countries, events and of course special people.

So, in this book you will find designs for, among others, the brilliantly coloured anemone, two varieties of narcissus, the exotic bird of paradise flower, the pretty pansy, the gorgeous but short-lived peony, the deliciously scented lily-of-the-valley, the rambling sweet pea, the distinctive black tulip and the butterfly's favourite, the buddleia. The flower designs have been grouped into a rainbow of colours so you can choose from among white, yellow and orange, red, pink, purple and blue flowers. You could stitch several from one coloured section to make a toning group of pictures, perhaps a spring, summer or winter collection, or stitch from across the colour spectrum for a brightly coloured display.

All the designs in this book are accessible for beginners new to cross stitch, but are challenging enough to appeal to experienced stitchers as

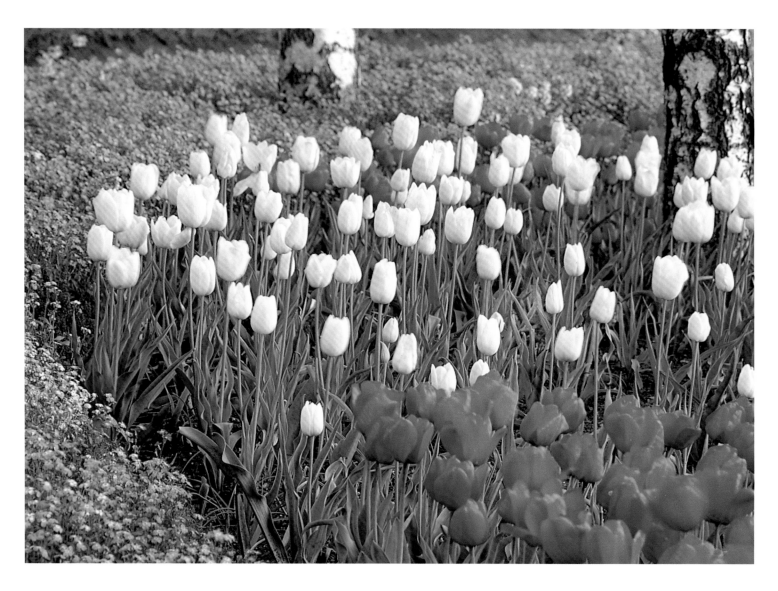

well. They are all roughly the same size, but some designs use more colours of threads than others. Those more experienced will find no problems attempting the passion flower or regal lily designs, for example, while beginners might do better to start with the coneflower or chrysanthemum daisy designs.

The basic techniques needed for cross stitch can be found at the back of the book. These explain the

materials required for cross stitch and show you how to prepare the fabric, how to use a hoop or frame, how to follow the charts, and how to work the stitches. Once you start with one design, I am sure you will want to sew some more. Simply choose your favourite flower and begin stitching!

I am very glad to have been born into a flower-loving family in a flower-growing district. Flowers have given

me such joy throughout my life. I only hope that I can pass some of this enthusiasm on to you through enjoying stitching the wonderful floral designs in this book.

THEA GOUVERNEUR

Passion flower

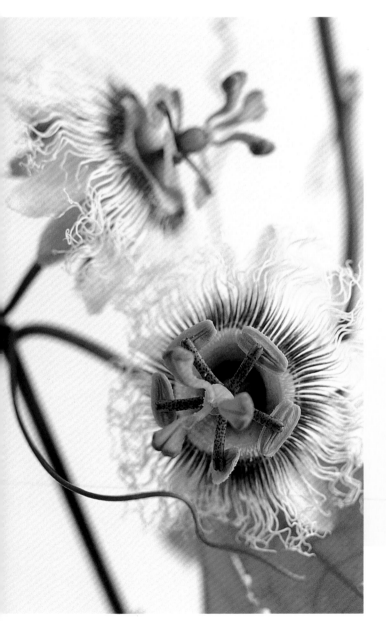

These beautiful and strong-growing climbing plants are from South America. They received their name from the early Jesuit missionaries who saw in the flower, symbols of the Crucifixion. Growing best in sunlight, against a wall or fence or twining up through a tree, passion flowers range in colour from creamy white to bright pink or even scarlet, and usually have a sweet scent.

Years ago, I had a huge passion flower plant growing against the back wall of my house but, unfortunately, it died during a very cold winter. Designing this panel has encouraged me to plant some new passion flowers in my garden.

See pages 158–159 for cross stitch instructions.

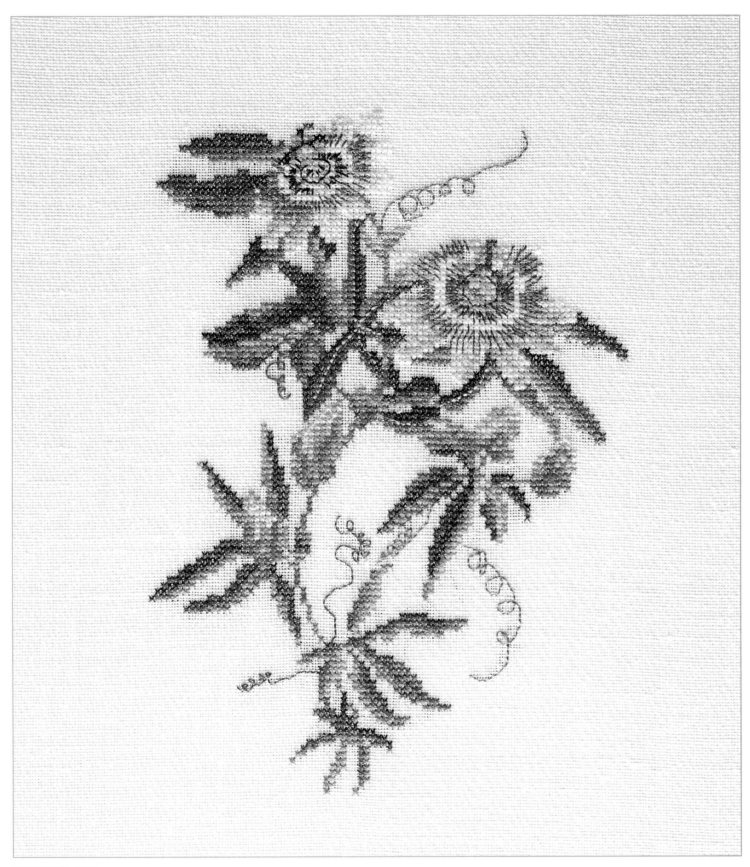

FINISHED SIZE
12 x 16.5cm (4¾ x 6½in)

DMC	Anchor
3346	262
3345	263
934	862
746	275
369	1043
966	240
368	214
3722	1027
221	837
798	146
327	101
3834	99
3047	852
3821	305
3045	945
833	874
831	888
830	889
644	391
640	393
blanc	1
320	215
367	216
319	218
890	212
3013	853
3012	855
3011	856
950	4146
3064	883
3772	1007
632	936
3371	382
677	300
676	891
729	890
3829	901
772	259
3348	264
471	265
3347	261

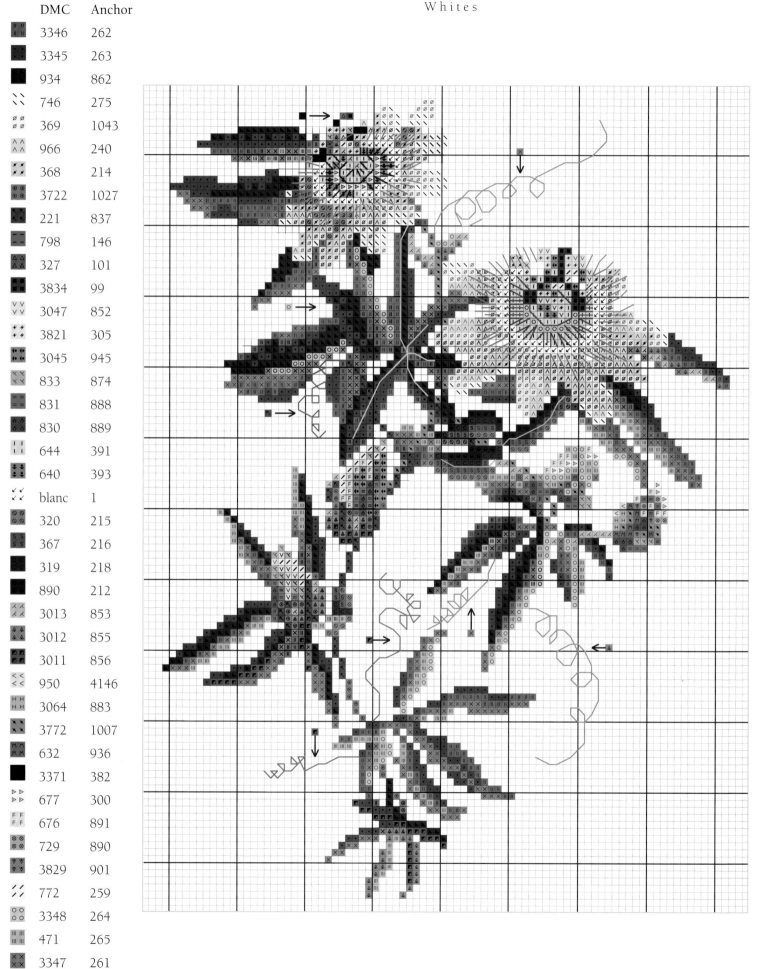

Regal lily

The stately lily with its tall stem and fragrant flowers blooms in the summer and early autumn. An ancient flower, the lily was grown by the Romans and Greeks. Lilies come in a wide variety of colours; the trumpet-shaped petals of the lilium regale are white with a pale yellow throat. These plants can grow above head height, but lilies make superb cut flowers for indoors, too – lasting well in a large flower arrangement.

See pages 158–159 for cross stitch instructions.

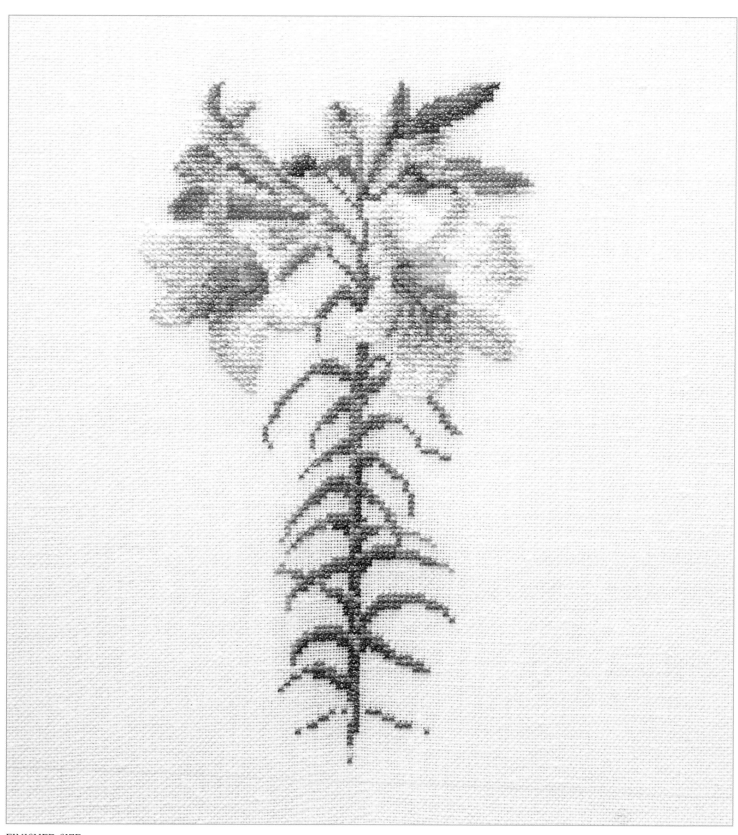

FINISHED SIZE
9.5 x 16cm (3¾ x 6¼in)

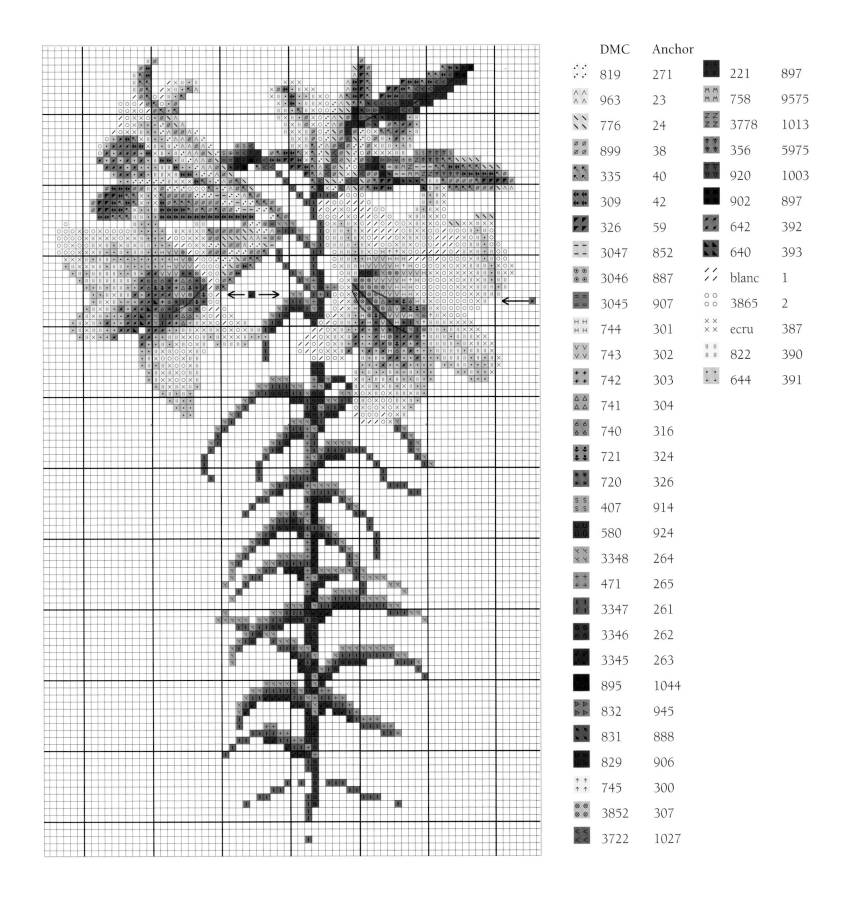

	DMC	Anchor			DMC	Anchor
	819	271			221	897
	963	23			758	9575
	776	24			3778	1013
	899	38			356	5975
	335	40			920	1003
	309	42			902	897
	326	59			642	392
	3047	852			640	393
	3046	887			blanc	1
	3045	907			3865	2
	744	301			ecru	387
	743	302			822	390
	742	303			644	391
	741	304				
	740	316				
	721	324				
	720	326				
	407	914				
	580	924				
	3348	264				
	471	265				
	3347	261				
	3346	262				
	3345	263				
	895	1044				
	832	945				
	831	888				
	829	906				
	745	300				
	3852	307				
	3722	1027				

Water lily

If you are lucky enough to have a pond in your garden, then you are able to grow water lilies. Their tight buds unfurl each morning, opening into an array of white petals centred with yellow, and each evening they close again. Water lilies are extremely ornamental plants, producing flowers over a long season, and their leaves spread decoratively over the surface of the water. I have a lovely view of my water lilies each summer when I look out of the window towards my pond.

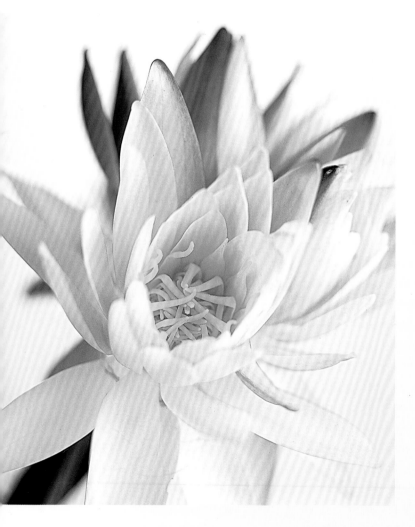

See pages 158–159 for cross stitch instructions.

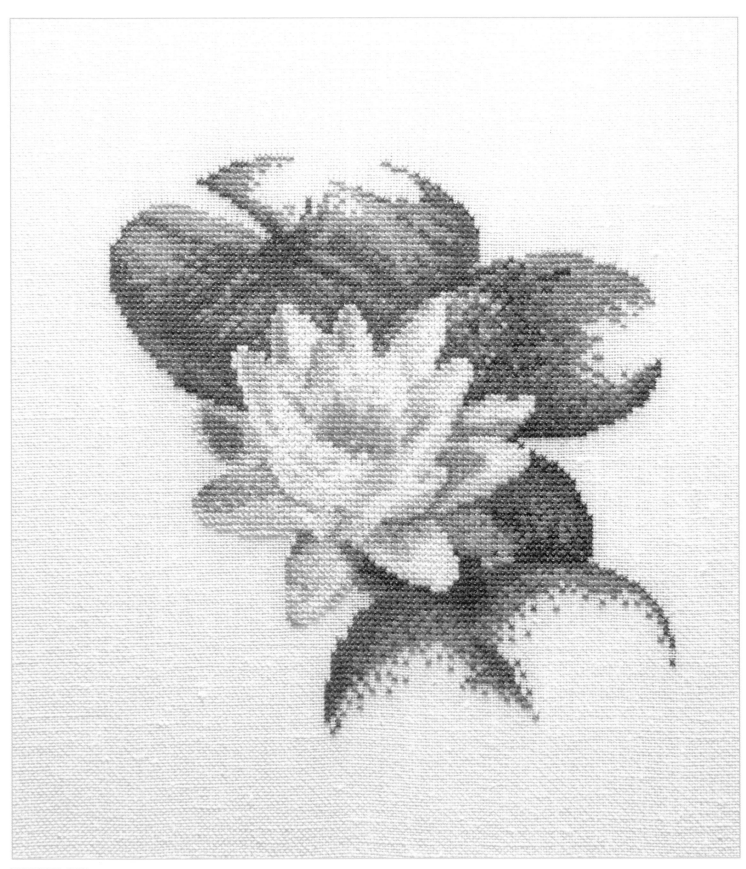

FINISHED SIZE
14.5 x 14.5cm (5¾ x 5¾in)

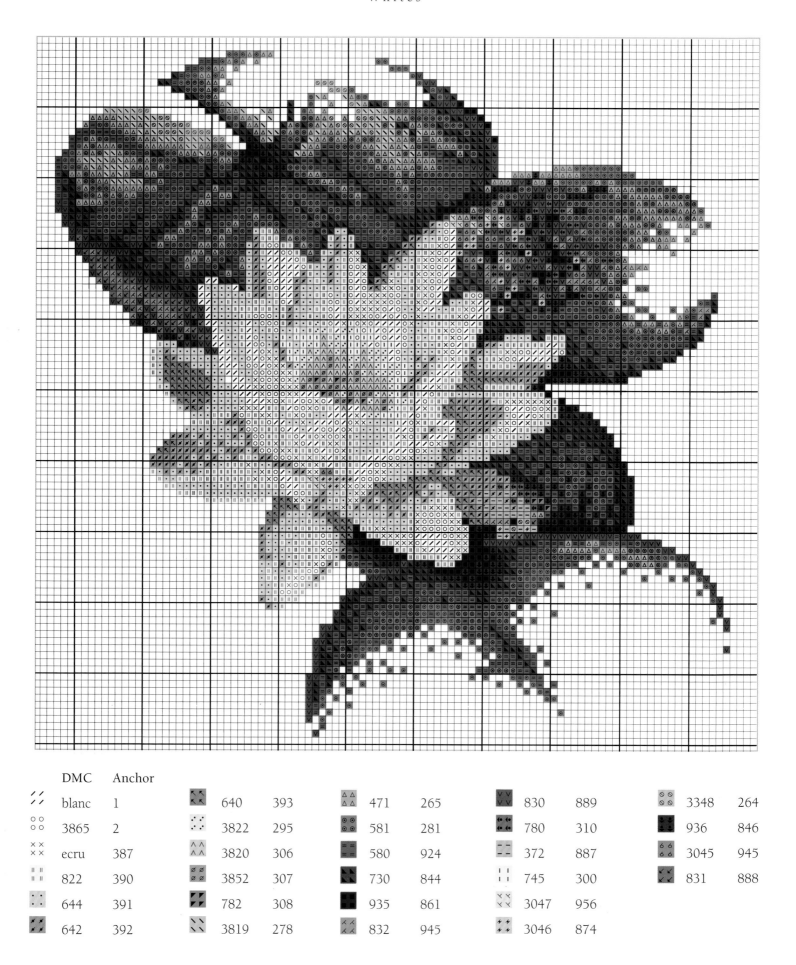

DMC	Anchor								
blanc	1	640	393	471	265	830	889	3348	264
3865	2	3822	295	581	281	780	310	936	846
ecru	387	3820	306	580	924	372	887	3045	945
822	390	3852	307	730	844	745	300	831	888
644	391	782	308	935	861	3047	956		
642	392	3819	278	832	945	3046	874		

Snowdrop

Among the first flowers to appear in the spring – the dainty white heads of snowdrops push their way through the cold, frozen ground. I like growing them in clumps in the lawn – their drooping white petals contrast beautifully with the green grass. They also make good cut flowers indoors, where you can appreciate their delicate scent and shape in warm surroundings. What better way to herald the arrival of spring than to cross stitch this panel of a dainty snowdrop?

See pages 158–159 for cross stitch instructions.

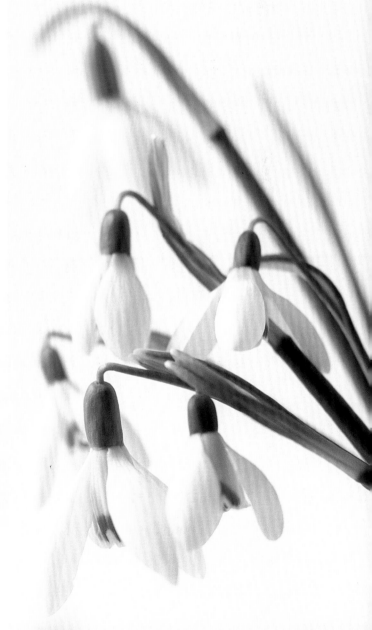

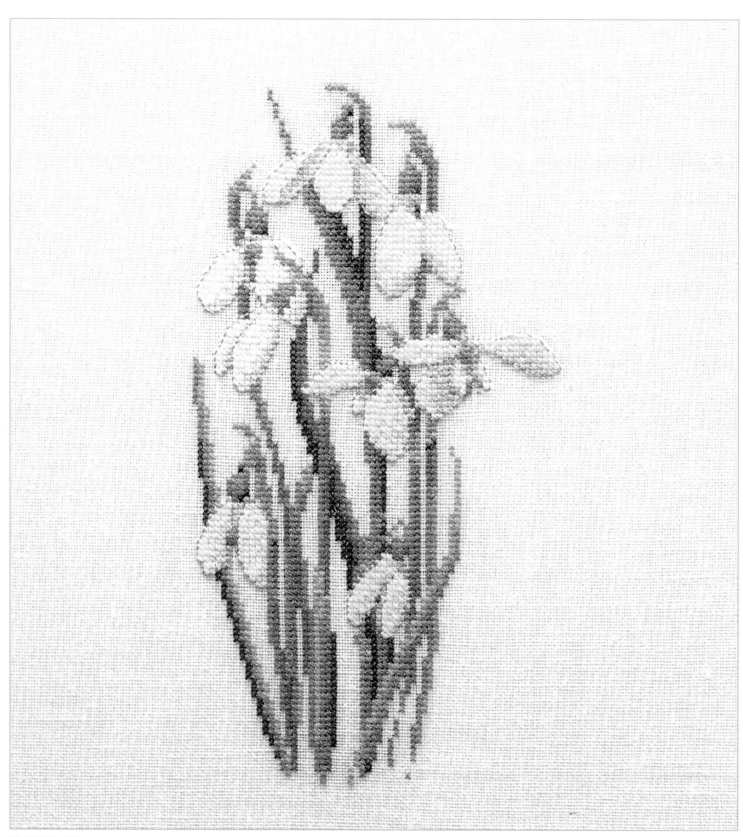

FINISHED SIZE
9 x 17cm (3½ x 6¾in)

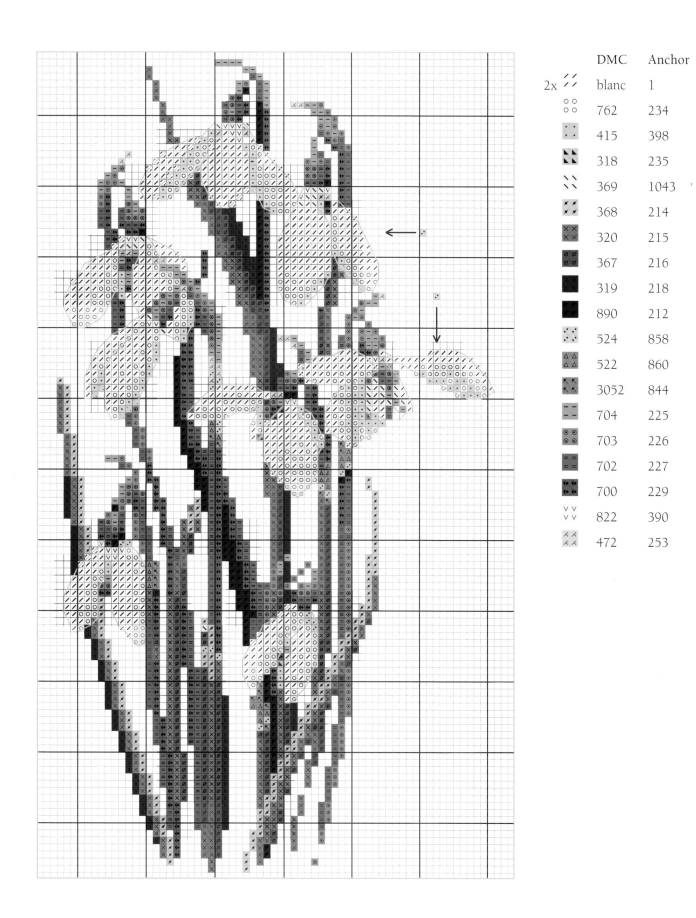

		DMC	Anchor
2x	⁄⁄	blanc	1
	○○	762	234
	·.·	415	398
	◤◥	318	235
	＼＼	369	1043
	▞▞	368	214
	✕✕	320	215
	∅∅	367	216
	■	319	218
	◨	890	212
	:·:	524	858
	△△	522	860
	◤◤	3052	844
	− −	704	225
	◉◉	703	226
	＝＝	702	227
	◐◐	700	229
	∨∨	822	390
	⅄⅄	472	253

Lily-of-the-valley

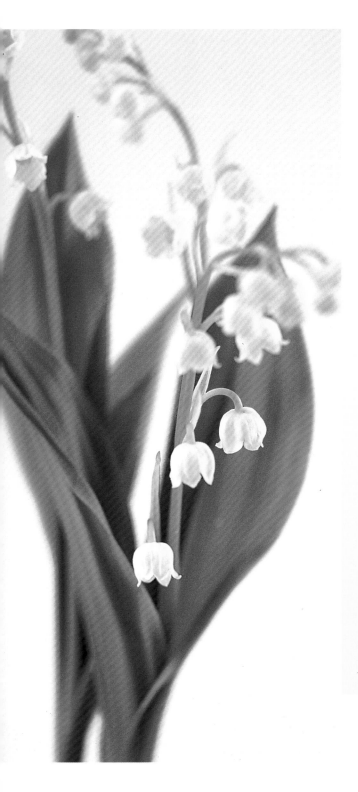

A dainty spring flower, the lily-of-the-valley produces pretty white bells dangling from arching flower stems, which contrast with its large green leaves. This is a great flower to cut and bring indoors – its beautiful fragrance fills the room.

It is a low-growing plant and looks lovely growing beneath trees and shrubs in the garden. Make the most of the lily-of-the-valley, as its season is regrettably brief.

See pages 158–159 for cross stitch instructions.

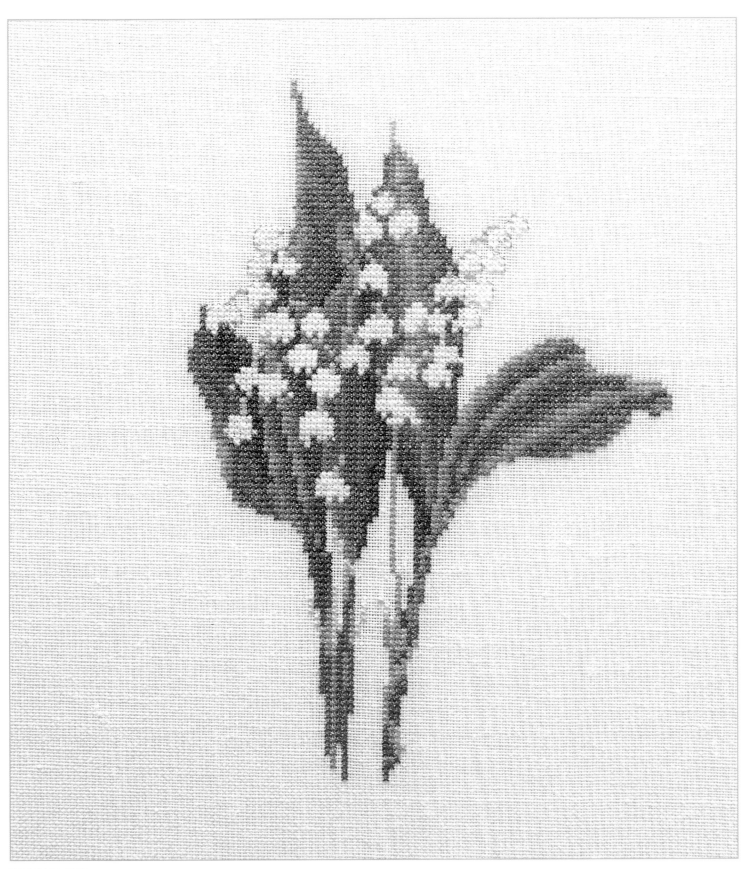

FINISHED SIZE
12 x 17cm (4¾ x 6¾in)

DMC	Anchor
772	259
472	253
471	265
470	266
469	267
936	846
935	861
blanc	1
ecru	387
822	390
224	893
223	895
3721	896
221	897
677	361
422	372
3828	373
869	375
907	255
906	256
905	257
904	258
895	1044
632	936
3799	236

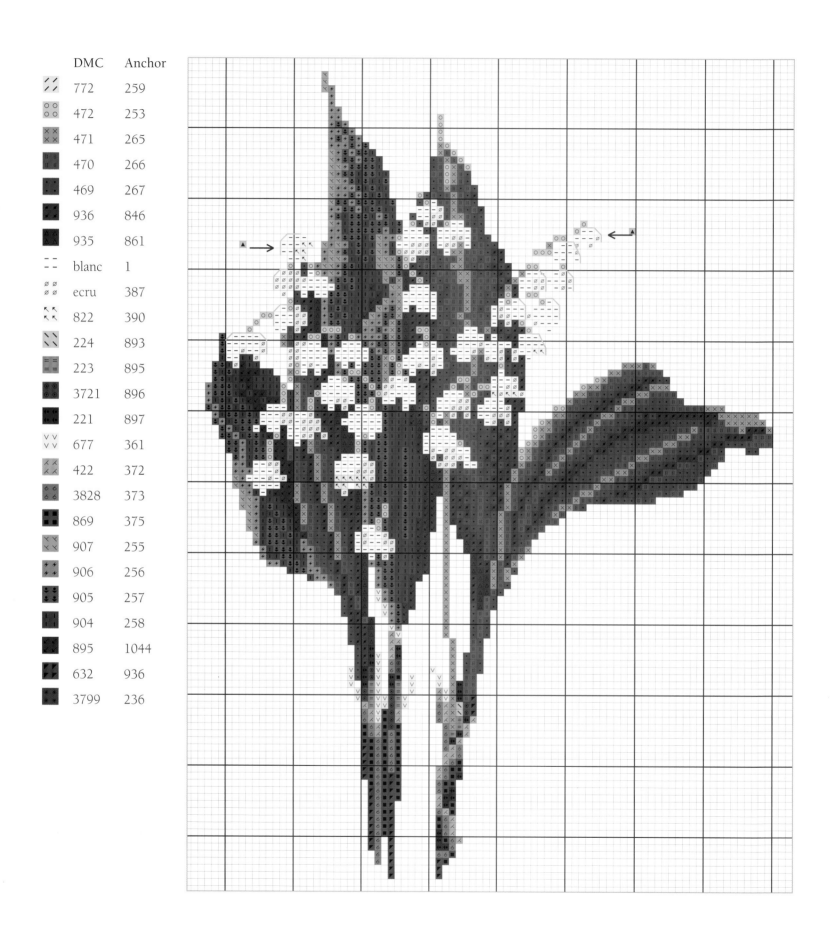

Hellebore

Otherwise known as the Christmas rose, the helleborus niger blooms from late winter to early spring, depending on how cold the weather is. At first, the flowers are white, then magically the petals change to purplish pink, contrasting with their dark green leaves.

These flowers bring elegance to any garden, blooming in low clumps when few others dare to flower. They look best clustered at the front of a bed in a shady area of the garden. Don't eat them, however, as they are very poisonous!

See pages 158–159 for cross stitch instructions.

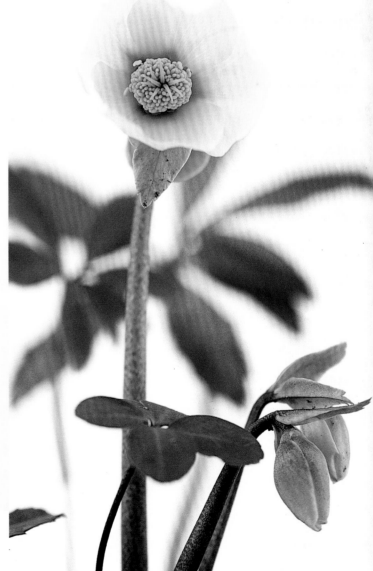

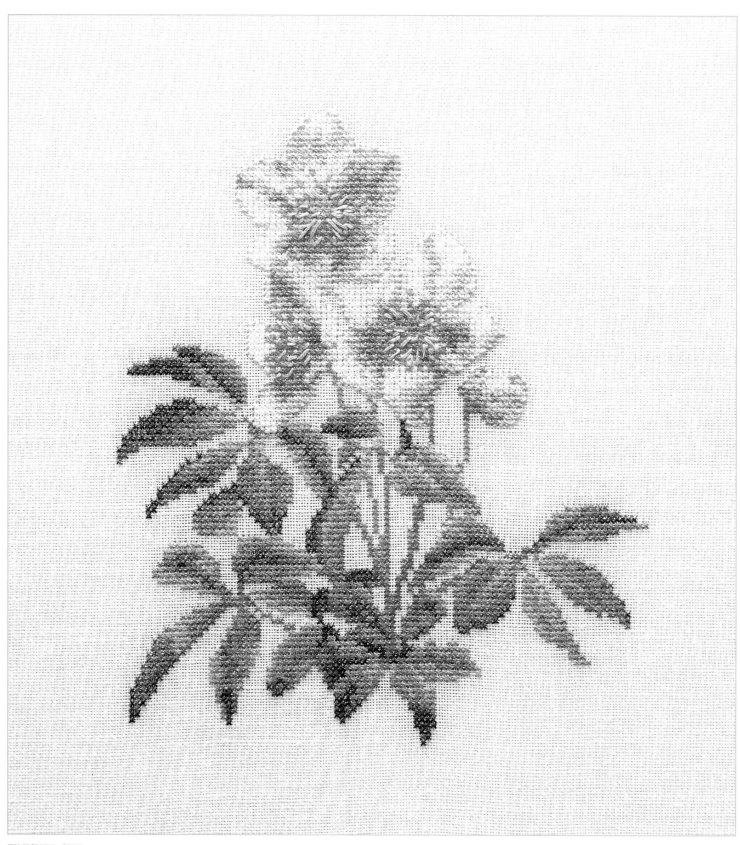

FINISHED SIZE
13.5 x 15.5cm (5¼ x 6¼in)

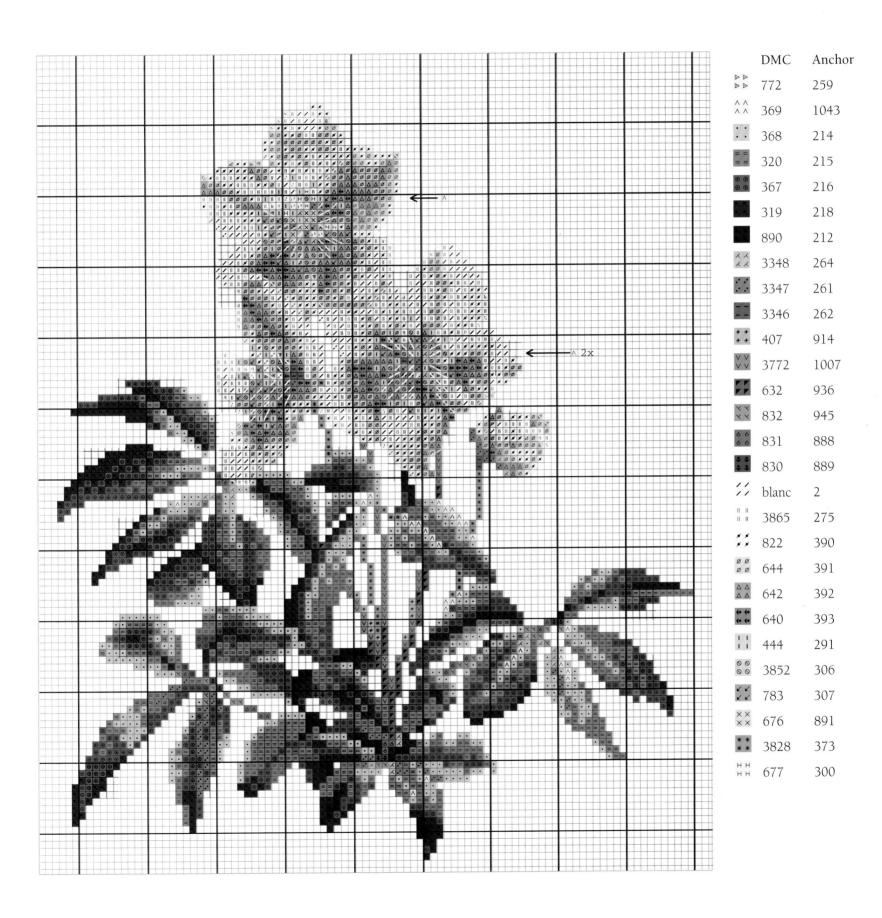

	DMC	Anchor
▷▷ ▷▷	772	259
∧ ∧ ∧ ∧	369	1043
	368	214
= = = =	320	215
	367	216
	319	218
	890	212
↗ ↗ ↗ ↗	3348	264
	3347	261
− − − −	3346	262
	407	914
∨ ∨ ∨ ∨	3772	1007
	632	936
✕ ✕ ✕ ✕	832	945
6 6 6 6	831	888
	830	889
∕ ∕ ∕ ∕	blanc	2
‖ ‖ ‖ ‖	3865	275
∕ ∕ ∕ ∕	822	390
∅ ∅ ∅ ∅	644	391
△ △ △ △	642	392
	640	393
∣ ∣ ∣ ∣	444	291
◦ ◦ ◦ ◦	3852	306
	783	307
✕ ✕ ✕ ✕	676	891
∗ ∗ ∗ ∗	3828	373
H H H H	677	300

Narcissus 'Thalia'

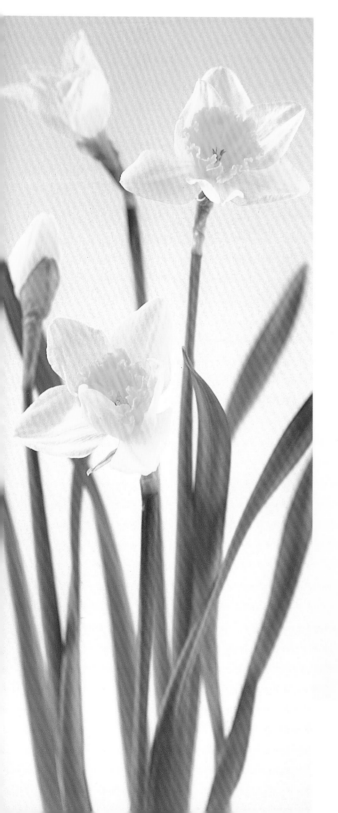

Daffodils are among the most popular spring flowers, as a walk down any suburban street in the spring will testify. Unlike the more traditional yellow daffodil, the elegant narcissus 'thalia' featured in this panel is completely white, with drooping petals, and usually has several flowers on each stem.

In the garden, these flowers look lovely growing in the grass. If you leave them year after year, they will reproduce naturally in a spreading clump.

See pages 158–159 for cross stitch instructions.

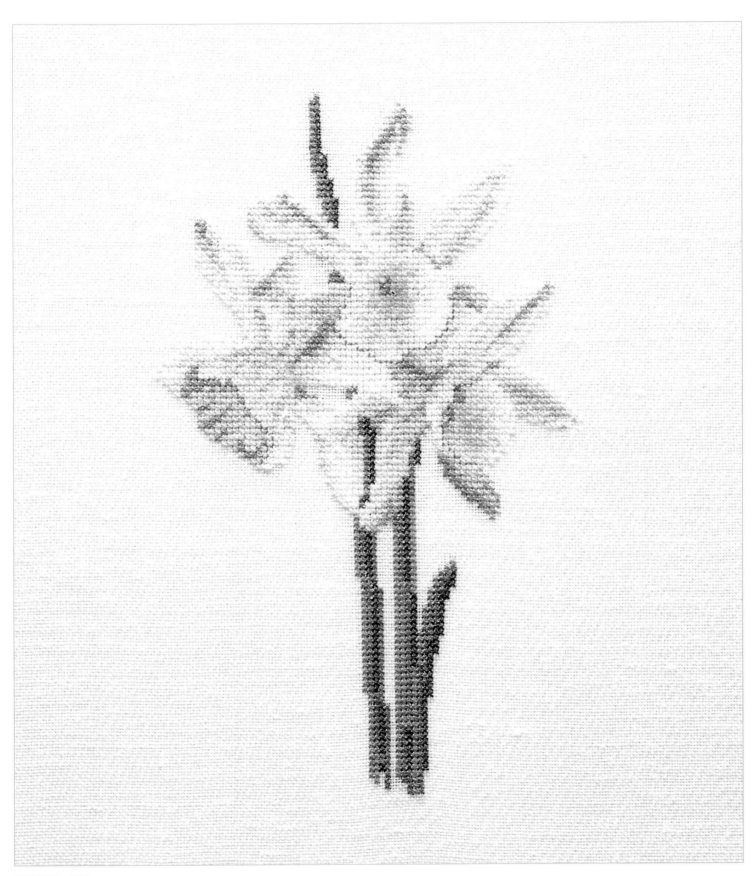

FINISHED SIZE
10.5 x 16.5cm (4¼ x 6½in)

	DMC	Anchor
╱╱	blanc	1
○○	746	275
✕✕	822	390
‖‖	644	391
··	642	392
▨▨	640	393
╲╲	320	215
⌀⌀	367	216
■	319	1044
∧∧	677	361
⸜⸜	676	891
△△	729	890
◪◪	3829	901
▦▦	869	375
══	741	304
◉◉	740	316

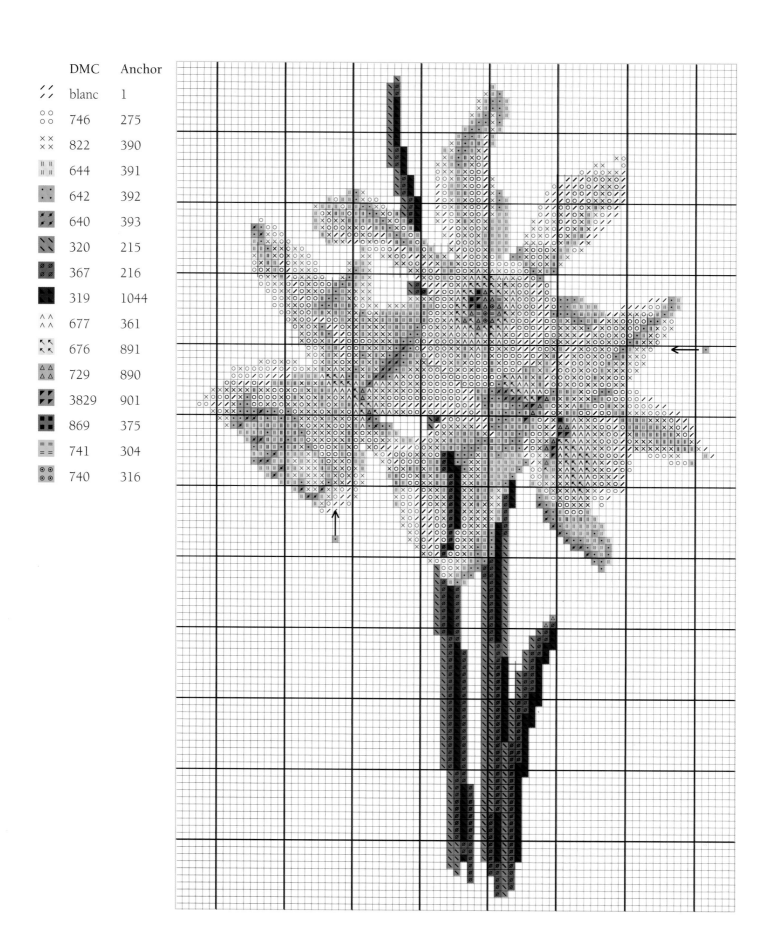

Daisy chrysanthemum

Originating from the Pyrenean mountains and from Corsica, this large garden daisy with its crisp white petals and yellow heart makes a lovely flower for the border in late summer and early autumn. These are also ideal flowers to display indoors – in formal arrangements or simply placed in a jam jar on the kitchen table.

These flowers remind me of the wild daisies that grow along the roadsides in The Netherlands – nestling between the poppies and moving in the wind.

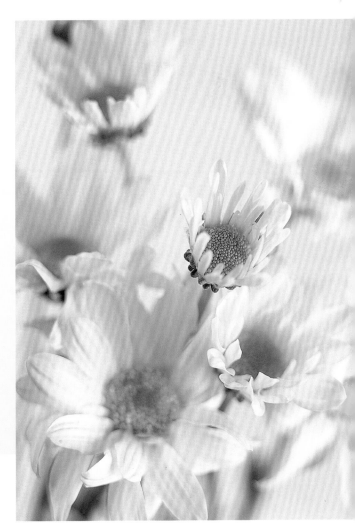

See pages 158–159 for cross stitch instructions.

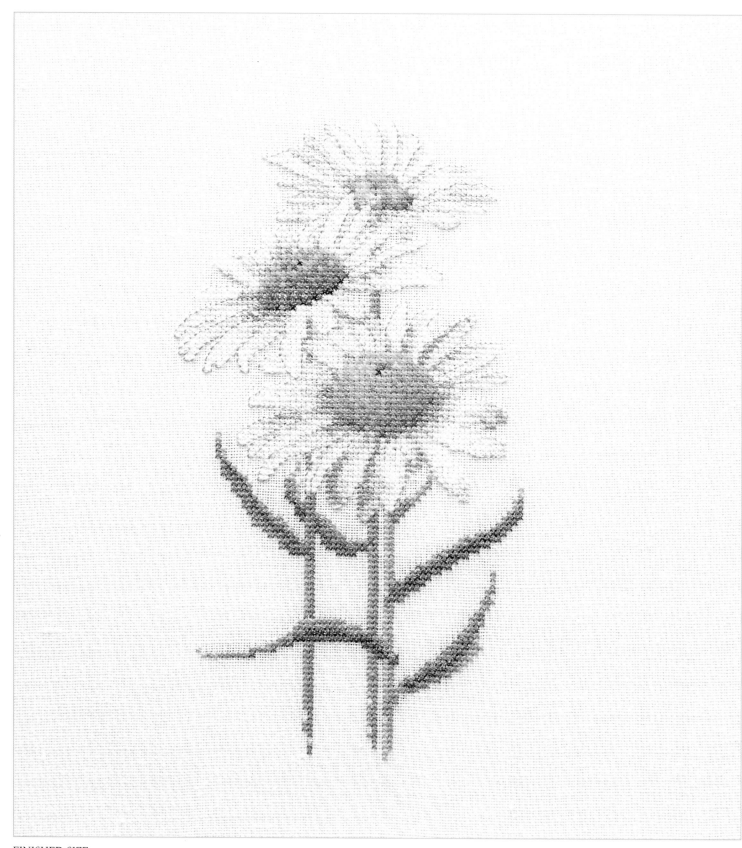

FINISHED SIZE
9.5 x 16.5cm (3¾ x 6½in)

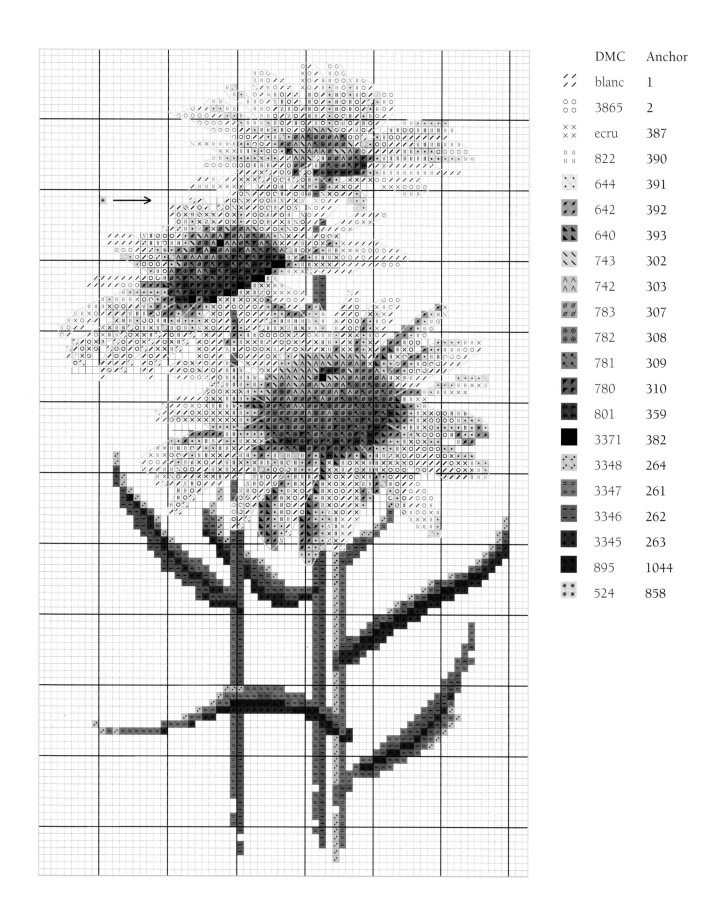

	DMC	Anchor
∕ ∕	blanc	1
○ ○	3865	2
× ×	ecru	387
‖ ‖	822	390
∴	644	391
◢◣	642	392
◥◤	640	393
╲ ╲	743	302
∧ ∧	742	303
∅ ∅	783	307
⊙ ⊙	782	308
◤◥	781	309
◢◣	780	310
▨	801	359
■	3371	382
⠿	3348	264
⊟	3347	261
⊟	3346	262
▦	3345	263
■	895	1044
✳ ✳	524	858

Honeysuckle

A traditional much-loved cottage garden flower, honeysuckle is very sweetly scented, especially after a shower of rain or in the evening. It produces clusters of pale yellow flowers throughout the summer months, followed by sticky red fruits in the autumn.

I have a honeysuckle plant in my garden, climbing through a pine tree, and its delicious perfume drifts right across my terrace. Rambling over walls and trellises, or even grown as a shrub, honeysuckle is a pretty climbing plant that adds a sense of charm to any garden.

See pages 158–159 for cross stitch instructions.

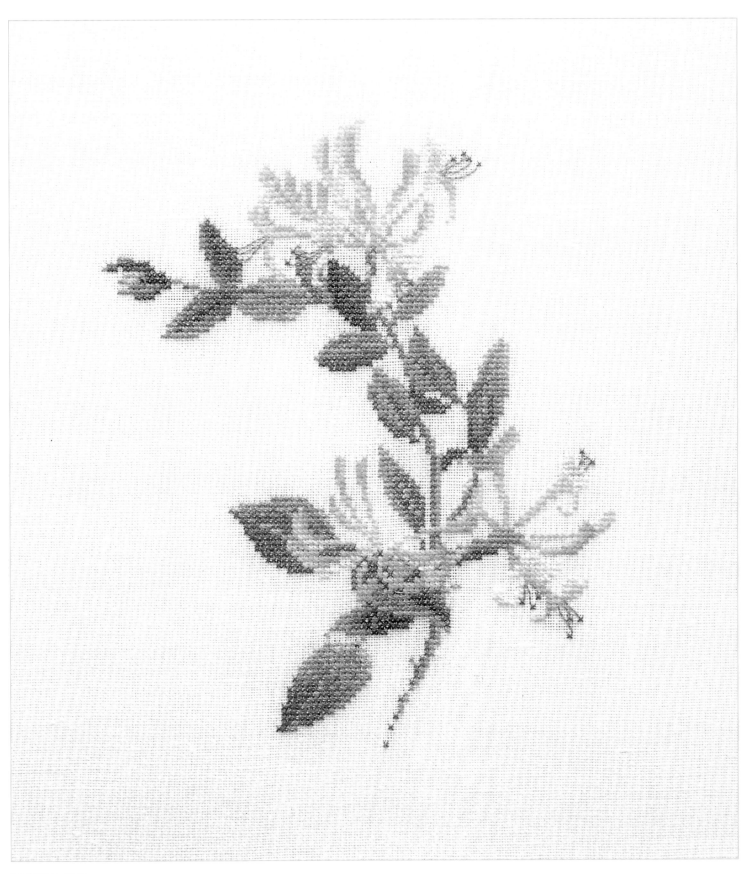

FINISHED SIZE
14 x 16.5cm (5½ x 6½in)

DMC	Anchor
472	253
471	265
470	266
469	267
936	846
935	861
934	862
3823	2
745	300
744	301
743	302
742	303
741	304
740	316
3852	306
3828	373
782	308
869	375
733	279
732	280
730	924

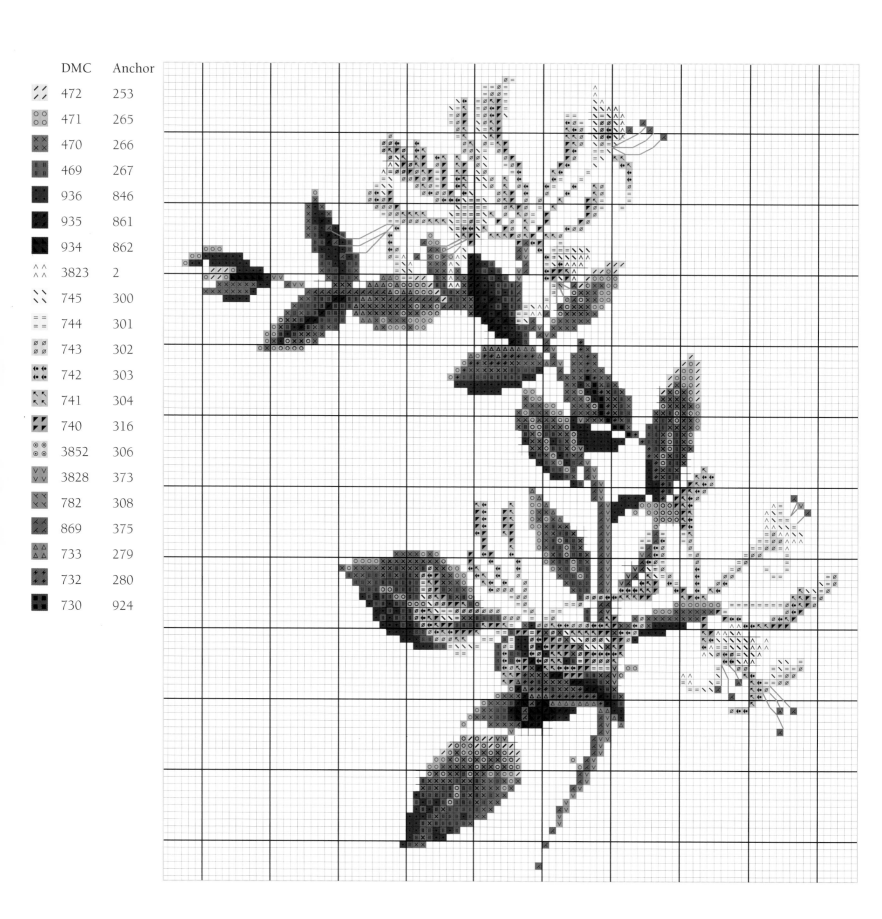

Angel's trumpet

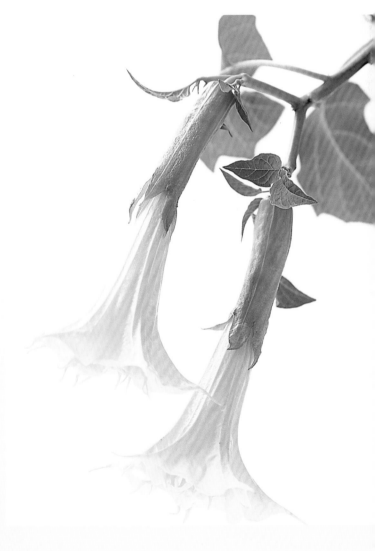

Also known as the thorn apple, this plant is one of my favourite summer-flowering plants, with its large pale yellow flower head and delicious scent. Last summer I bought a very large one but was too busy to spend much time tending to it – it produced not a single flower. So I talked to it and gave it extra food and water and, to my surprise, I discovered almost a hundred buds on the plant in early autumn! And they all flowered beautifully – right through into the winter.

See pages 158–159 for cross stitch instructions.

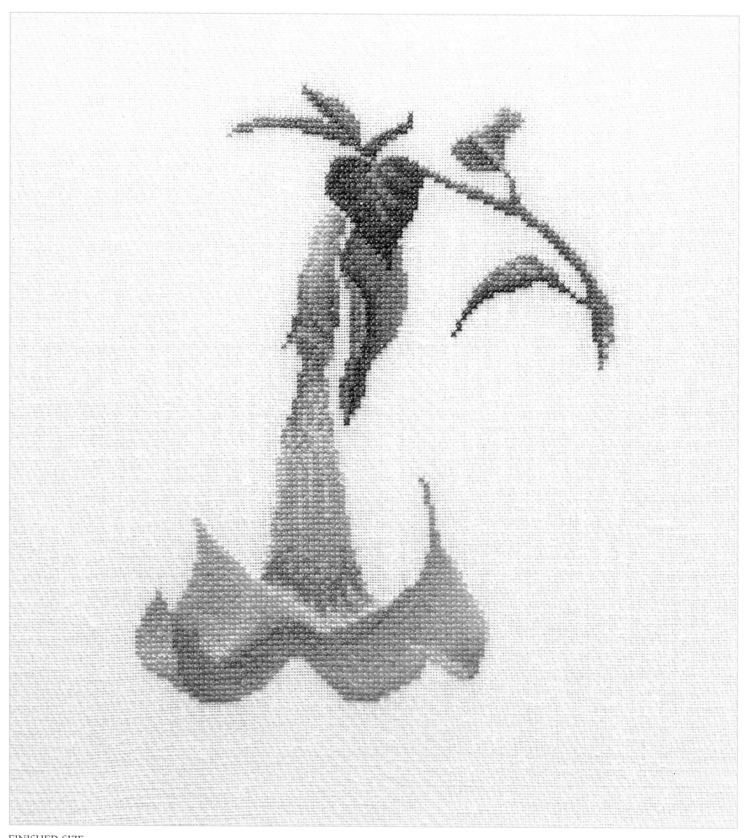

FINISHED SIZE
13 x 16.5cm (5¼ x 6½in)

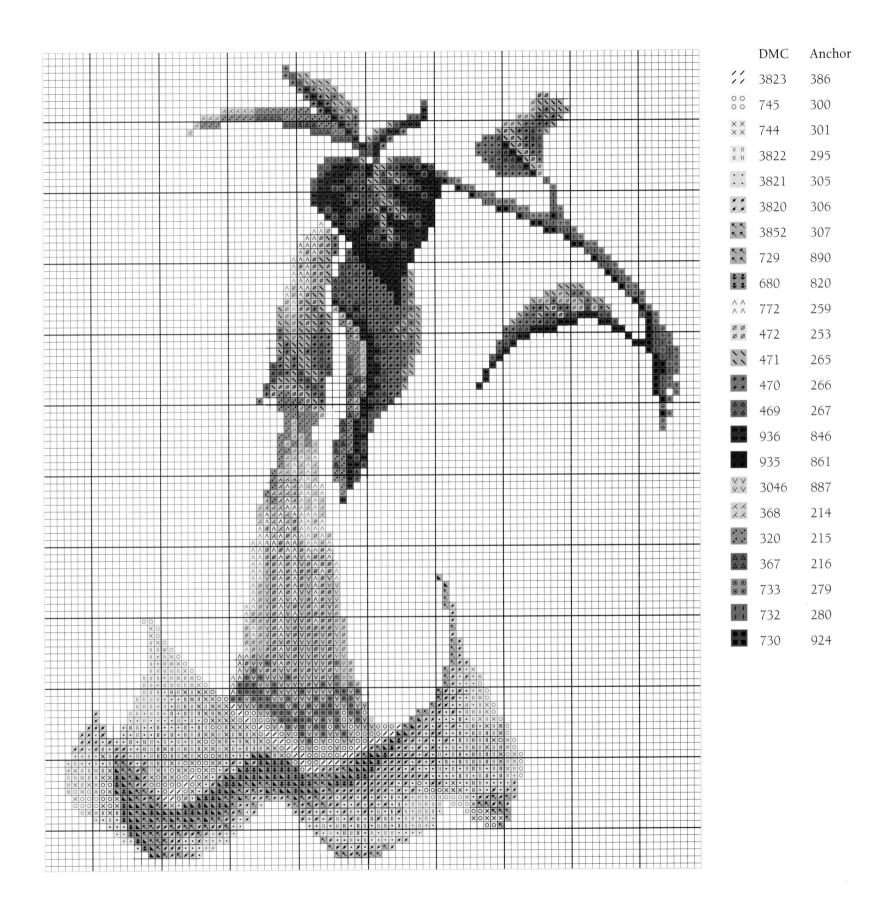

	DMC	Anchor
∕∕	3823	386
○○	745	300
✕✕	744	301
‖‖	3822	295
∶∶	3821	305
◤◢	3820	306
ĸĸ	3852	307
ĸĸ	729	890
⚓⚓	680	820
∧∧	772	259
∅∅	472	253
＼＼	471	265
⚡⚡	470	266
♦♦	469	267
◣◣	936	846
■■	935	861
∨∨	3046	887
⋌⋌	368	214
∴∴	320	215
△△	367	216
◎◎	733	279
∥∥	732	280
▦▦	730	924

Narcissus 'Tête à tête'

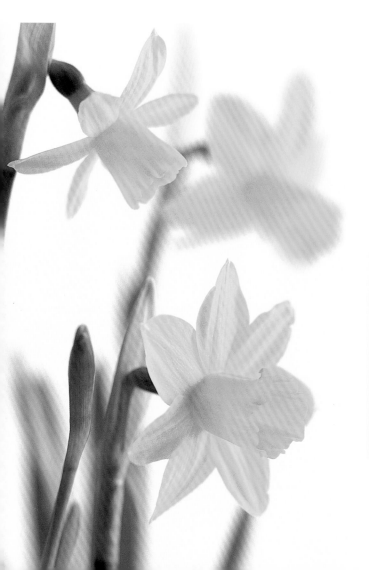

This pretty daffodil is yellow with an orange-coloured throat. On each stalk two flowers grow next to each other, hence the name 'tête-à-tête'. It is often grown in pots, window boxes and other containers, as well as in borders. I like to have a basket of these flowers in my kitchen. Appearing in mid spring, the narcissus tête à tête will add a splash of colour to a bleak garden or rockery.

See pages 158–159 for cross stitch instructions.

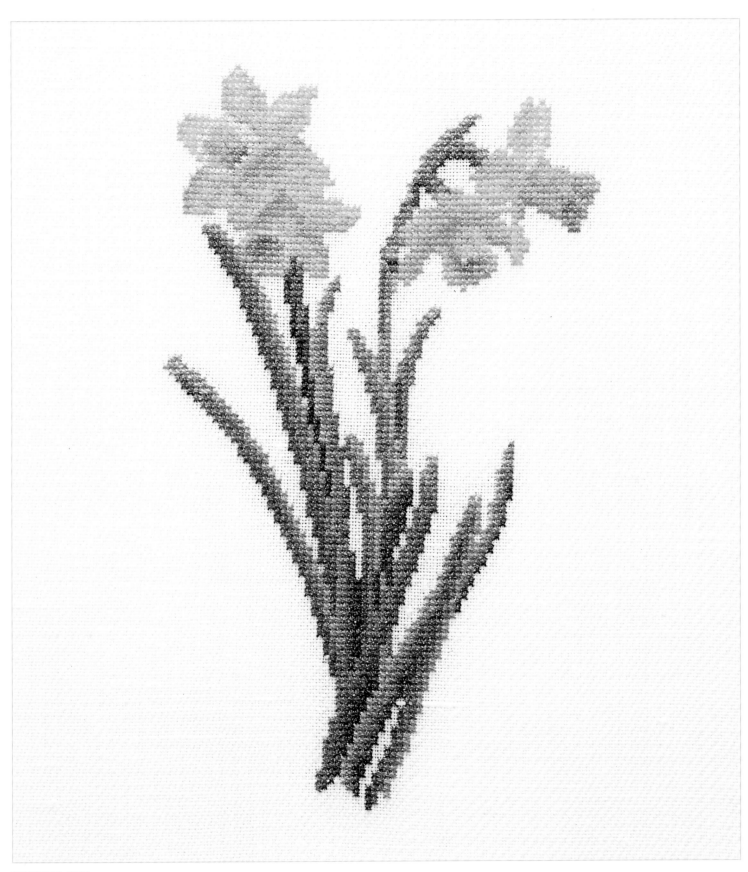

FINISHED SIZE
10 x 16.5cm (4 x 6½in)

	DMC	Anchor
⁄⁄	3078	292
○○	727	293
××	726	295
‖‖	725	305
∴	742	303
⁄⁄	741	304
∅∅	740	316
＼＼	783	307
==	368	214
△△	320	215
◉◉	367	216
■	319	218
■	890	212
--	3053	843
∨∨	989	242
♦♦	987	244
◀▶	986	246
∨∨	372	854
✦✦	371	855
‖‖	370	856
♦♦	611	898
△△	3821	305
↙↙	3820	306
＊＊	3852	307
HH	834	887
▷▷	833	874
‖‖	832	945
◀◢	831	888
ss	3348	264
■	895	1044

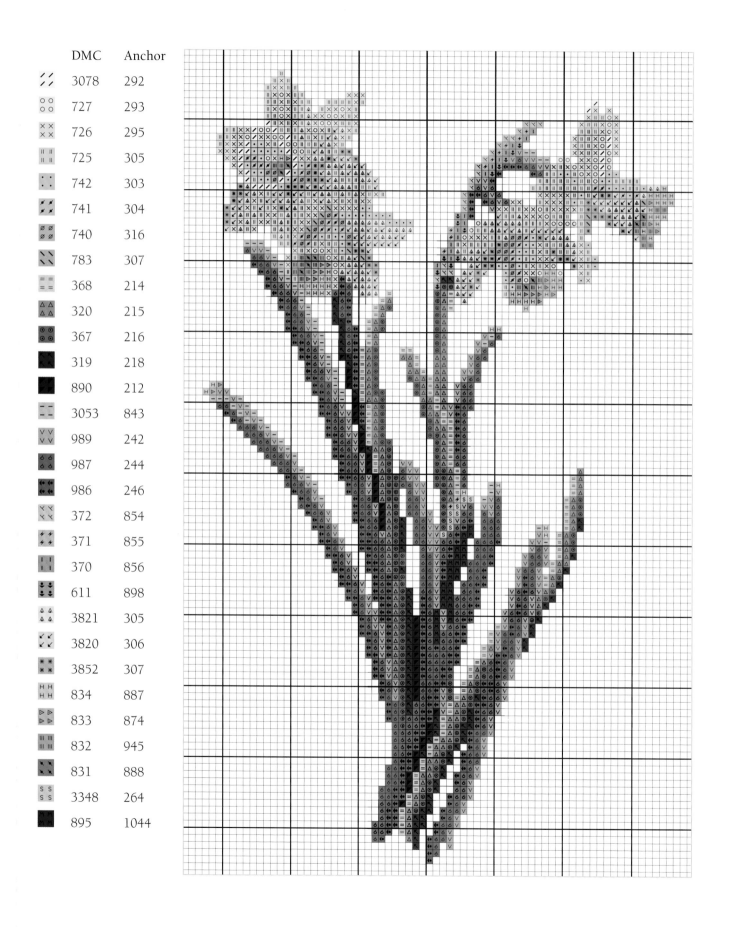

Yellow flag

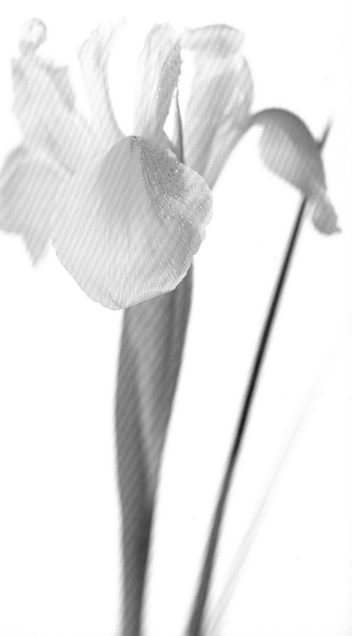

The iris is one of the most cultivated plants in the world with over a thousand different varieties. The yellow flag, which blooms in early summer, has tall stems topped with lemon-yellow flowers delicately patterned with a tracery of veins.

It grows well in boggy areas, such as around bogs and streams; I grow yellow flags in my pond and they do so well that I constantly have to cut them back! This yellow flag is the heraldic symbol of kings – it is also known as the *fleur de lis*.

See pages 158–159 for cross stitch instructions.

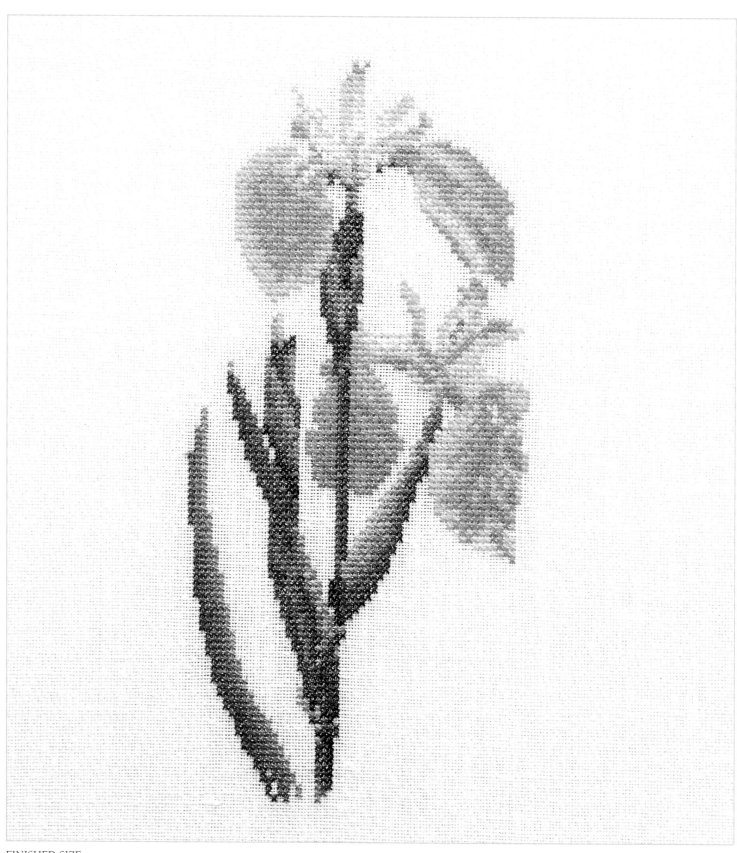

FINISHED SIZE
8 x 17cm (3¼ x 6¾in)

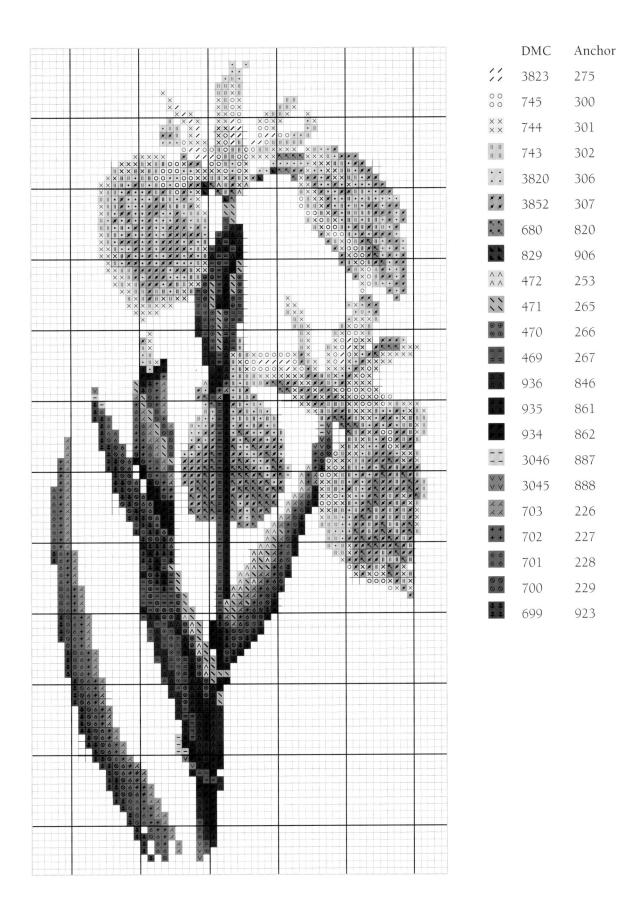

	DMC	Anchor
⁄⁄	3823	275
∘∘	745	300
××	744	301
‖‖	743	302
⦂⦂	3820	306
▞▞	3852	307
◤◤	680	820
◣◣	829	906
∧∧	472	253
╲╲	471	265
⊚⊚	470	266
==	469	267
◭◭	936	846
◼◼	935	861
◪◪	934	862
--	3046	887
∨∨	3045	888
⋌⋌	703	226
⚡⚡	702	227
⑥⑥	701	228
◕◕	700	229
⚓⚓	699	923

Ranuncula

From the same family as the buttercup, this bright yellow flower with its layers of petals grows in early summer. There are many varieties of ranuncula with red, pink, orange and white flowers. Some flowers have a familiar pompom flower head, while others have only one layer of petals.

The ranuncula is easy to grow in the garden in the sun or the shade, but it does not last long if cut and brought indoors. Admire these flowers growing naturally outside, and stitch yourself a cross stitch panel for indoor enjoyment!

See pages 158–159 for cross stitch instructions.

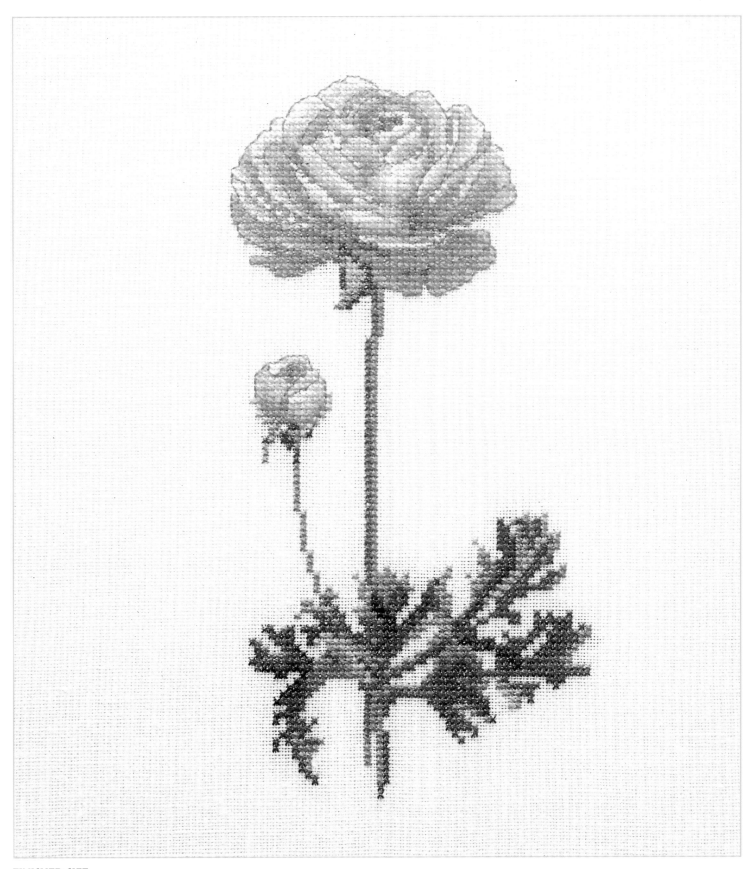

FINISHED SIZE
8.5 x 16cm (3¼ x 6¼in)

DMC	Anchor
∕∕ 3823	275
∘∘ 745	300
×× 744	301
‖‖ 743	302
∙∙ 742	303
⚡⚡ 741	304
øø 783	307
↖↖ 782	308
◣◣ 780	310
∧∧ 472	253
∴∴ 471	265
◨◨ 469	267
■■ 936	846
■■ 934	862
⊙⊙ 834	887
△△ 833	874
‐‐ 832	945
∨∨ 733	279
◀◀ 732	280
▦▦ 3829	901

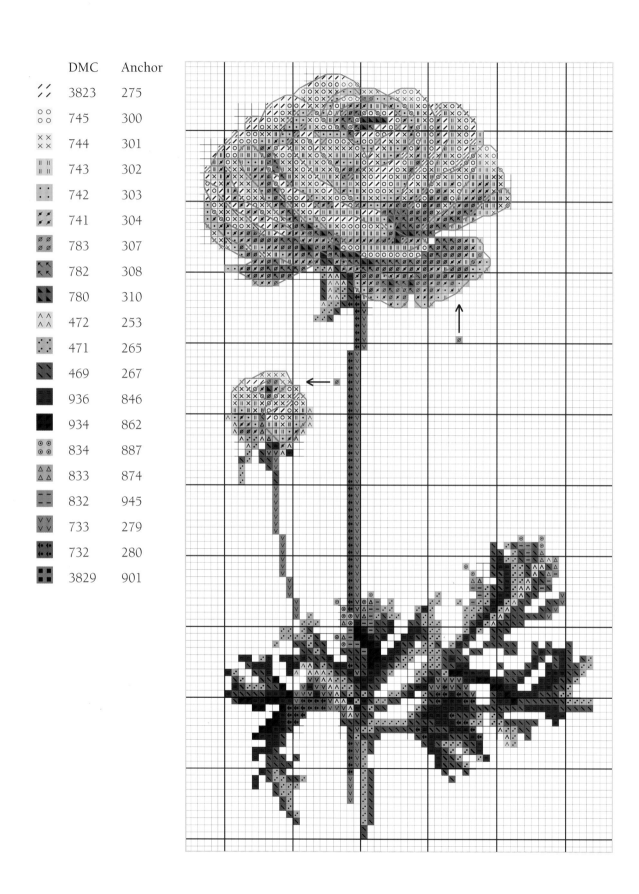

Coneflower

The coneflower is a large daisy-shaped flower, with drooping petals and a large cone-like centre, hence its name. It is a majestic plant, growing to waist height, and spreading gently in clumps. When the flowers are gone, the seed heads can be cut and added to bouquets.

The coneflower featured in this design is yellow, but there are also pink and purple varieties. If you like wildlife in the garden, the coneflower is ideal, as it tends to attract both butterflies and bees.

See pages 158–159 for cross stitch instructions.

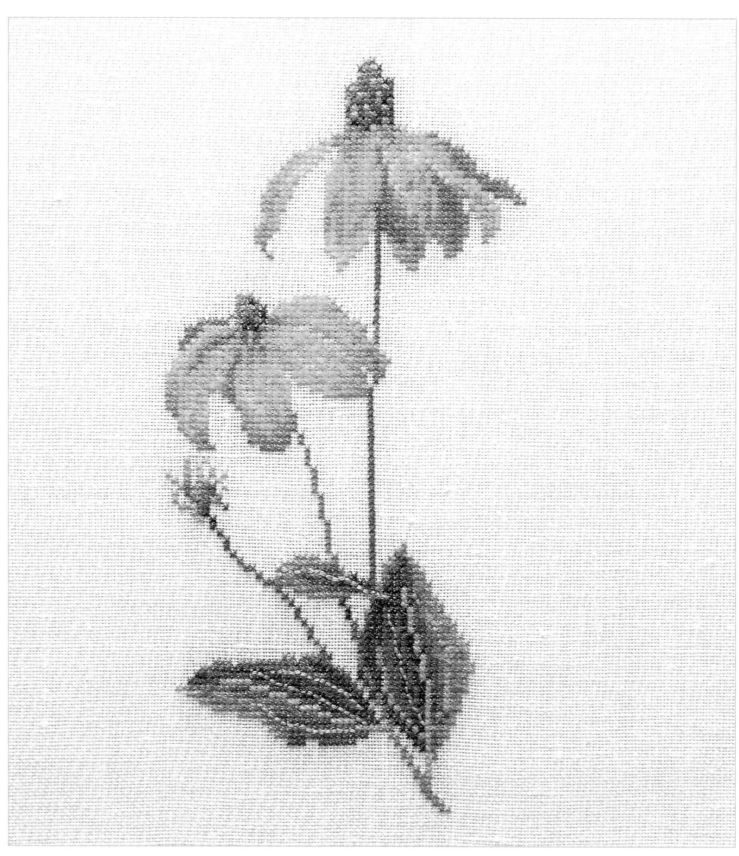

FINISHED SIZE
8 x 16.5cm (3 x 6½in)

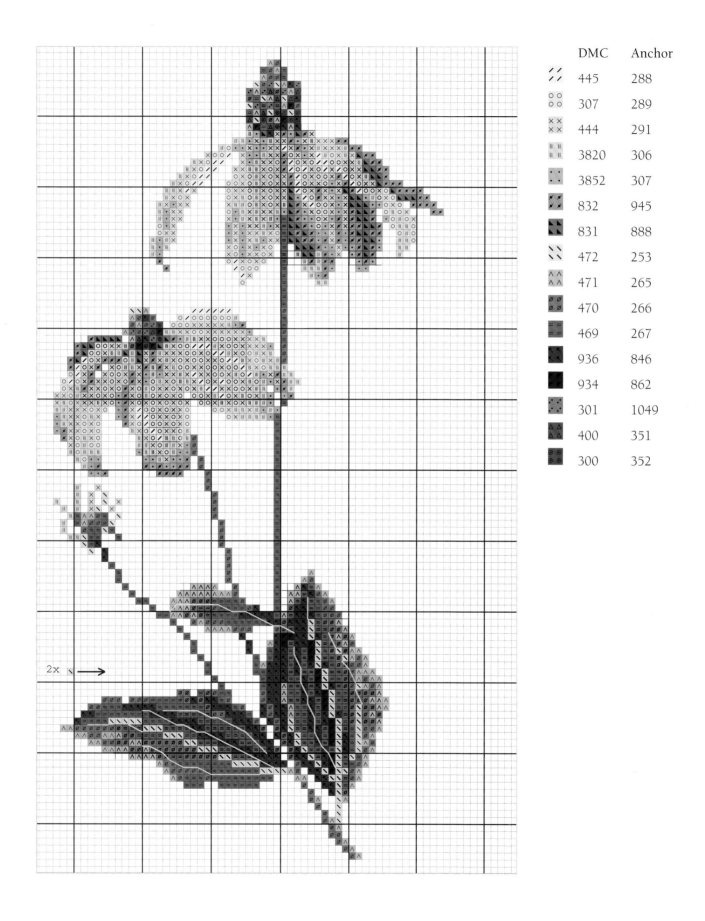

	DMC	Anchor
∕∕	445	288
○○	307	289
✕✕	444	291
‖‖	3820	306
∴	3852	307
◪	832	945
◪	831	888
∖∖	472	253
∧∧	471	265
∅∅	470	266
≡≡	469	267
◼	936	846
◼	934	862
∴	301	1049
△△	400	351
⊛⊛	300	352

2x →

Fritillary

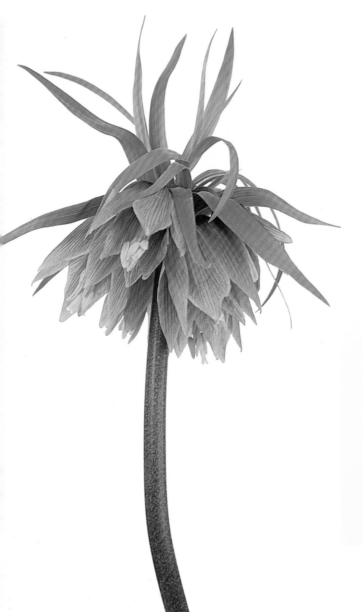

Known also as the emperor's crown, this golden yellow fritillary comes from Afghanistan and the north-western part of the Himalayan mountains. It can grow to an imposing height, flowering in the spring. At the top of each stem is a cluster of hanging yellow blooms topped with a pineapple-like crown of short green leaves. Many Dutch flower painters included these regal-looking flowers in their work.

Although the fragrance of the fritillary is somewhat peculiar, this plant makes a good cut flower for displaying indoors.

See pages 158–159 for cross stitch instructions.

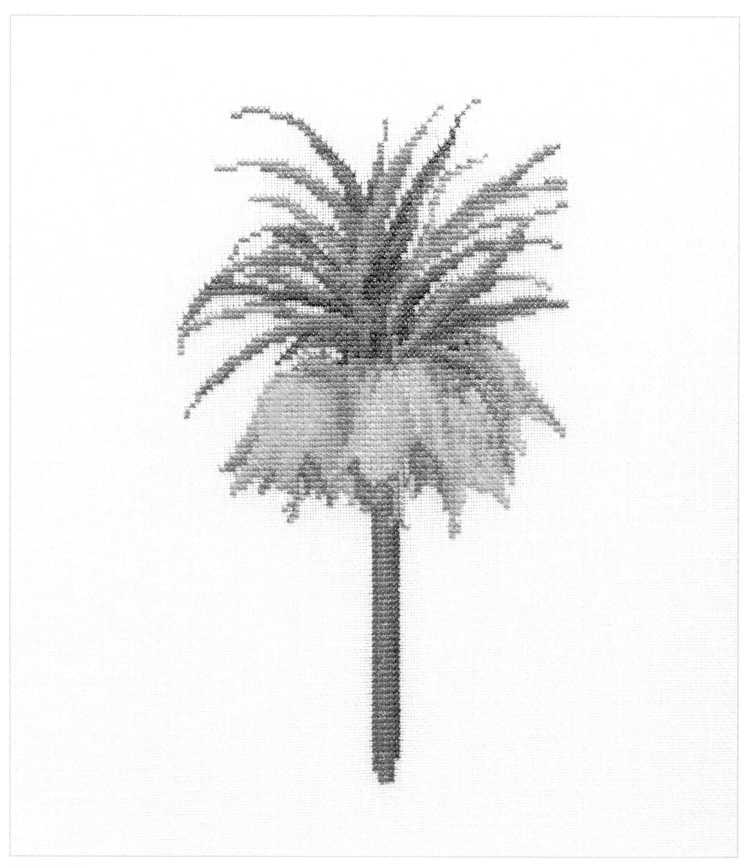

FINISHED SIZE
10 x 17cm (4 x 6¾in)

DMC	Anchor
745	300
744	301
743	302
742	303
3820	306
729	890
680	820
3829	901
704	256
703	238
702	226
701	227
699	923
3819	278
581	281
580	924
3348	264
3347	261
3346	262
3345	263
895	1044
734	278
733	279
732	280
444	291

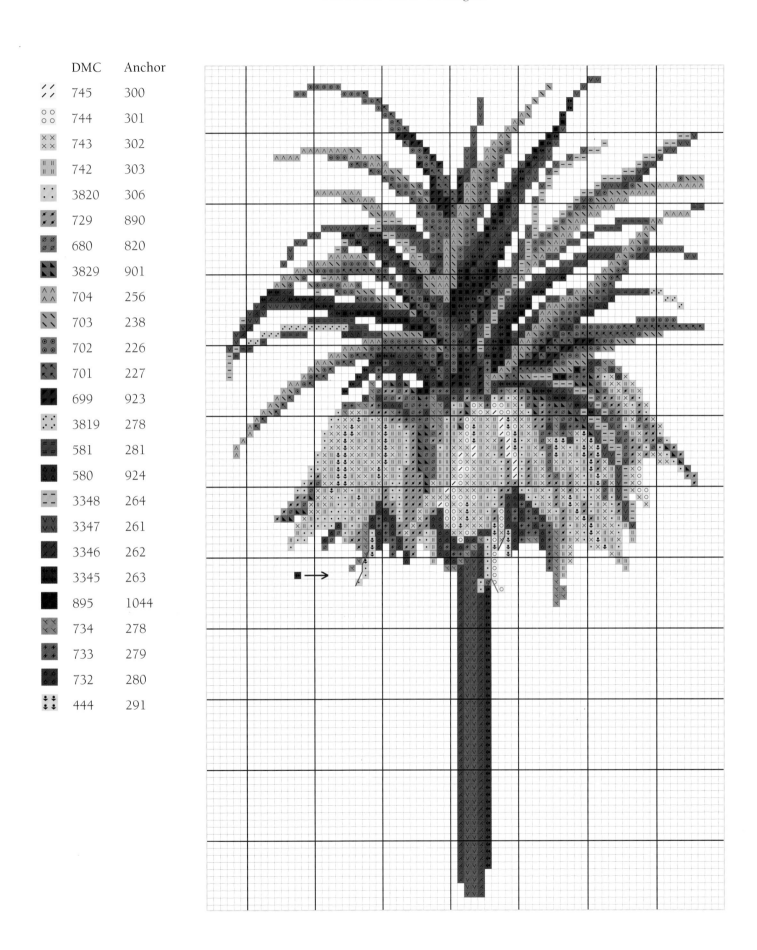

Nasturtium

With its cheerful orange and yellow flower heads and attractive round leaves, this is one of my favourite summer flowers. Nasturtiums have a special smell that reminds me of when I used to stay with my godfather as a young girl; next to his house he grew a big field of these flowers. Nasturtiums look lovely growing up walls and trailing prettily over the sides of hanging baskets. You can even add nasturtium blooms to summer salads, where their peppery flavour will add a flash of colour and a distinctive bite!

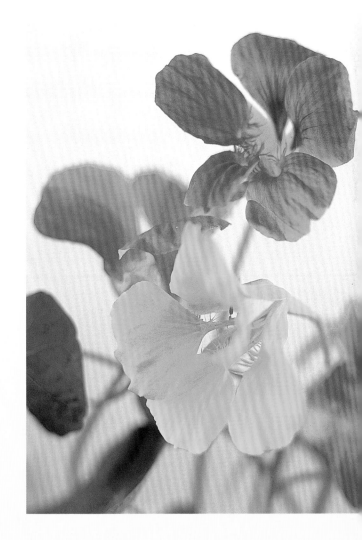

See pages 158–159 for cross stitch instructions.

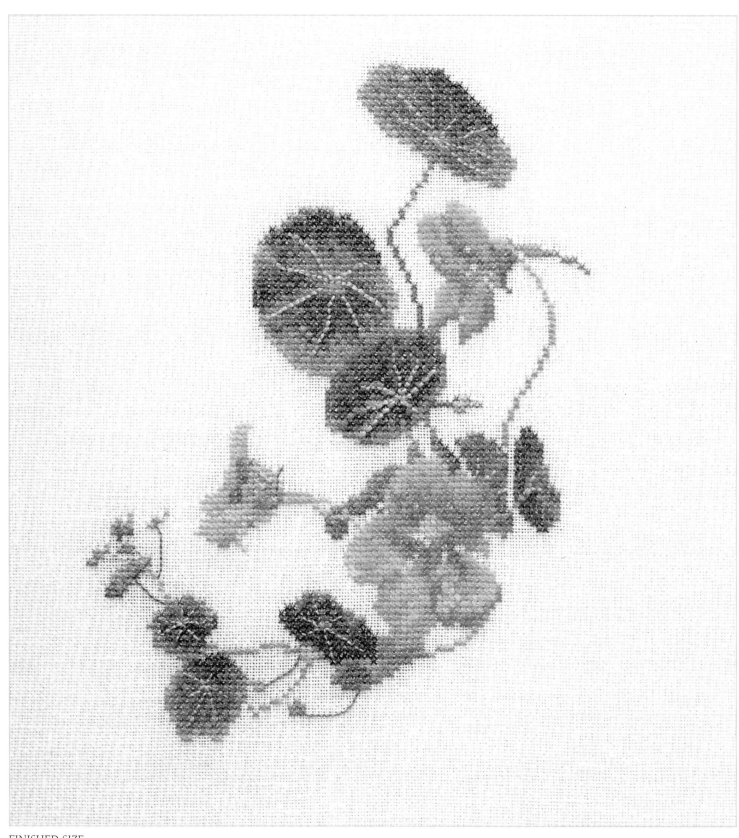

FINISHED SIZE
12.5 x 16cm (5 x 6¼in)

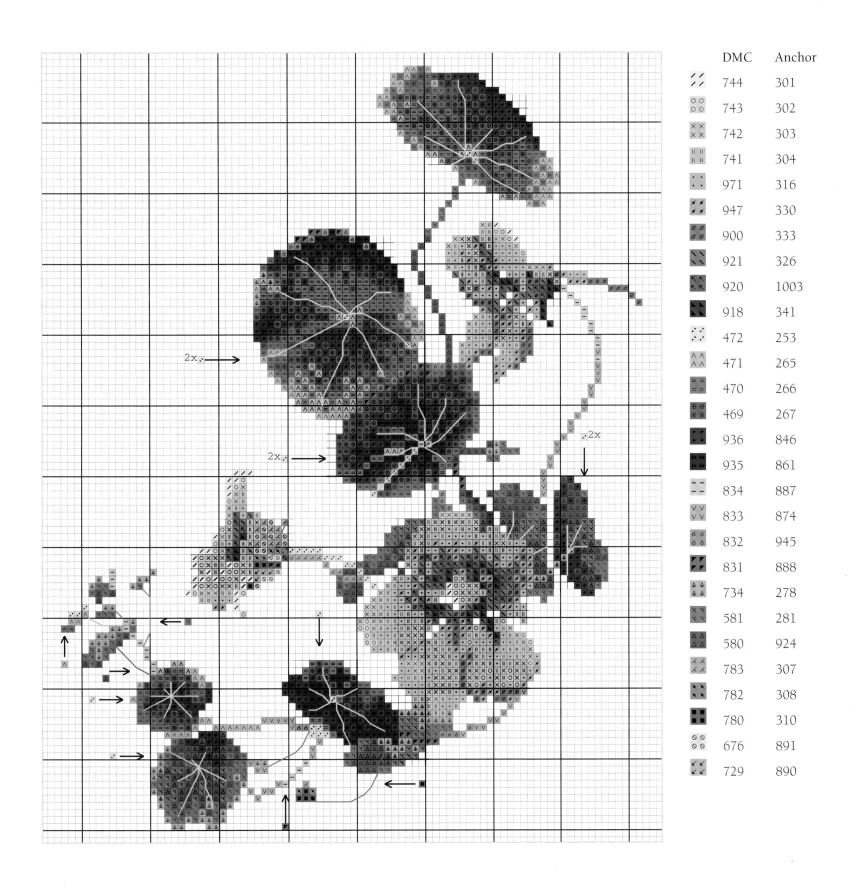

DMC	Anchor
744	301
743	302
742	303
741	304
971	316
947	330
900	333
921	326
920	1003
918	341
472	253
471	265
470	266
469	267
936	846
935	861
834	887
833	874
832	945
831	888
734	278
581	281
580	924
783	307
782	308
780	310
676	891
729	890

Bird of paradise

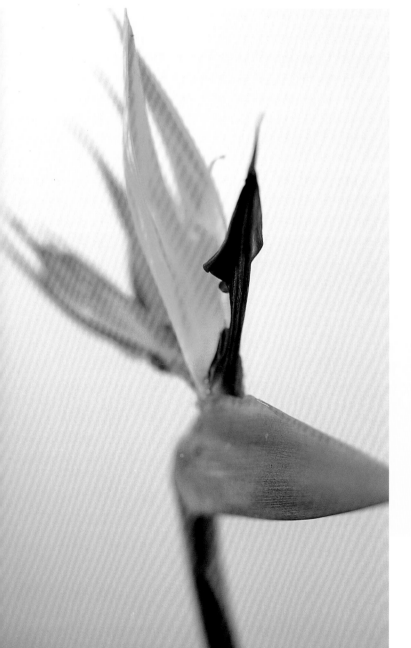

When you first see the bird of paradise flower, you can scarcely believe that it is real and not artificial. Its large exotic flowers resemble the head of a bird with a bright orange crest and are excellent for special flower arrangements.

The flower originates from South Africa; so it needs heat and will only grow in cooler climates in a greenhouse or conservatory, flowering in the spring. If you do not own either, don't despair – the bird of paradise flower is available from florists all year round.

See pages 158–159 for cross stitch instructions.

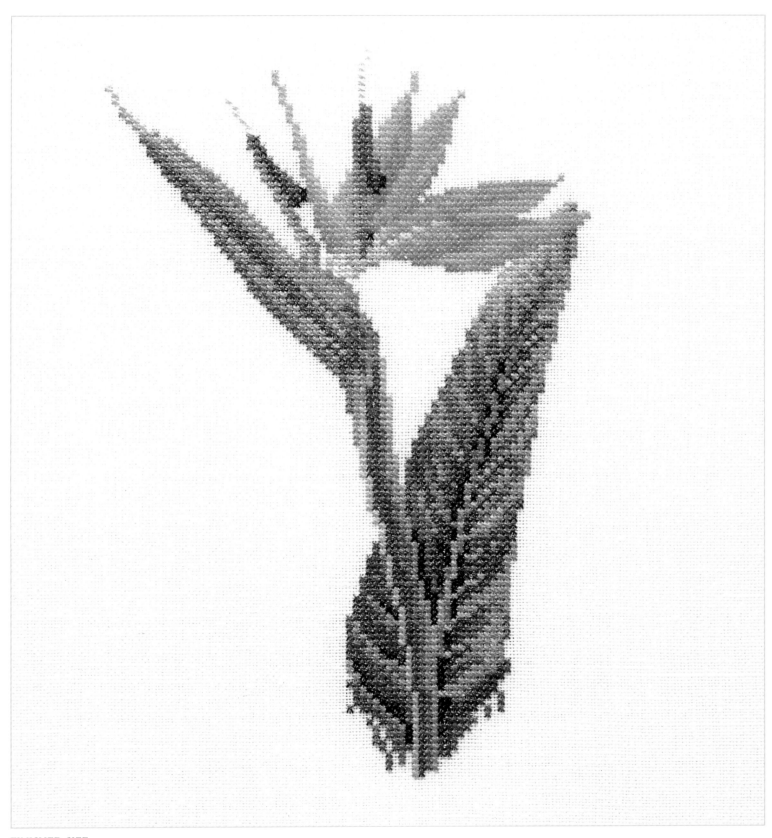

FINISHED SIZE
10.5 x 16.5cm (4¼ x 6½in)

DMC	Anchor
745	300
744	301
743	302
742	303
741	304
740	316
947	330
946	332
900	333
341	117
340	118
3746	1030
333	119
792	941
791	178
899	38
335	40
309	42
472	253
471	265
470	266
469	267
936	846
935	861
939	152
437	362
436	363
434	310
433	358
822	390
644	391
642	392
3053	843
3052	844
3051	845

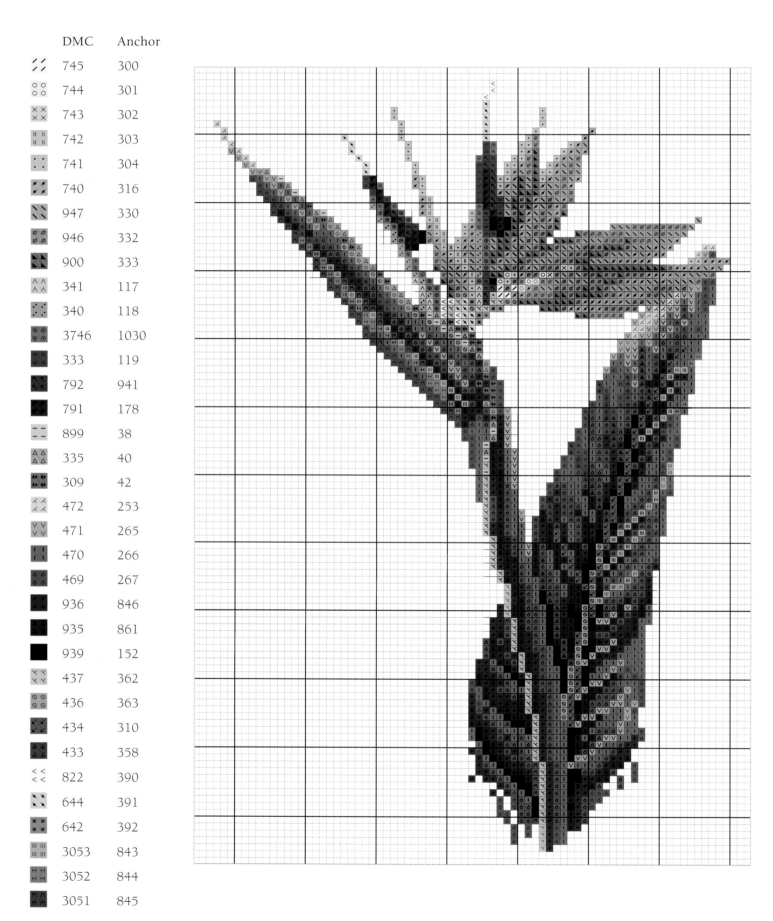

Glory lily

The glory lily, or gloriosa, is an exotic African plant and, as its name suggests, it is a glorious sight when in full bloom in the summer. The first glory lilies arrived in Europe way back in 1607 and, at their peak, they have been known to grow taller than head height.

I remember the glory lily when it was first fashionable and my father brought some back home from a trip. My mother put them into a little silver vase on the corner of our black marble fireplace. I still love these flowers and their exuberant free spirit.

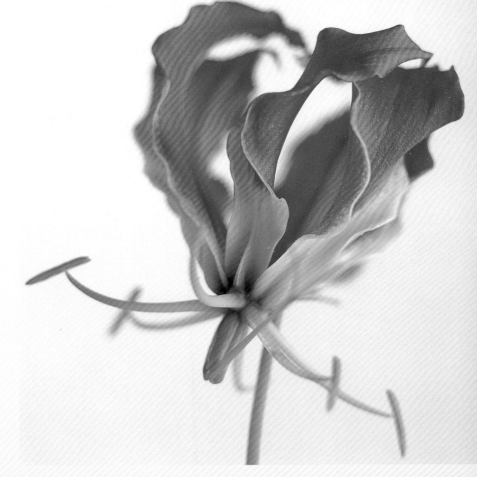

See pages 158–159 for cross stitch instructions.

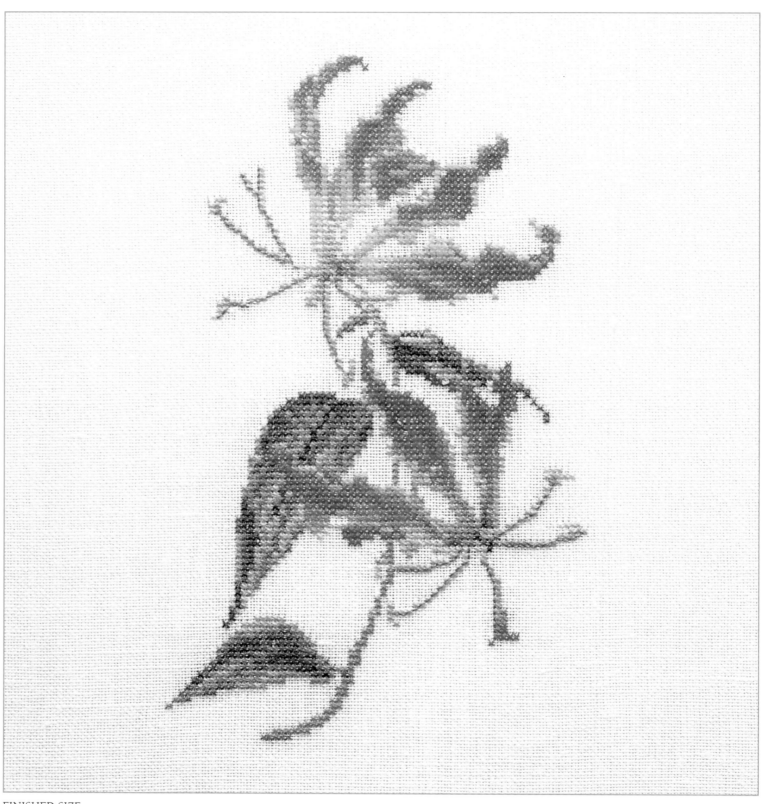

FINISHED SIZE
9.5 x 16.5cm (3¾ x 6½in)

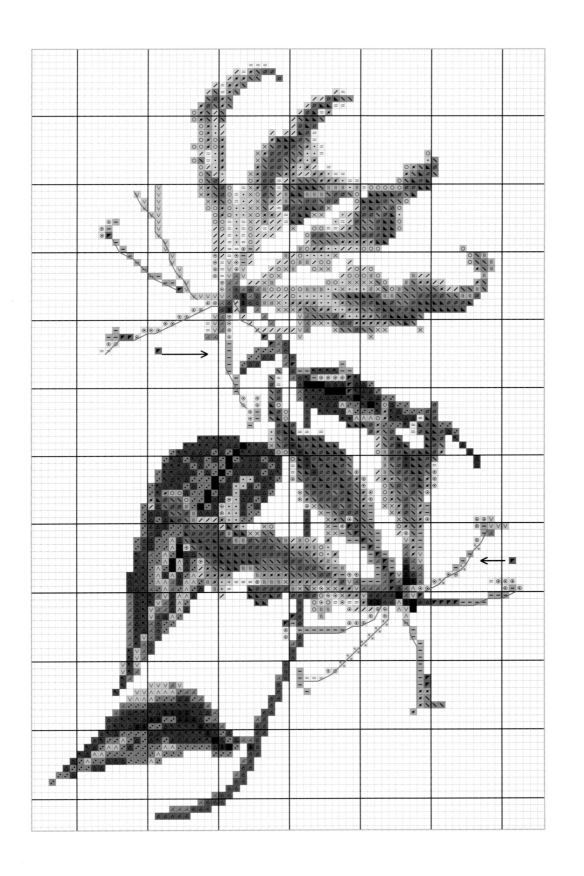

DMC	Anchor
743	302
742	303
741	304
740	316
3706	33
3705	35
666	46
304	19
816	43
814	45
966	240
989	242
987	244
986	246
677	300
676	891
729	890
3829	901
472	253
471	265
470	266
469	267
935	861

Poppy

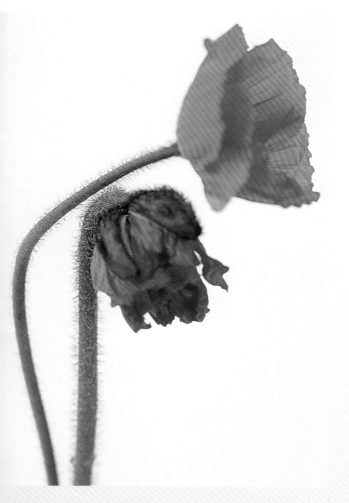

The beautiful bright red poppy is my favourite flower of all. This papaver orientalis looks truly magnificent during its short flowering season. When the huge fragile petals are fully open I keep my fingers crossed that the weather stays dry, as rain can ruin the flowers.

Once the petals fall, however, the greyish-green seed pods provide dramatic definition in the garden or indoors. Each year I save the seeds so that I can grow new plants; I have mixed the full red poppy with a pale pink one, with beautiful results.

See pages 158–159 for cross stitch instructions.

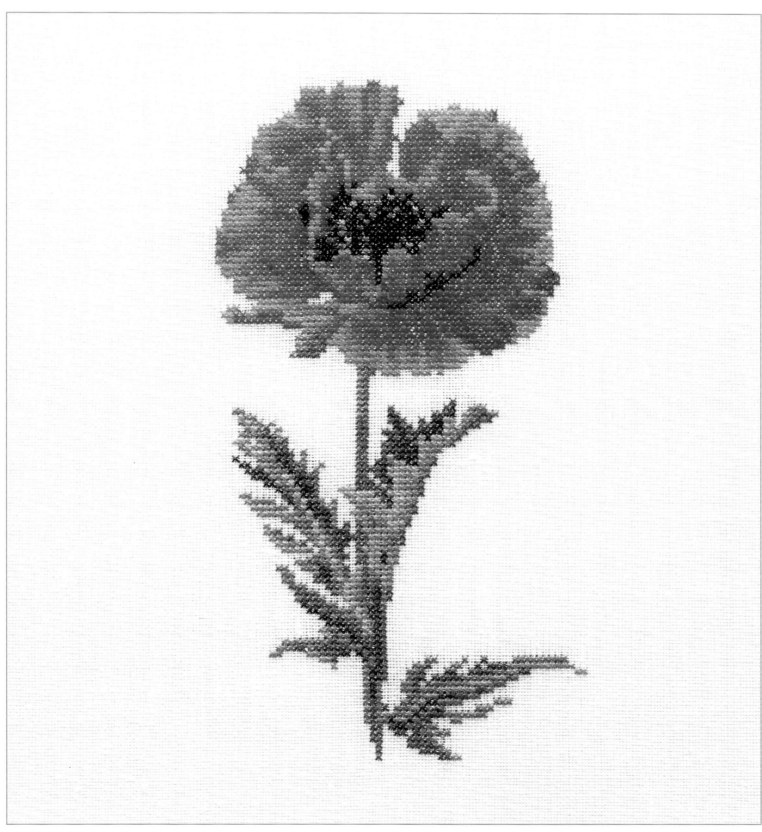

FINISHED SIZE
9.5 x 16.5cm (3¾ x 6½in)

DMC	Anchor
971	316
947	330
946	332
606	334
666	46
817	13
304	19
815	44
472	253
471	265
470	266
469	267
936	846
934	862
3042	870
317	400
3799	236
550	99
823	152
310	403
3371	382
581	281
580	924
3011	856
3740	872

Dahlia

Originating in Mexico, the dahlia is a very popular garden plant with varieties in all colours and sizes. Those featured here are a rich glowing scarlet and ideal for enlivening a fading garden in early autumn. Dahlias also make excellent cut flowers indoors.

My father used to grow bulbs and next to our house we had a field full of different dahlias. I loved to cut big armfuls of these flowers to make arrangements in our home. Add colour to your garden with these vibrant flowers, and stitch this panel to brighten up your house.

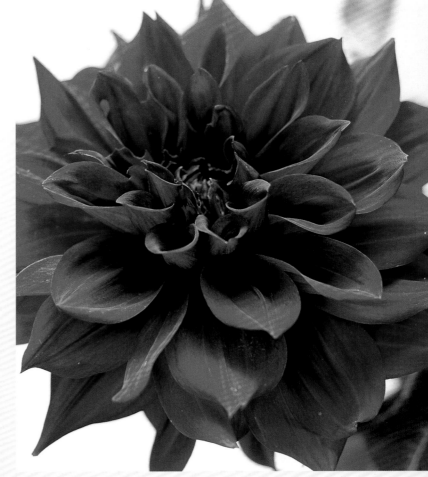

See pages 158–159 for cross stitch instructions.

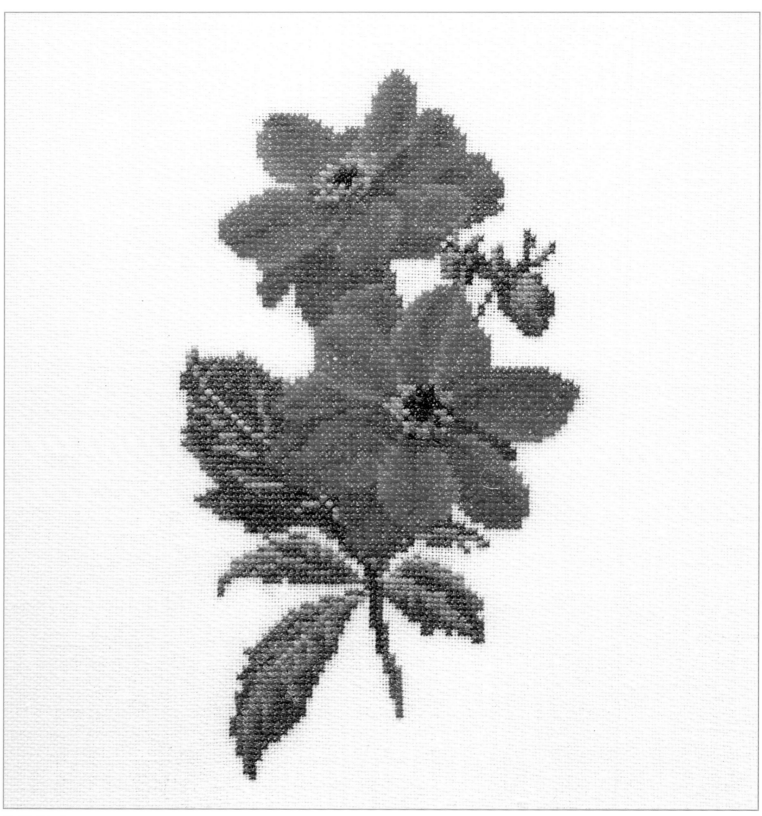

FINISHED SIZE
9 x 16.5cm (3½ x 6½in)

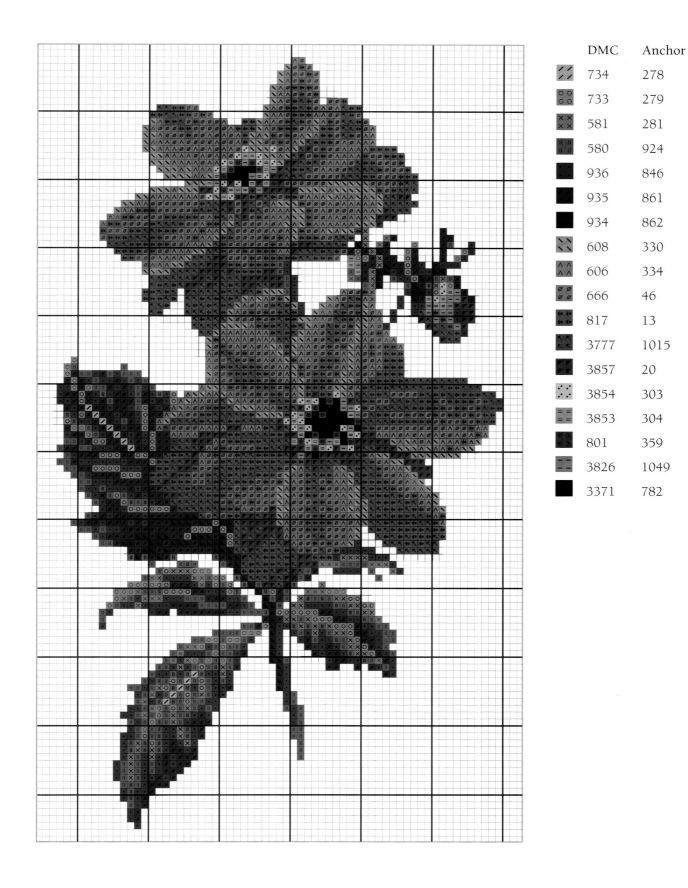

	DMC	Anchor
	734	278
	733	279
	581	281
	580	924
	936	846
	935	861
	934	862
	608	330
	606	334
	666	46
	817	13
	3777	1015
	3857	20
	3854	303
	3853	304
	801	359
	3826	1049
	3371	782

Rose

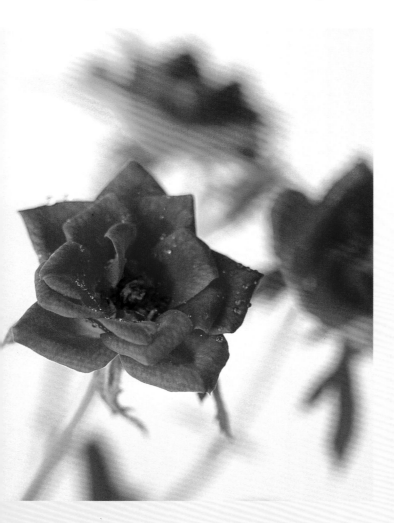

One of the most popular flowers grown today, the rose has long been associated with love and romance – a bouquet of vibrant red roses, in particular, is often given to a loved one on a special occasion. This design reminds me of one of my favourite climbing roses. Every summer it decorated my wall with bright red blooms until, one day, a builder chopped it off by mistake. I planted another to replace it, but it has never flowered in such profusion.

If you don't have a rose bush in your garden, you can stitch this elegant panel to remind you of this glorious flower.

See pages 158–159 for cross stitch instructions.

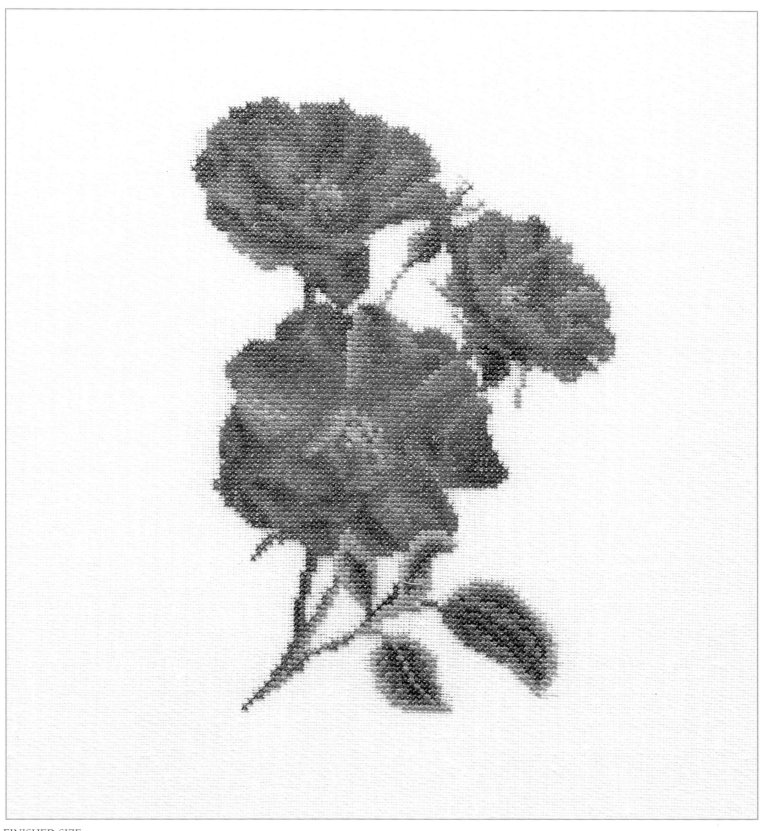

FINISHED SIZE
11 x 16.5cm (4¼ x 6½in)

DMC	Anchor
352	8
351	9
350	10
349	11
817	13
3777	1015
3857	20
900	333
3854	303
472	253
471	265
469	267
936	846
934	862
3822	295
3821	305
729	890
869	375
733	279
732	280

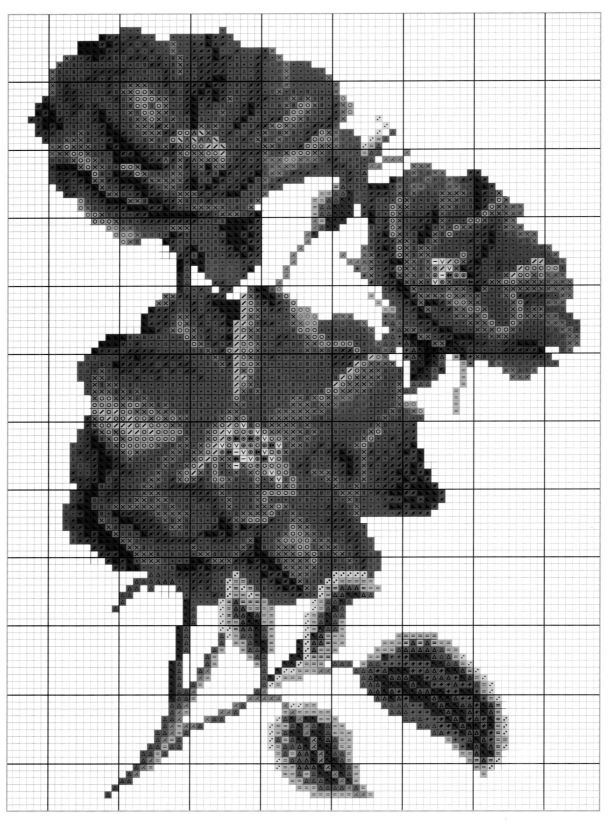

Poinsettia

This very familiar Mexican plant is also known as the Christmas star and you will find it flowering in many homes at Christmas. It looks wonderful displayed in festive arrangements together with cut berried holly and other beautiful winter foliage, such as pine and ivy.

There are many different sizes and colours of poinsettia; you can buy trees or small pot plants, in brilliant red, pink, cream or white. Poinsettias are long-lasting plants, flowering indoors from winter right through until summer.

See pages 158–159 for cross stitch instructions.

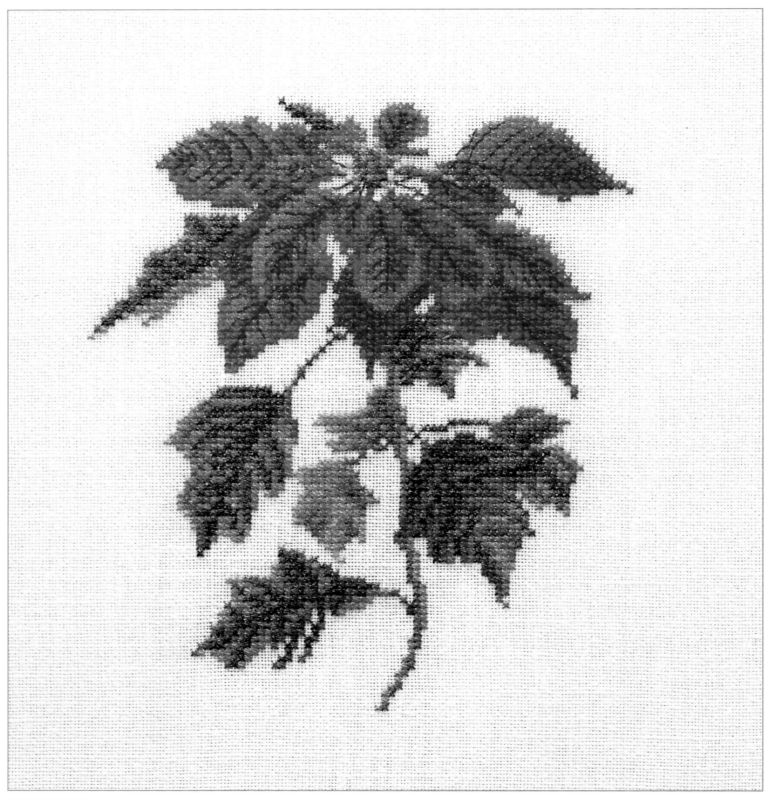

FINISHED SIZE
11.5 x 13.5cm (4½ x 5¼in)

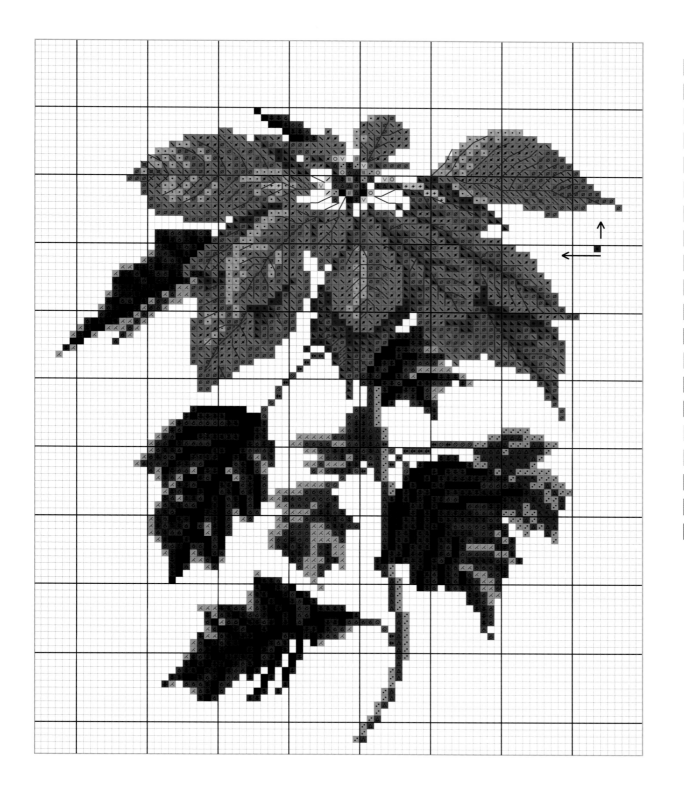

DMC	Anchor
3726	1018
3802	1019
743	302
742	303
740	316
3706	33
3705	35
3801	1098
666	46
304	19
816	43
814	45
989	242
987	244
986	246
472	253
471	265
470	266
469	267
935	861

Pelargonium

As soon as hanging baskets appear outside houses and shops in the spring, pelargoniums are sure to feature strongly. With their clusters of bright red flowers and scalloped leaves, these plants are the essence of summer.

Each year I have pelargoniums growing in pots next to my front door, and they produce a beautiful waterfall of pink and red. They are easy to grow and flower from spring through to autumn. Why not stitch a panel to celebrate this favourite flower?

See pages 158–159 for cross stitch instructions.

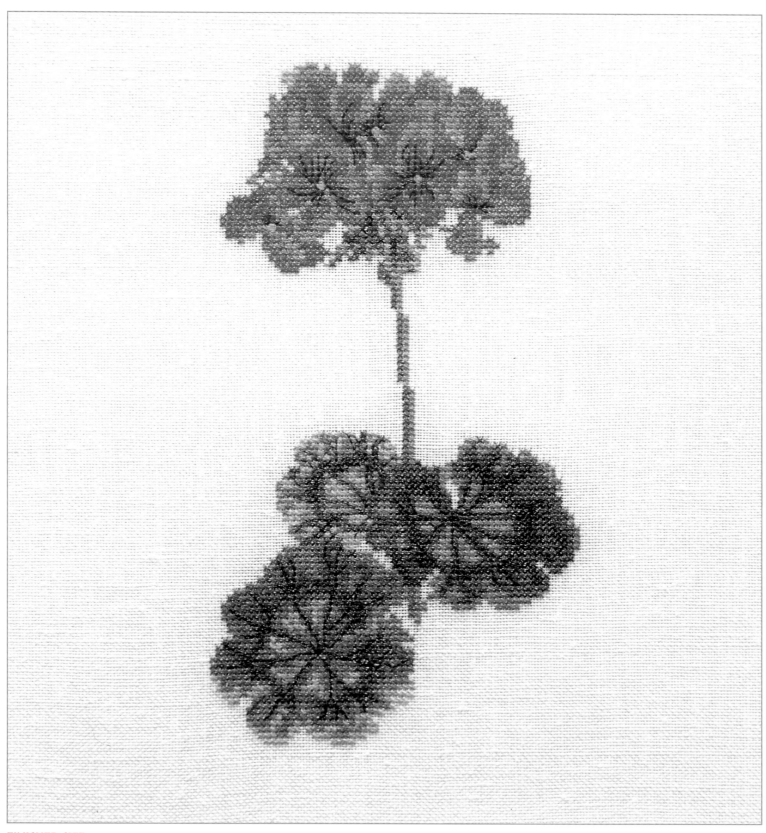

FINISHED SIZE
9 x 16.5cm (3½ x 6½in)

DMC	Anchor
772	259
3348	264
3347	261
3347	262
3345	263
895	1044
352	9
351	10
350	11
666	46
817	13
815	44
471	265
470	266
937	268
936	846
934	862
832	945
831	888
829	906
902	897
472	253
581	281
580	924
335	40
309	42
326	59
444	291

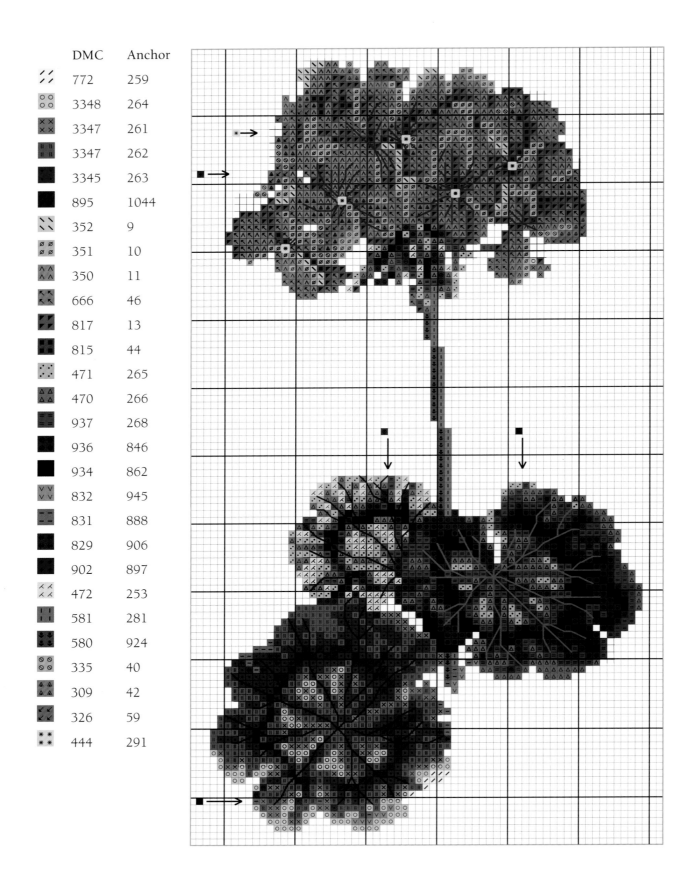

Hibiscus

Also known as the Chinese rose, the hibiscus is an evergreen shrub with glossy green leaves. It is very distinctive in that its elegant large pink flowers have unusual yellow-spotted anthers.

The hibiscus grows in profusion along the Mediterranean coast. There you can see huge hibiscus hedges and really tall shrubs flowering for the whole summer. In cooler regions, however, the hibiscus only grows outdoors on warm sunny days, or indoors in pots, where it will flower all year.

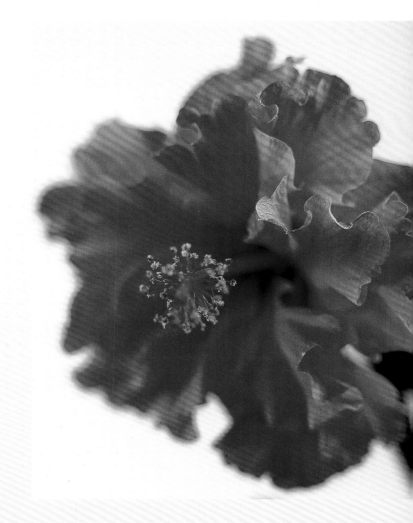

See pages 158–159 for cross stitch instructions.

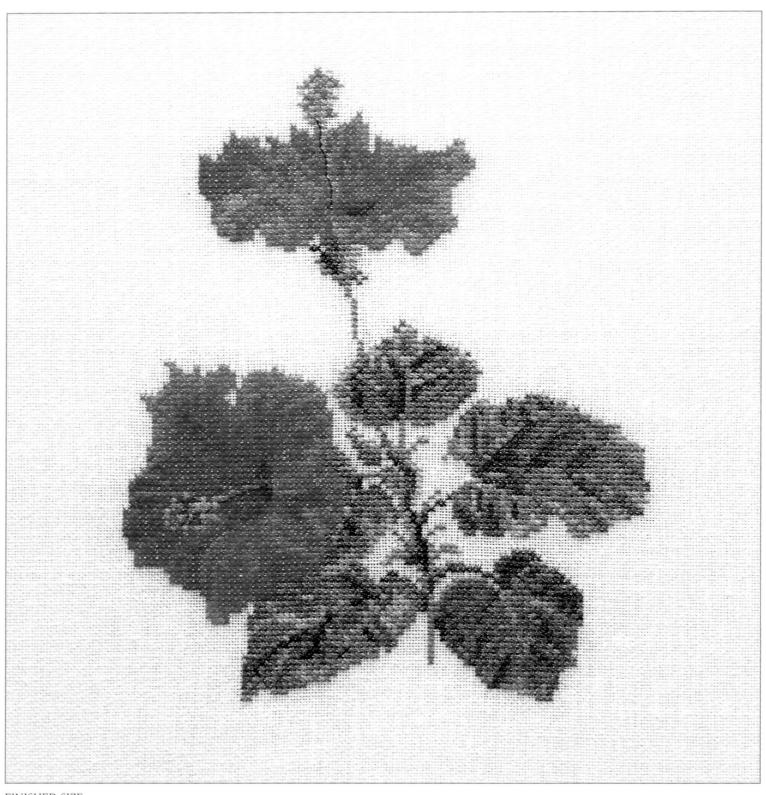

FINISHED SIZE
13 x 16cm (5¼ x 6¼in)

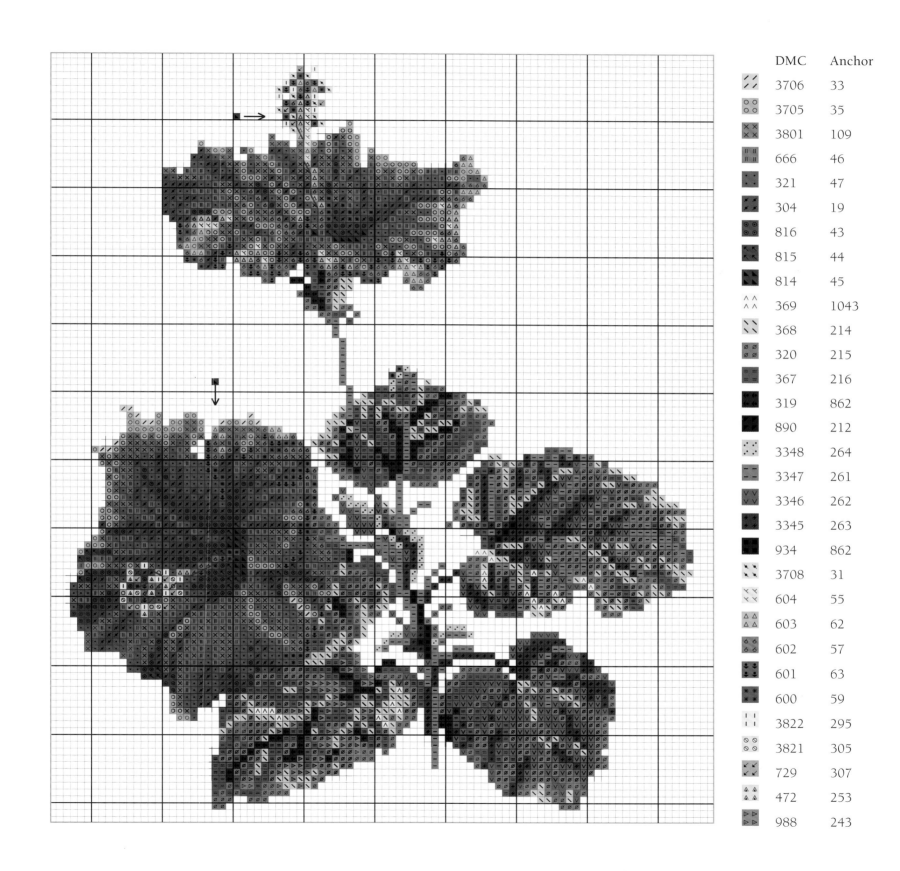

	DMC	Anchor
∕∕	3706	33
○○	3705	35
✕✕	3801	109
‖‖	666	46
⬚⬚	321	47
◣◣	304	19
◉◉	816	43
◤◤	815	44
◥◥	814	45
∧∧	369	1043
⟍⟍	368	214
∅∅	320	215
⊟⊟	367	216
■■	319	862
■■	890	212
⋰⋰	3348	264
−−	3347	261
∨∨	3346	262
⚡⚡	3345	263
■■	934	862
⋊⋉	3708	31
⋀⋁	604	55
△△	603	62
♭♭	602	57
⚎⚎	601	63
✶✶	600	59
¦¦	3822	295
⊘⊘	3821	305
⬿⬿	729	307
▲▲	472	253
▷▷	988	243

Fuchsia

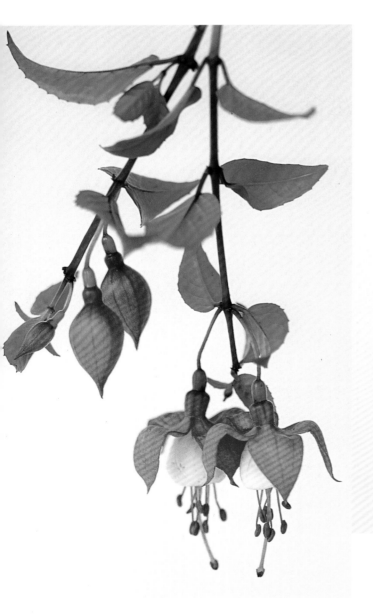

With its pretty pink bells waving in the breeze, the fuchsia makes a decorative garden shrub. Some varieties can be planted in hanging baskets and tubs, where their charming flowers trail over the edge.

The first fuchsias were discovered at the end of the 17th century and were named after the physician and botanist Leonard Fuchs. Since then, the fuchsia has become a beloved garden plant with a huge fan club – it is certainly one of my personal favourites.

See pages 158–159 for cross stitch instructions.

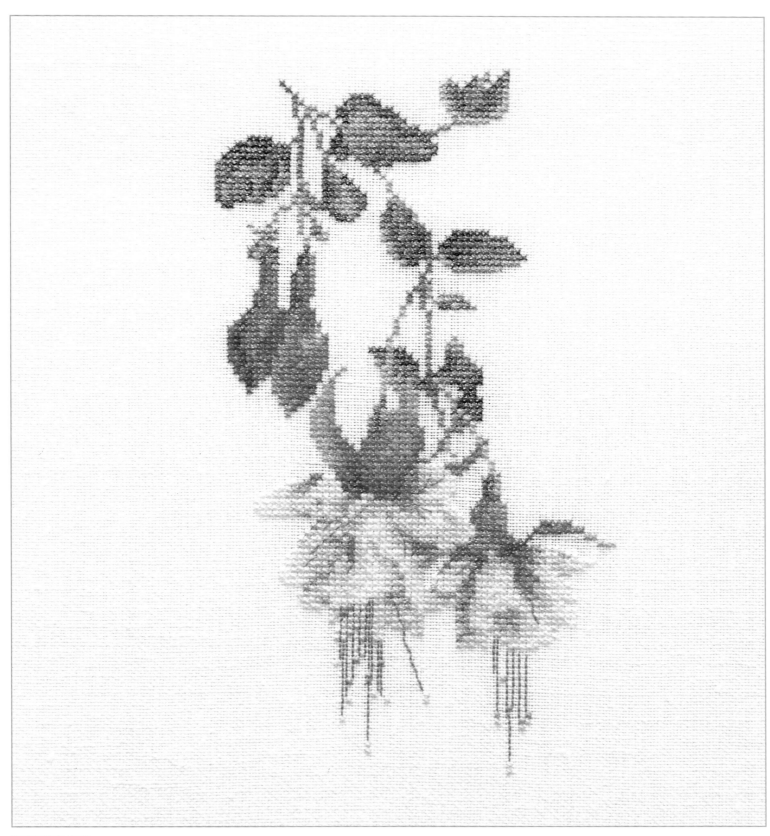

FINISHED SIZE
9.5 x 16.5cm (3³⁄₄ x 6¹⁄₂in)

	DMC	Anchor
○ ○	776	24
✗ ✗	3326	36
‖ ‖	899	38
∴	335	40
◢ ◢	309	42
◤ ◤	326	59
◥ ◥	815	44
◼	814	45
^ ^	blanc	2
╲ ╲	ecru	387
◉ ◉	822	390
= =	644	391
◖◗ ◖◗	642	392
- -	472	253
∅ ∅	471	265
△ △	470	266
◆ ◆	469	267
◼	936	846
◼	935	861
⁘	422	372
✕ ✕	3828	373
6 6	869	375
⚡ ⚡	3047	852
✗ ✗	224	893
∨ ∨	223	895
╏ ╏	3722	1027
◔ ◔	3721	896
▲ ▲	3731	76
▶ ▶	3350	77
◤ ◤	989	242
‖‖ ‖‖	987	244
◈ ◈	986	245

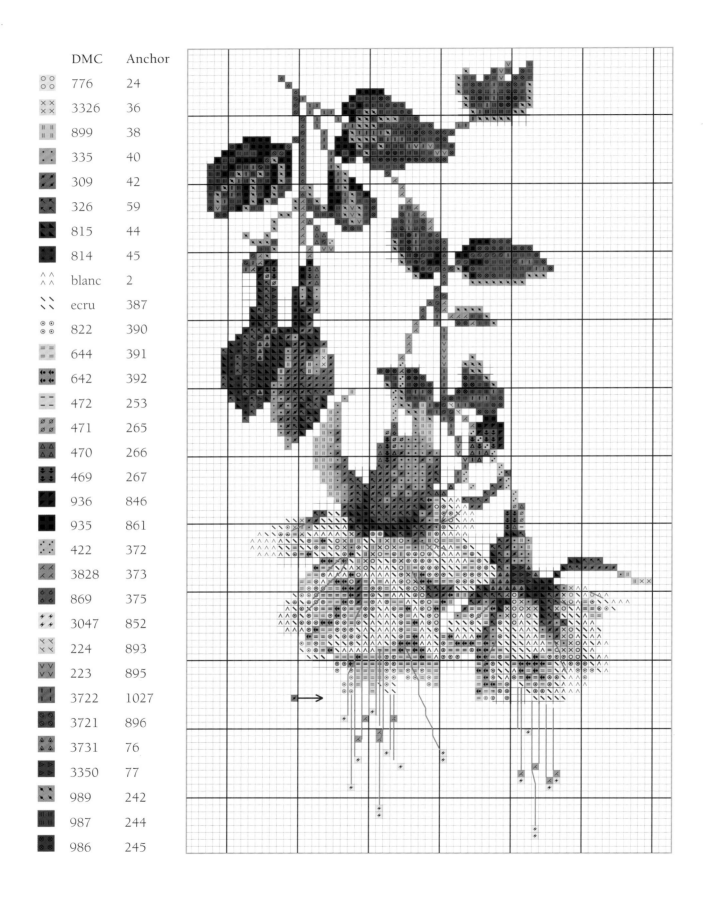

Camellia

Originating in Asia, the camellia was introduced into Europe in 1792 by a Jesuit priest who travelled to the Far East. There, camellias were highly regarded; Chinese women wore the flowers for decoration and brushed sweet-smelling camellia oil through their hair.

After being ignored for several years, the camellia is now slowly becoming fashionable again, although I find it strange that this evergreen shrub with its exotic colourful flowers should ever have been out of favour.

Although not difficult to grow, camellias need a warm climate to flourish.

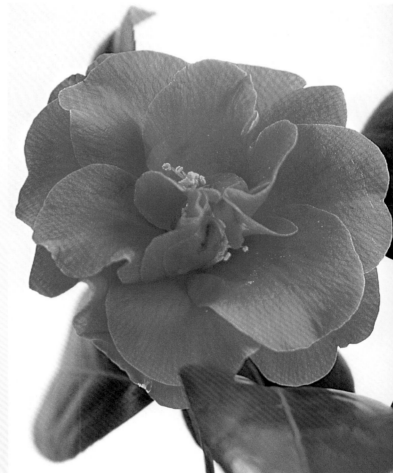

See pages 158–159 for cross stitch instructions.

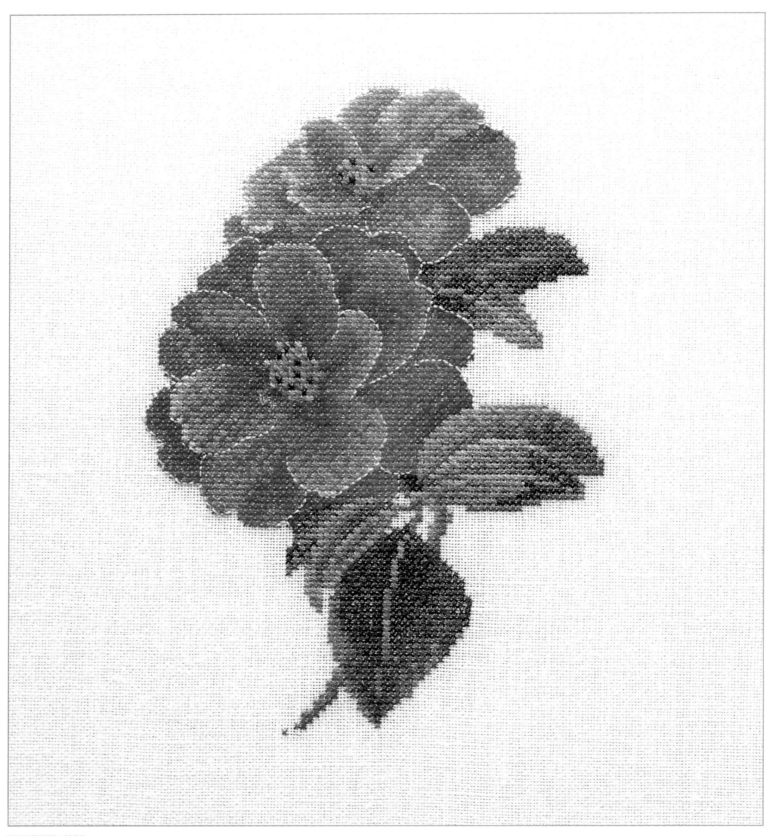

FINISHED SIZE
11 x 16cm (4¼ x 6¼in)

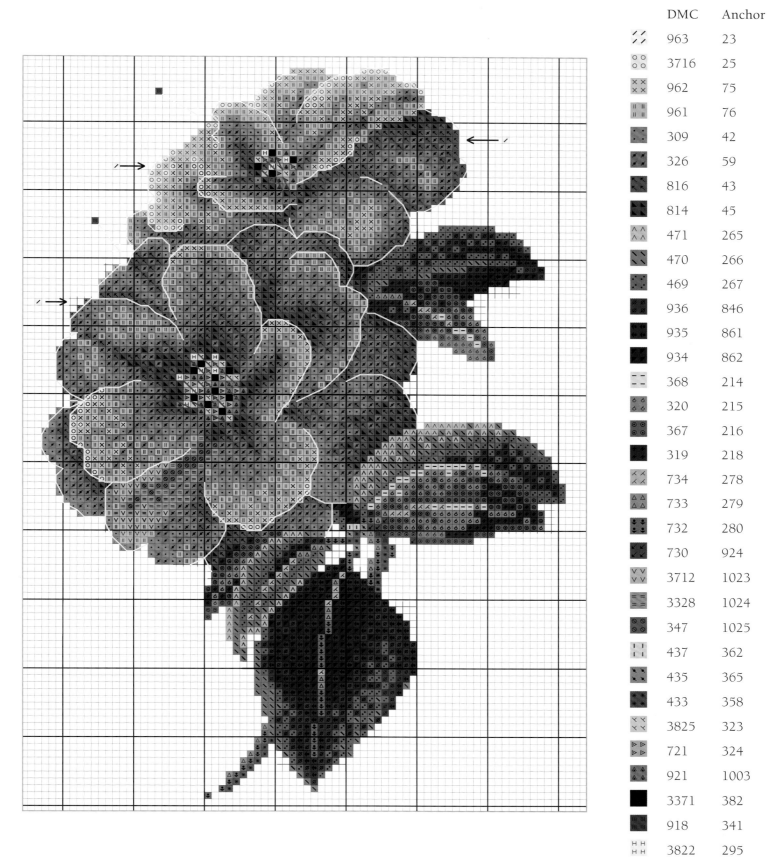

	DMC	Anchor
⁄⁄	963	23
○○	3716	25
××	962	75
‖‖	961	76
•	309	42
	326	59
	816	43
	814	45
∧∧	471	265
	470	266
	469	267
	936	846
	935	861
	934	862
– –	368	214
6 6	320	215
⊙⊙	367	216
	319	218
⋋⋋	734	278
△△	733	279
	732	280
	730	924
∨∨	3712	1023
= =	3328	1024
⊘⊘	347	1025
⌐⌐	437	362
	435	365
	433	358
⋋⋋	3825	323
▷▷	721	324
▲▲	921	1003
■	3371	382
	918	341
HH	3822	295

Busy lizzie

I was given a busy lizzie plant by a dear neighbour several years ago and every year since then it has multiplied, so that now these lovely plants grow all over my garden! This is because the seed pods have a tendency to split open at the slightest touch and shoot out their seeds.

Busy lizzies grow well in shady gardens and, with their mounds of bright colour, make beautiful edgings for flower borders throughout the summer.

See pages 158–159 for cross stitch instructions.

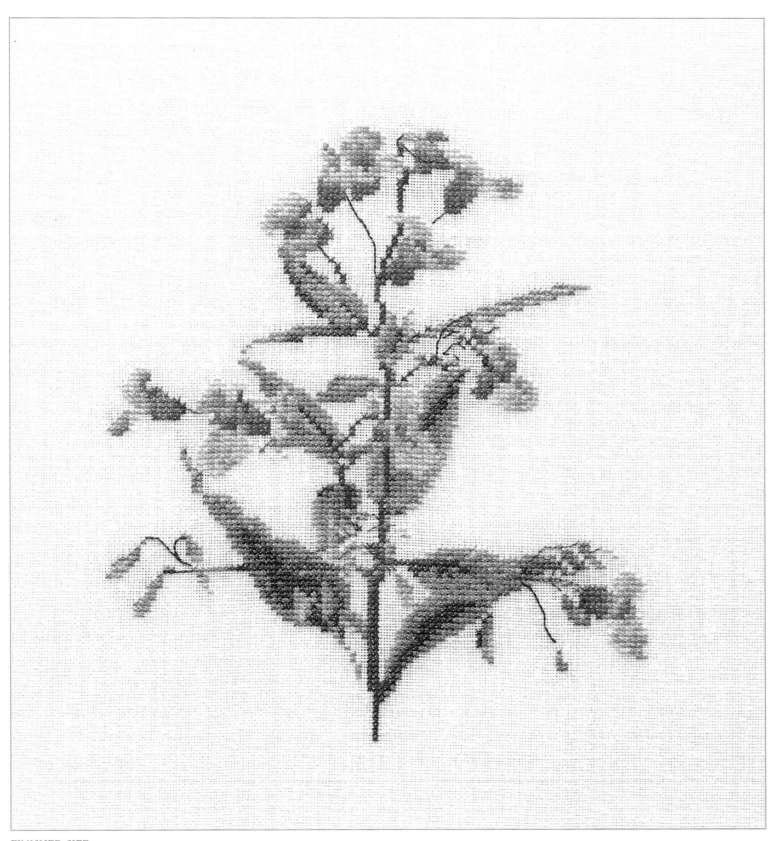

FINISHED SIZE
14 x 16.5cm (5½ x 6½in)

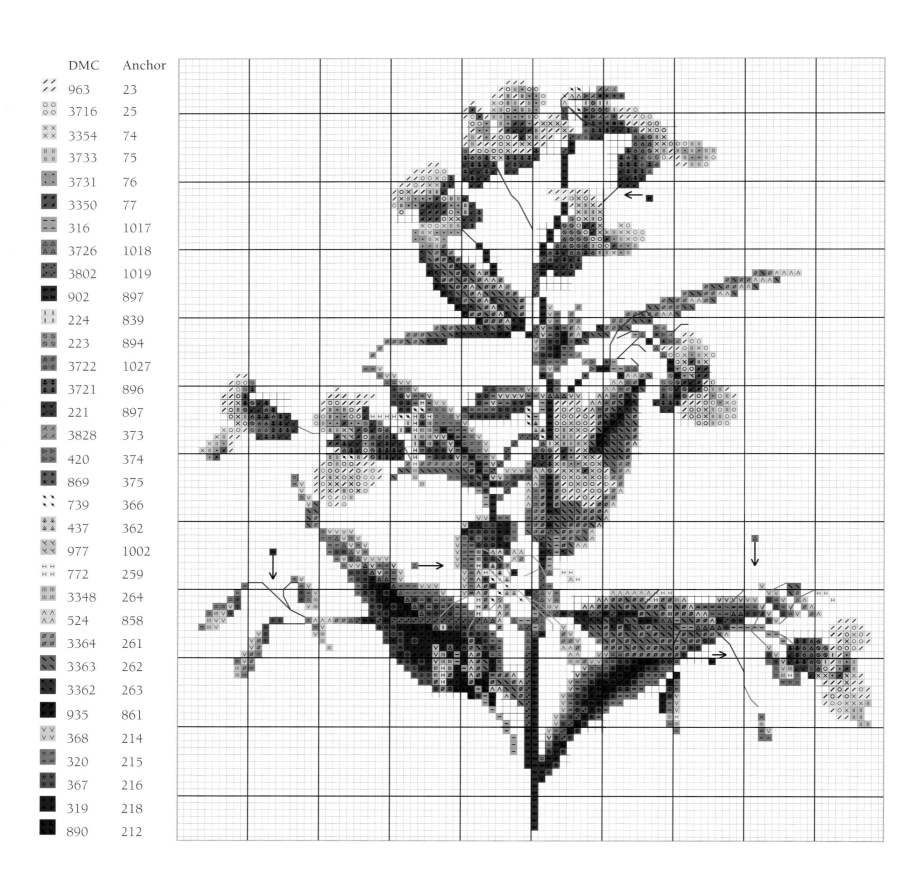

DMC	Anchor
963	23
3716	25
3354	74
3733	75
3731	76
3350	77
316	1017
3726	1018
3802	1019
902	897
224	839
223	894
3722	1027
3721	896
221	897
3828	373
420	374
869	375
739	366
437	362
977	1002
772	259
3348	264
524	858
3364	261
3363	262
3362	263
935	861
368	214
320	215
367	216
319	218
890	212

Geranium

This lovely plant, with its silvery pink flowers lightly etched with red and its light green buttercup-like leaves, originated in the Pyrenean mountains. It has a long flowering season, producing a succession of small flowers throughout the summer months, and is very easy to grow.

With its mound of foliage, the geranium provides excellent ground cover or edging for a border. The name geranium means 'crane', and the plant is so-called because the long, thin shape of its seed pods resembles the head and bill of this graceful bird.

See pages 158–159 for cross stitch instructions.

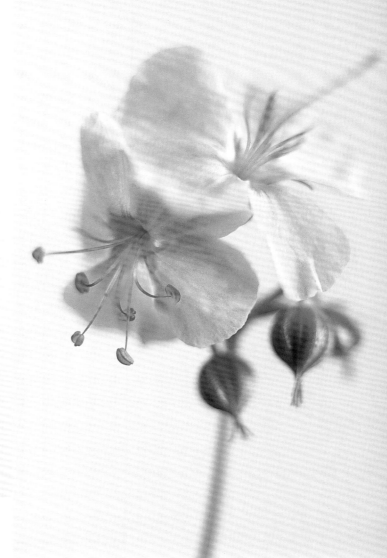

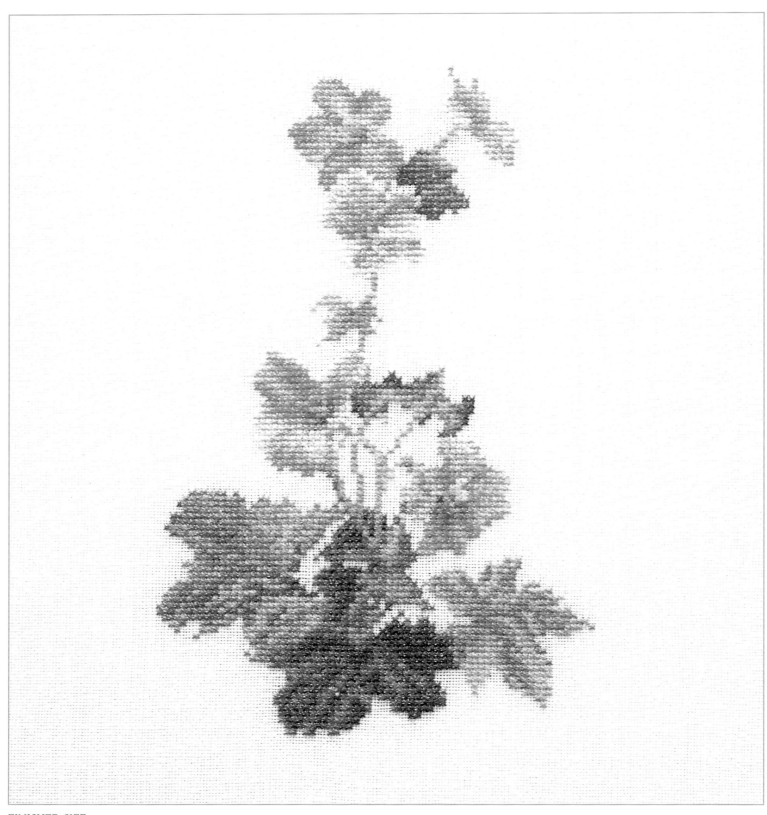

FINISHED SIZE
10.5 x 16.5cm (4¼ x 6½in)

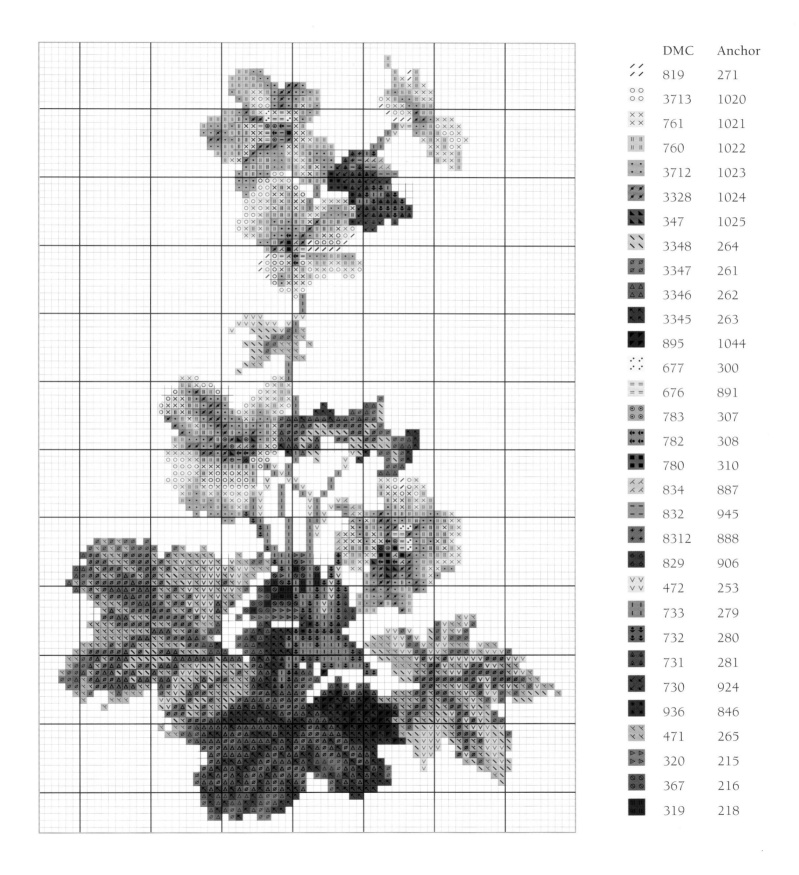

	DMC	Anchor
∕∕	819	271
∘∘	3713	1020
✕✕	761	1021
‖‖	760	1022
∶∶	3712	1023
	3328	1024
	347	1025
∖∖	3348	264
∅∅	3347	261
△△	3346	262
	3345	263
	895	1044
∵∴	677	300
＝＝	676	891
⊙⊙	783	307
◀▶	782	308
■■	780	310
⤫⤫	834	887
－－	832	945
⚡⚡	8312	888
	829	906
⋁⋁	472	253
┃┃	733	279
⬇⬇	732	280
	731	281
	730	924
	936	846
⤫⤫	471	265
▷▷	320	215
⊘⊘	367	216
■■	319	218

Dianthus

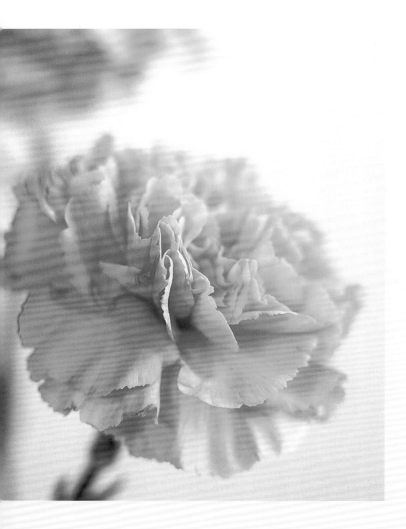

Popularly known as pinks, these flowers have been cultivated for thousands of years. In 50BC, the Roman scholar Pliny wrote about the dianthus grown then. Now there are hundreds of different varieties of pinks, ranging from small flowers for growing in the garden to big carnations for displaying indoors.

These large flowers look great either mixed with others or placed singly in a long elegant vase. Pinks have a delicate grey–green stalk, which must be handled with great care because it can break very easily.

See pages 158–159 for cross stitch instructions.

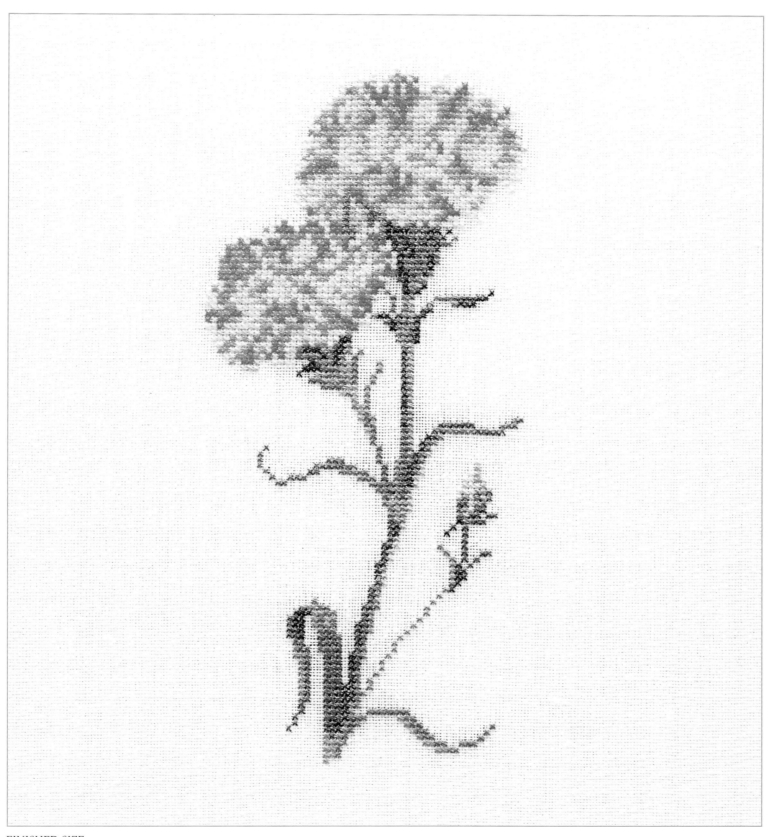

FINISHED SIZE
7.5 x 17cm (3 x 6¾in)

	DMC	Anchor
∕∕	818	23
○○	776	24
××	899	38
‖‖	309	42
∖∖	928	274
∗∗	927	849
∅∅	926	850
⊾⊾	3768	779
◼◼	924	851
∧∧	369	1043
--	368	214
≡≡	320	215
∴∴	367	216
■■	319	218

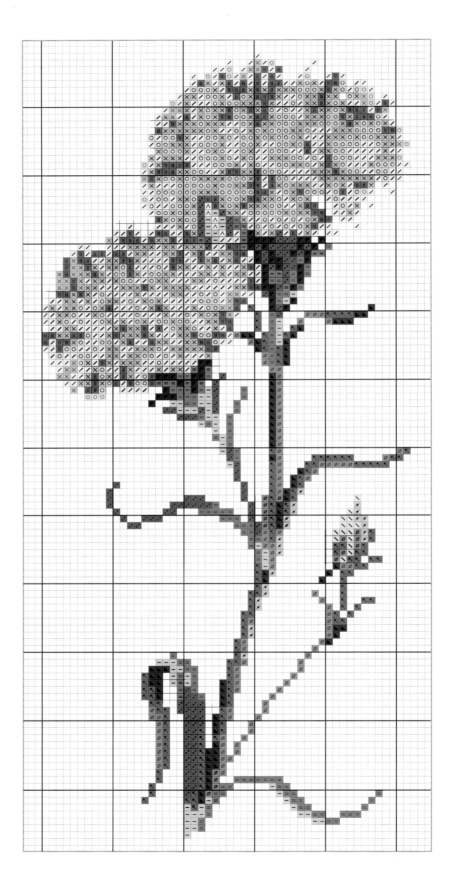

Bleeding heart

This is a very elegant Japanese plant, which forms a neat clump of ferny leaves, with dangling heart-shaped pink and white flowers in early summer. Its Latin name is dicentra and its other melancholy common names include broken hearts, woman's tears and lady-in-the-bath.

The dicentra was imported into Europe from China in 1847 by Robert Fortune and caused an overnight sensation among those bored with more familiar garden plants.

See pages 158–159 for cross stitch instructions.

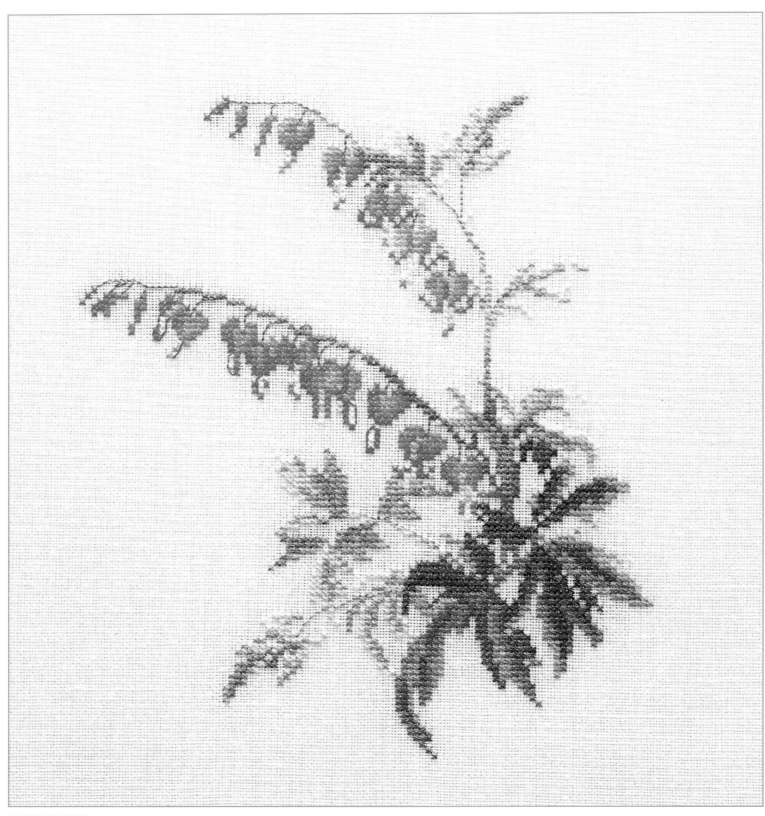

FINISHED SIZE
14 x 16.5cm (5½ x 6½in)

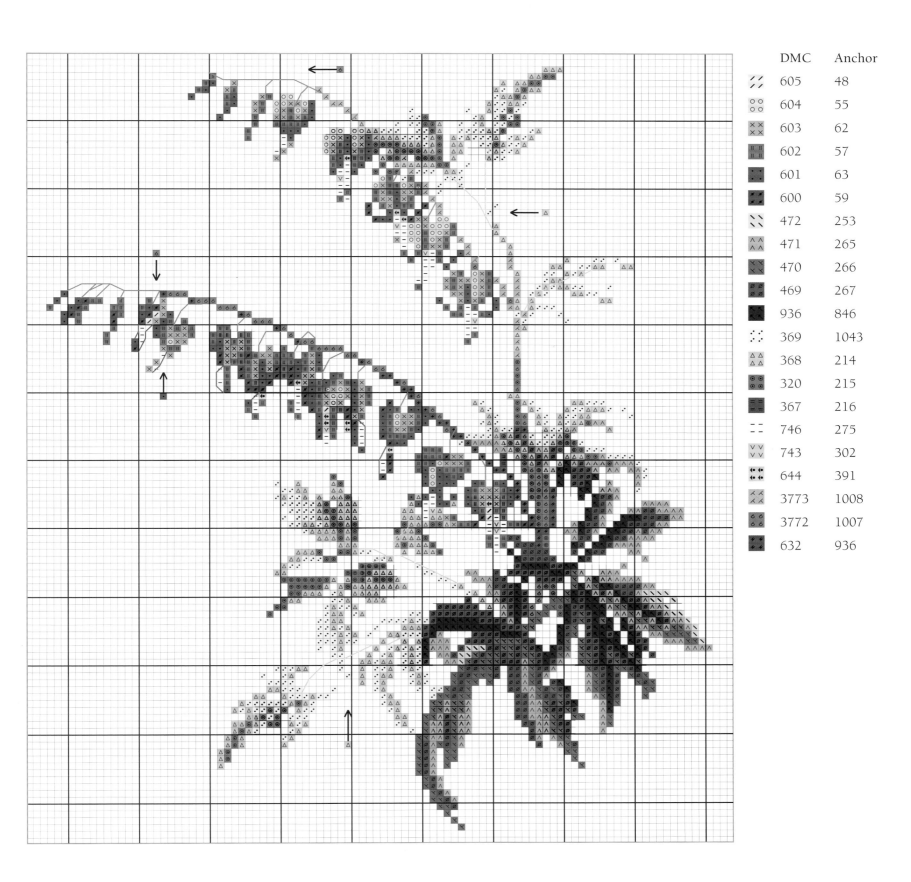

	DMC	Anchor
⁄⁄	605	48
○○	604	55
✕✕	603	62
‖‖	602	57
••	601	63
▨▨	600	59
⁄⁄	472	253
∧∧	471	265
✕✕	470	266
⌀⌀	469	267
■■	936	846
⋰⋰	369	1043
△△	368	214
◉◉	320	215
≣≣	367	216
– –	746	275
∨∨	743	302
↔↔	644	391
≺≺	3773	1008
♭♭	3772	1007
⚡⚡	632	936

Sweet pea

The delicate sweet pea was my mother's favourite flower. Whenever I could, I would take her a small bunch of these pretty pastel flowers. We always used to grow them in the garden, either in big pots, where they climbed up long canes, or against a sunny wall strung with wires.

Sweet peas have a delicious, distinctive scent and they grow throughout the whole summer. Their wavy petals can be yellow, white, cream, pink, red, purple or blue. When the flowers die, the seed pods shoot their seeds all over the garden.

See pages 158–159 for cross stitch instructions.

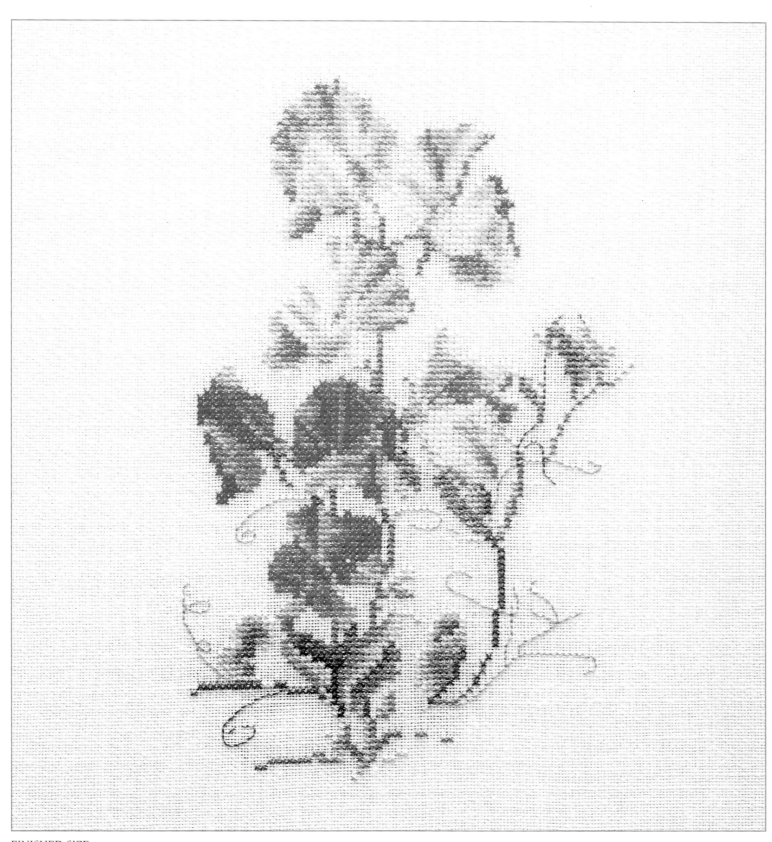

FINISHED SIZE
10.5 x 16.5cm (4¼ x 6½in)

	DMC	Anchor		
✓✓	819	271		
○○	818	23		
✗✗	776	24		
‖‖	3326	36		
∵∵	899	38		
◪◪	3731	76		
◤◤	3350	77		
∧∧	504	1042		
╲╲	3713	1020		
⊙⊙	503	875		
⚡⚡	502	876		
◣◣	501	877		
■■	500	878		
∴∴	746	275		
==	677	300		
∅∅	676	891		
--	729	890		
∨∨	772	259		
⋋⋋	3348	264		
◔◔	3347	261		
♦♦	3346	262		
⊘⊘	224	839		
××	605	1094		
△△	604	55		
	‖		603	62
◀▶	602	57		
◹◹	601	63		
▦▦	600	59		

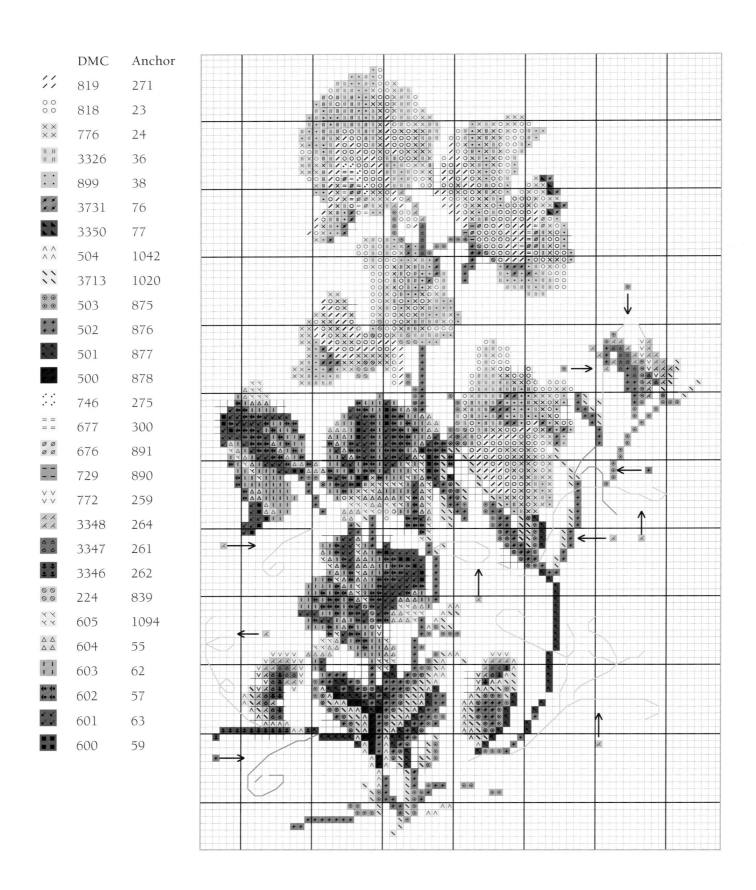

Peony

The peony is one of the most ornamental of all garden plants. Initially grown in China for its beauty and its medicinal properties, the peony was discovered by the Europeans many centuries later.

Peonies always remind me of when I was young – there was a high wall between our house and that of our neighbours and every spring, lovely huge peony plants grew all along the entire length of the wall.

My father was very fond of his peonies; I cherish an old photograph of him, proudly holding a big armful of them.

See pages 158–159 for cross stitch instructions.

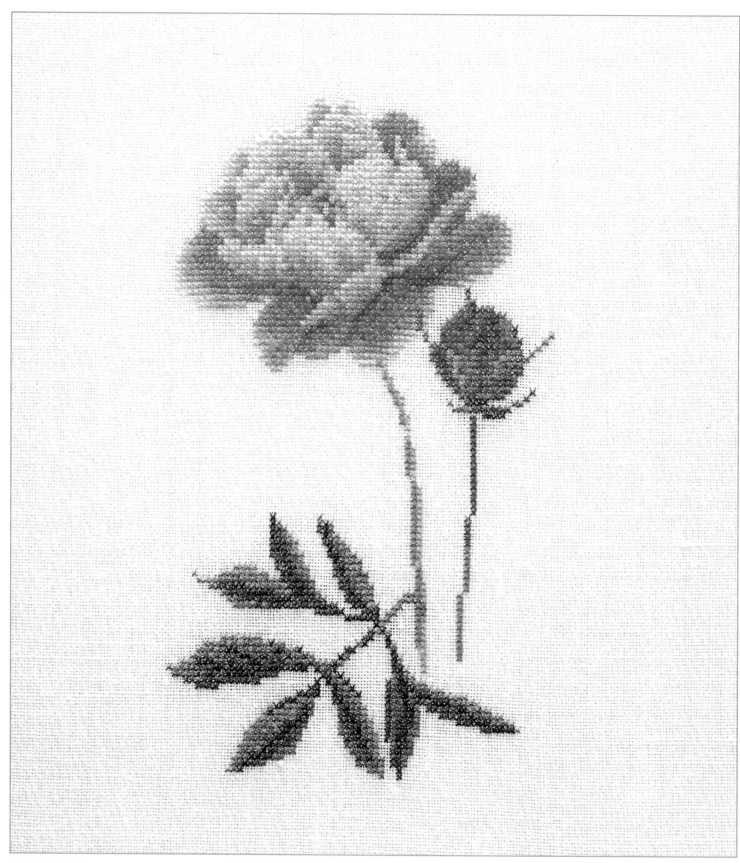

FINISHED SIZE
9.5 x 16cm (3¾ x 6¼in)

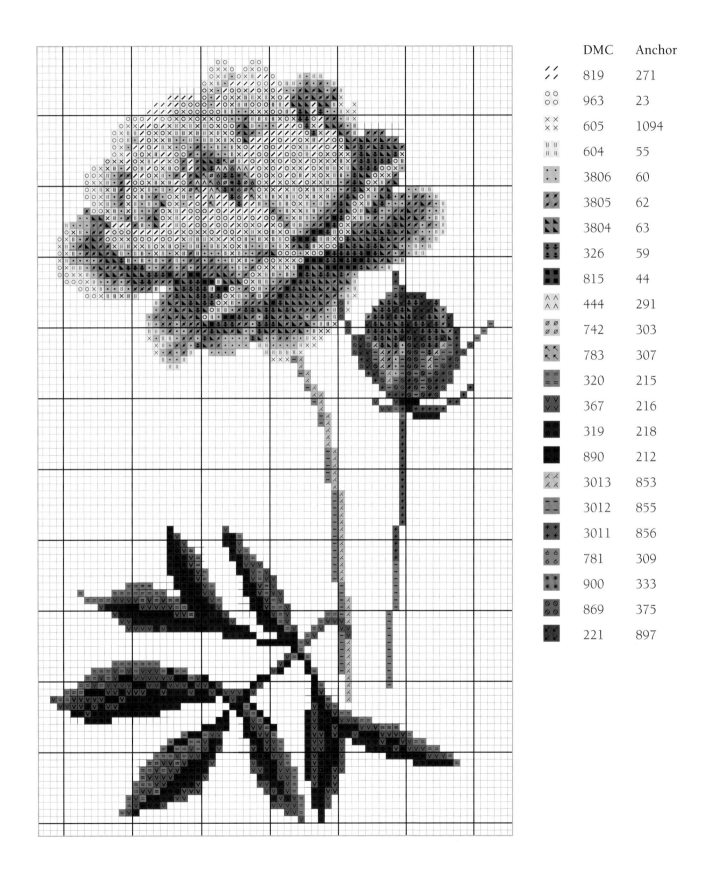

	DMC	Anchor
∕∕	819	271
○○	963	23
××	605	1094
‖‖	604	55
∙∙	3806	60
	3805	62
	3804	63
	326	59
	815	44
∧∧	444	291
∅∅	742	303
	783	307
==	320	215
∨∨	367	216
	319	218
	890	212
⋌⋌	3013	853
=-	3012	855
	3011	856
66	781	309
**	900	333
○○	869	375
	221	897

Auricula

T he familiar yellow primula is one of the first signs of spring and I always like to have some of these colourful plants in my home after the long, grey winter. One of my favourite primulas, however, and I think the prettiest, is primula auricula.

This is one of the oldest cottage garden plants, having been introduced into Europe in the 16th century. It produces a tight ball of pink and yellow flowers and pale green leaves and makes a lovely plant for the front of a border.

See pages 158–159 for cross stitch instructions.

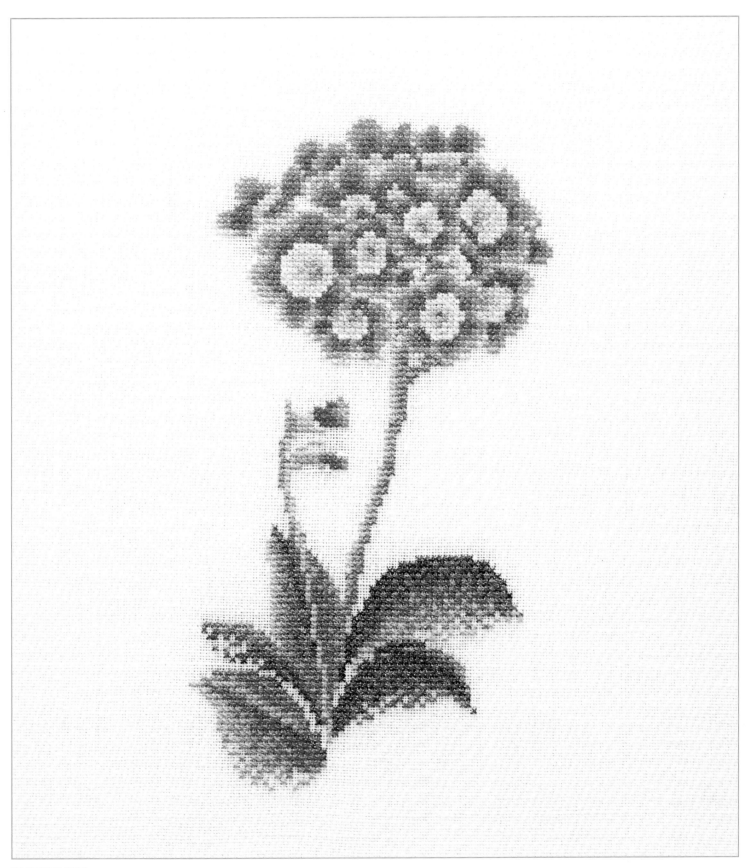

FINISHED SIZE
9 x 16.5cm (3½ x 6½in)

	DMC	Anchor
╱╱	3689	49
○○	3688	75
✕✕	3687	68
‖‖	3803	69
◣◣	3685	1028
^^	746	275
╲╲	677	300
∴	676	891
◪◪	729	890
◤◤	680	820
◥◥	869	375
▬	734	278
∵	733	279
▦	732	280
◔◔	730	924
△△	3348	264
✕✕	3347	261
◆◆	3346	262
■	3345	263
■	895	1044
‖	3013	853
∨∨	3012	855
▞▞	3011	856
■	936	846

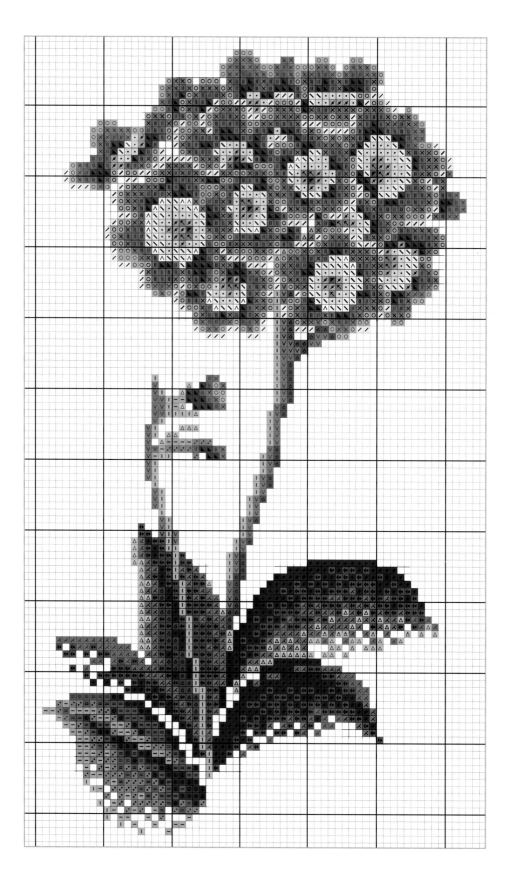

Anemone

As a child, I used to help my father in his bulb-exporting company, and one of my jobs was to count out the anemone tubers to put into small bags. The 'de Caen' anemones featured in this panel, with their brightly coloured petals and dark hearts, are the most impressive of the anemone family, and some of my favourite flowers. They bloom in the summer, making a bold display in beds and borders, and also lasting well indoors.

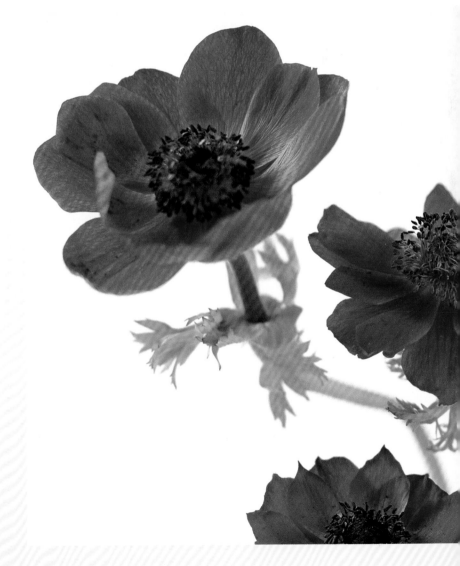

See pages 158–159 for cross stitch instructions.

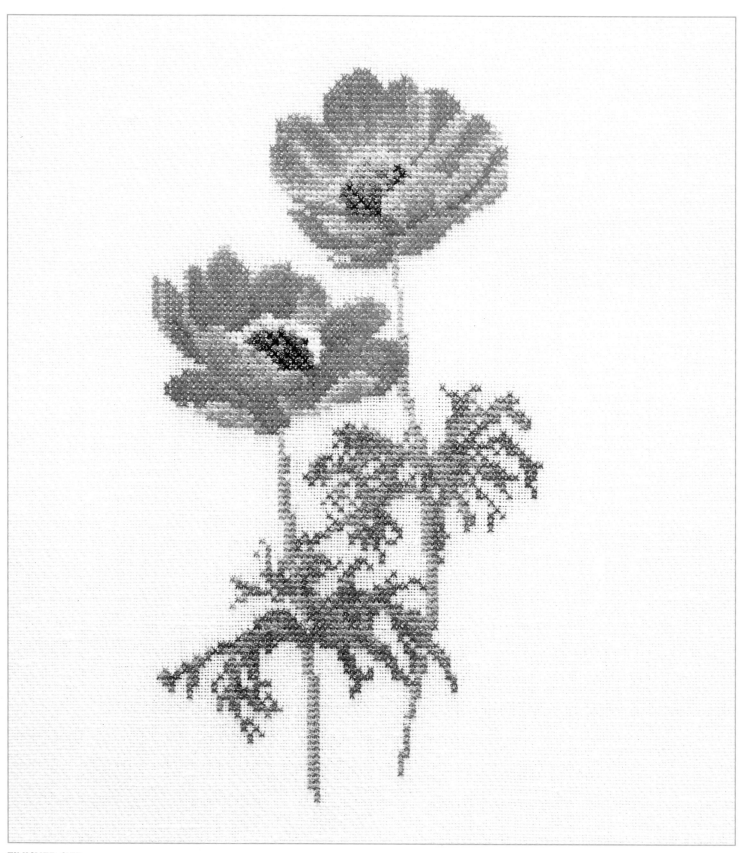

FINISHED SIZE
9.5 x 17cm (3¾ x 6¾in)

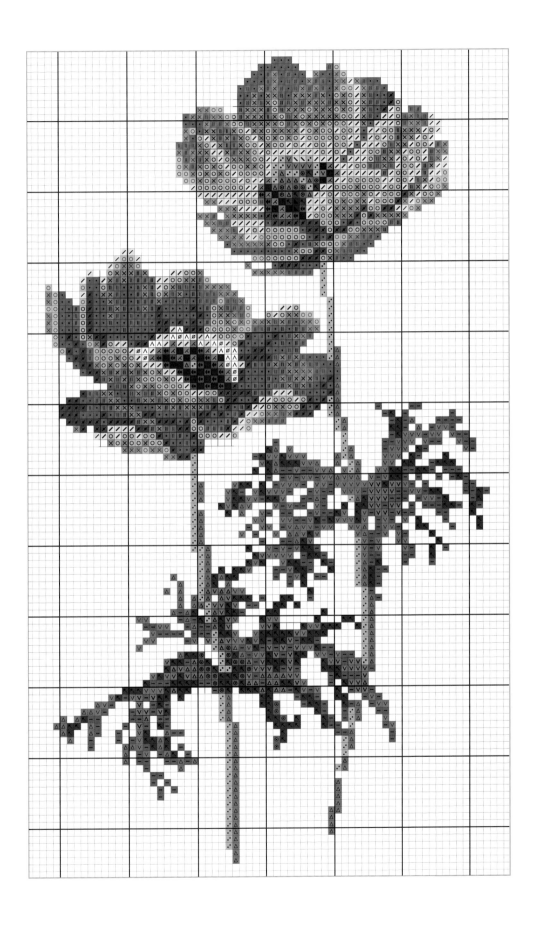

	DMC	Anchor
✔✔	3609	85
○○	3608	86
✕✕	3607	87
‖‖	718	88
∴∴	917	89
▨▨	915	1029
∧∧	blanc	2
⌀⌀	ecru	387
╲╲	472	253
∴∴	471	265
△△	470	266
⊙⊙	469	267
◥◣	936	846
◼◼	934	862
⋁⋁	581	281
−−	580	924
⚔⚔	317	400
▦▦	3799	236
■	310	403

Bougainvillea

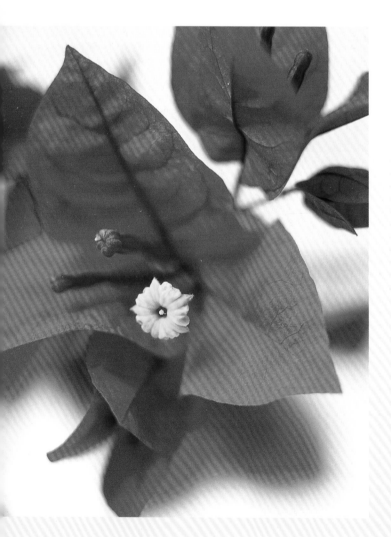

In my youth, I regarded the bougainvillea as simply an indoor plant with small, coloured flowers. It was not until I holidayed in the French Riviera that I discovered how spectacular the plant really is. Named in honour of the French explorer Louis Antoine de Bougainville, the bougainvillea can climb up walls or grow as a huge hedge. It produces an amazing display of colour during the late spring and summer months, but it does need good sunshine and warmth to really prosper.

See pages 158–159 for cross stitch instructions.

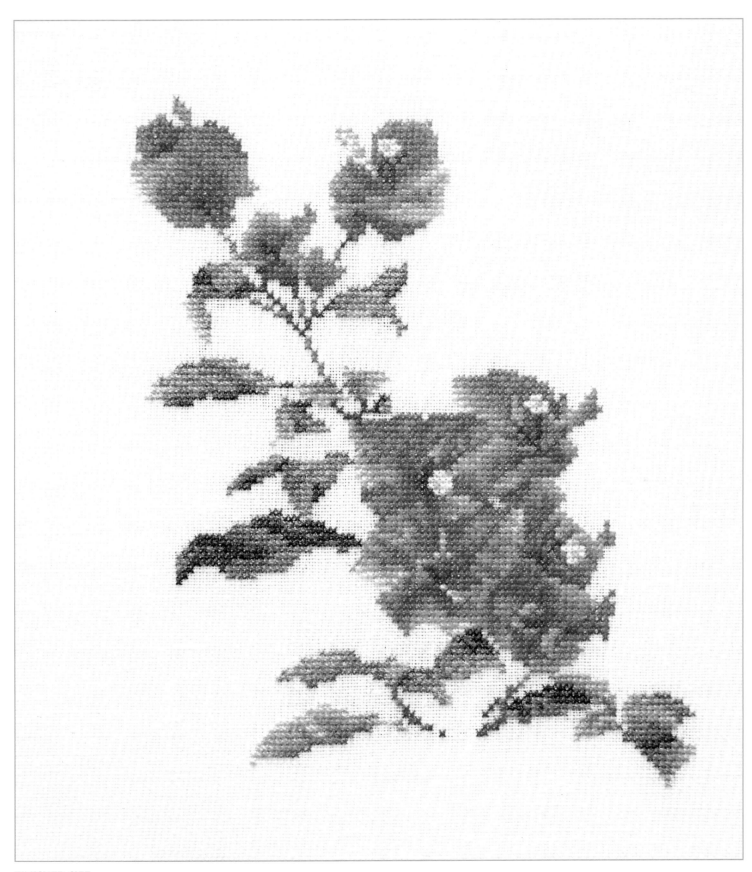

FINISHED SIZE
13.5 x 16cm (5¼ x 6¼in)

	DMC	Anchor
╱╱	819	271
○○	3609	85
××	3608	86
‖‖	3607	87
⦂	917	89
◢	915	1029
■	902	897
╲╲	369	1043
∧∧	368	214
◿	320	215
⊙⊙	367	216
⊠	319	218
■	890	212
⦙	3348	264
==	3347	261
△△	3346	262
◨	3345	263
∨∨	436	363
▬	434	310
◐◐	801	359
⤬⤬	834	887
⚡⚡	832	945
◔◔	830	889
┆┆	blanc	1
⌄⌄	3823	2
⬍⬍	725	305

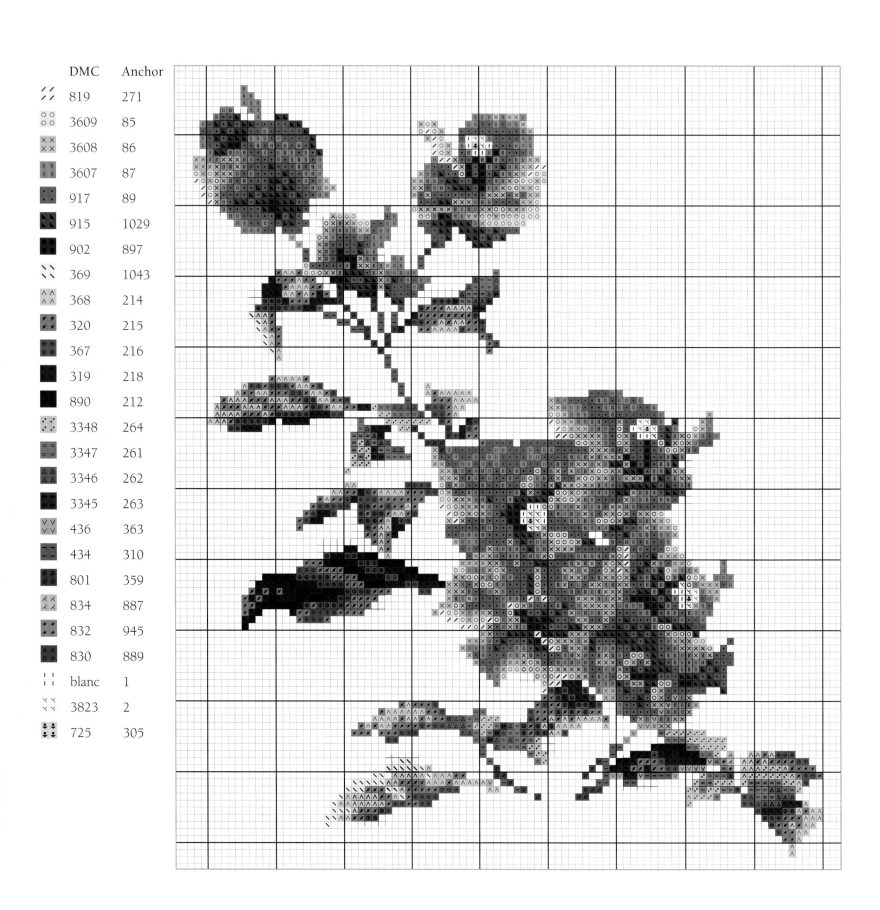

Tulip

Growing up as I did in the bulb-growing region of Holland, tulips were much in abundance. This tulip with its purplish-black petals is one of the most unusual varieties and one I especially like. It is such a special colour, I just had to include it in this collection of designs.

These spring flowers always remind me of the big flower festival held in our region each year; tulips would be growing in the fields in all their glorious colours, like a patchwork carpet.

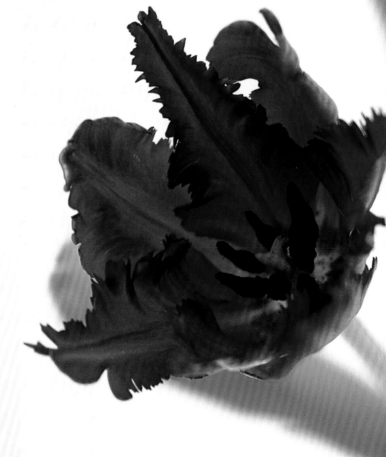

See pages 158–159 for cross stitch instructions.

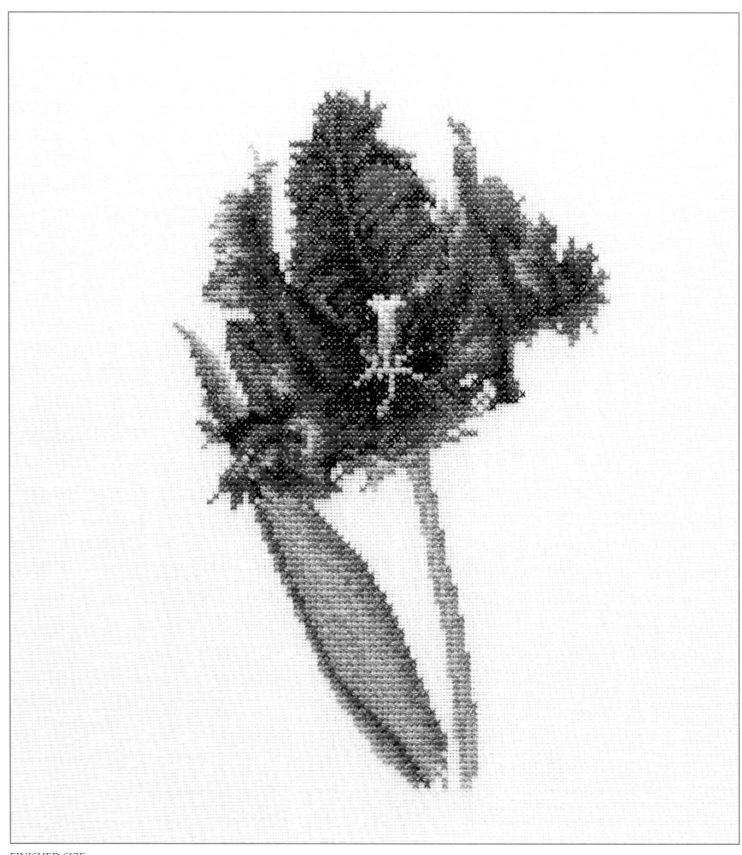

FINISHED SIZE
11 x 16.5cm (4¼ x 6½in)

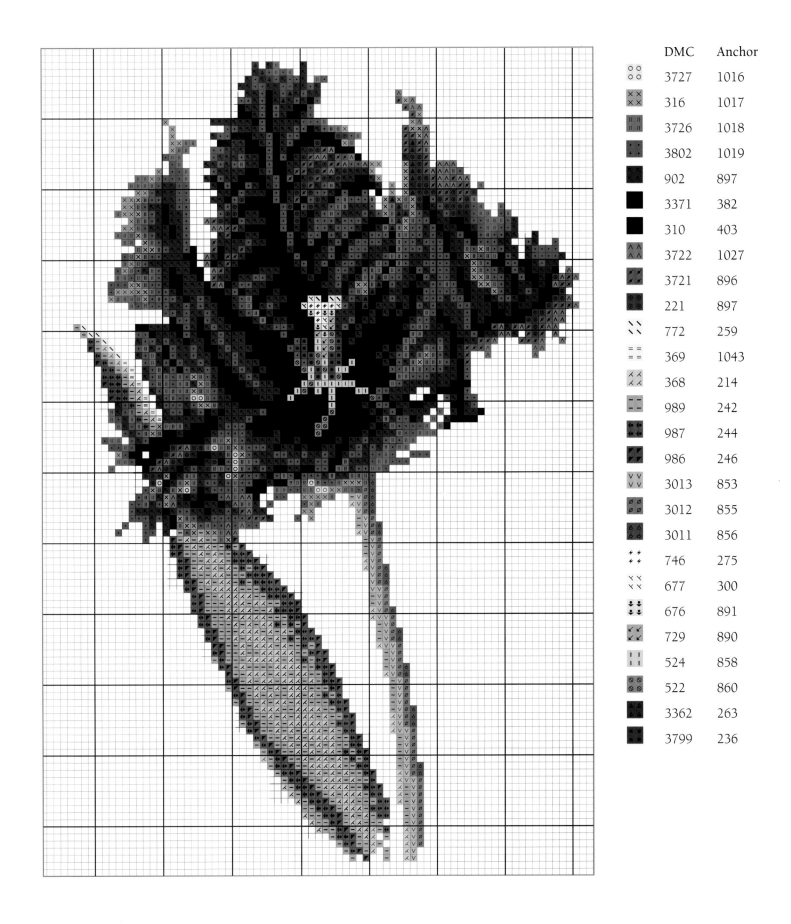

DMC	Anchor
3727	1016
316	1017
3726	1018
3802	1019
902	897
3371	382
310	403
3722	1027
3721	896
221	897
772	259
369	1043
368	214
989	242
987	244
986	246
3013	853
3012	855
3011	856
746	275
677	300
676	891
729	890
524	858
522	860
3362	263
3799	236

Crocus

The crocus is one of the most important bulbs in the bulb district where I live and my father used to grow several different varieties. Now there are even more – in many different colours and forms – to choose from.

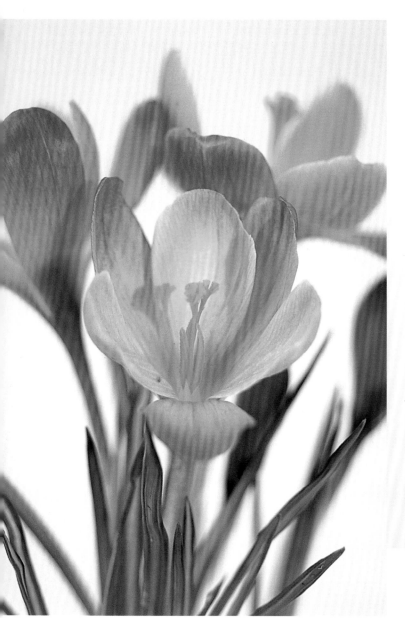

My two favourite crocuses are a strong yellow variety, and this dark violet one with lovely orange markings, which appear when the petals open out in the sun.

Unfortunately, birds are also fond of yellow crocuses – they eat the flowers in my garden every spring!

See pages 158–159 for cross stitch instructions.

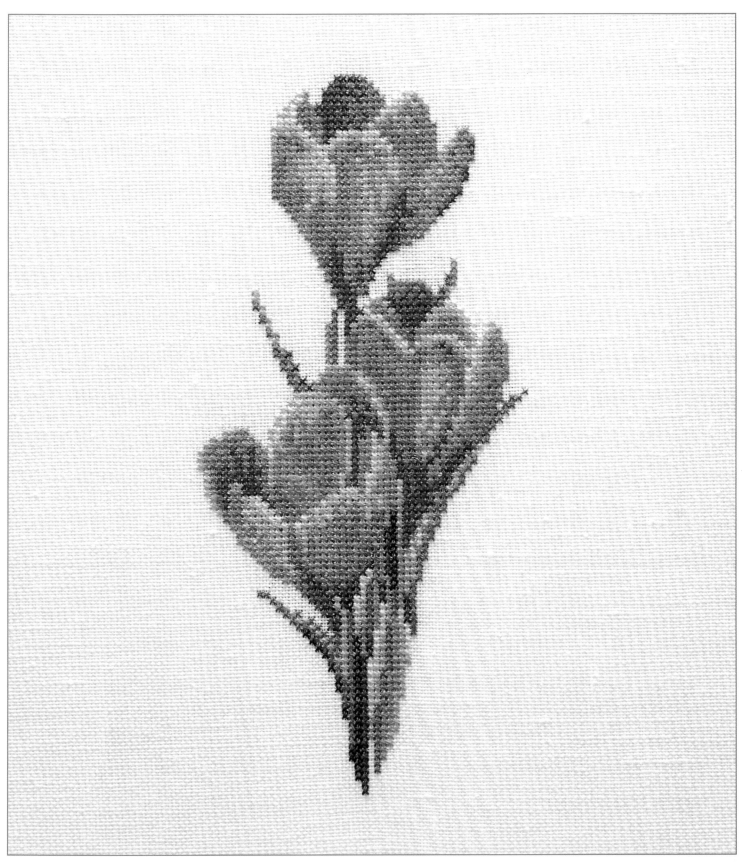

FINISHED SIZE
7.5 x 15.5cm (3 x 6¼in)

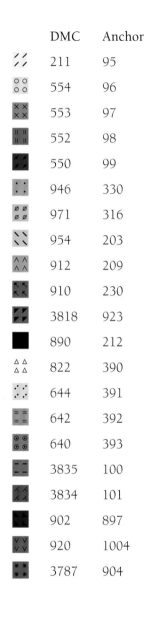

DMC	Anchor
211	95
554	96
553	97
552	98
550	99
946	330
971	316
954	203
912	209
910	230
3818	923
890	212
822	390
644	391
642	392
640	393
3835	100
3834	101
902	897
920	1004
3787	904

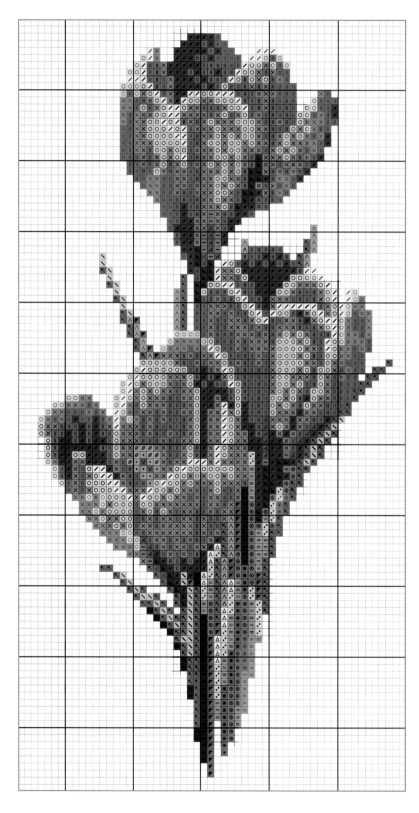

Buddleia

The buddleia is a fragrant garden shrub that produces long spikes of mauve or purple flowers in the summer and autumn. It is best appreciated outdoors, however, as the flowers do not last long if cut and brought into the house.

The buddleia also attracts butterflies, hence its common name of butterfly bush; one of the joys of summer in my garden is watching the butterflies fluttering around the blossoms. I think everyone should plant a buddleia in their garden to provide a guest house for these rapidly disappearing insects.

See pages 158–159 for cross stitch instructions.

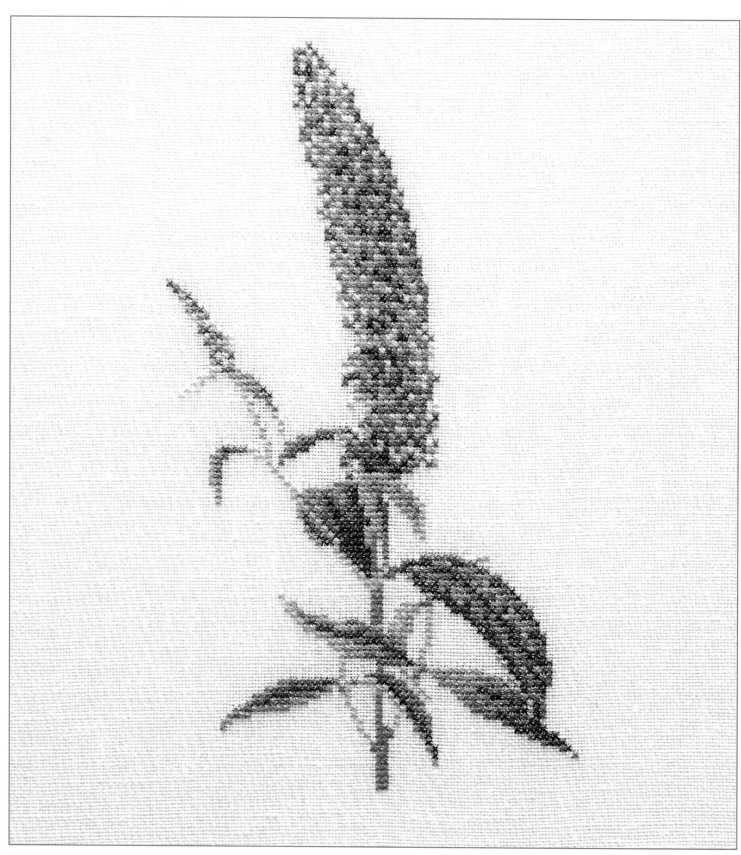

FINISHED SIZE
9.5 x 16.5cm (3¾ x 6½in)

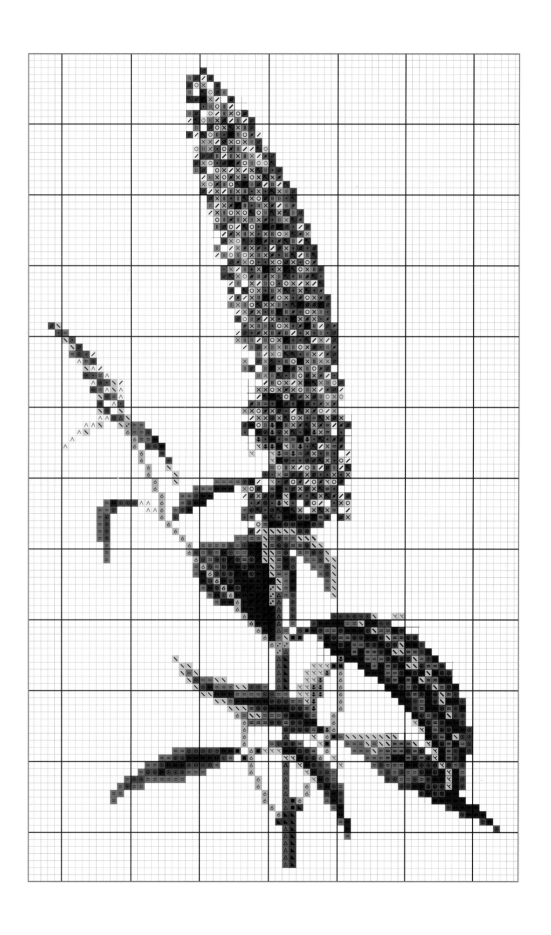

	DMC	Anchor
∕∕	211	342
○○	210	108
✕✕	209	109
‖‖	208	110
	327	101
	552	98
	550	99
	333	119
^^	369	1043
＼＼	368	214
══	320	215
	367	216
	319	218
	890	212
	734	278
△△	732	280
	730	924
66	3013	853
	632	936
✕✕	524	858
	522	860

Clematis

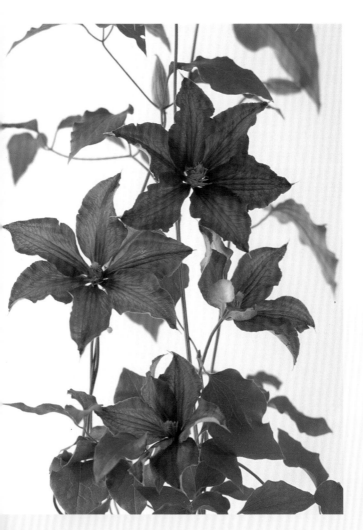

There are hundreds of different species of clematis. Clematis jackmanii is one of the most popular and certainly my favourite, because of the lovely rich, bright colour of its flowers. This climbing plant is easy to grow and blooms beautifully each summer and autumn.

I planted some clematis around the base of an old red hawthorn tree in my garden. The tree had grown too large and produced too much shadow, so I had it chopped back – now it serves as a frame for my clematis to climb through.

See pages 158–159 for cross stitch instructions.

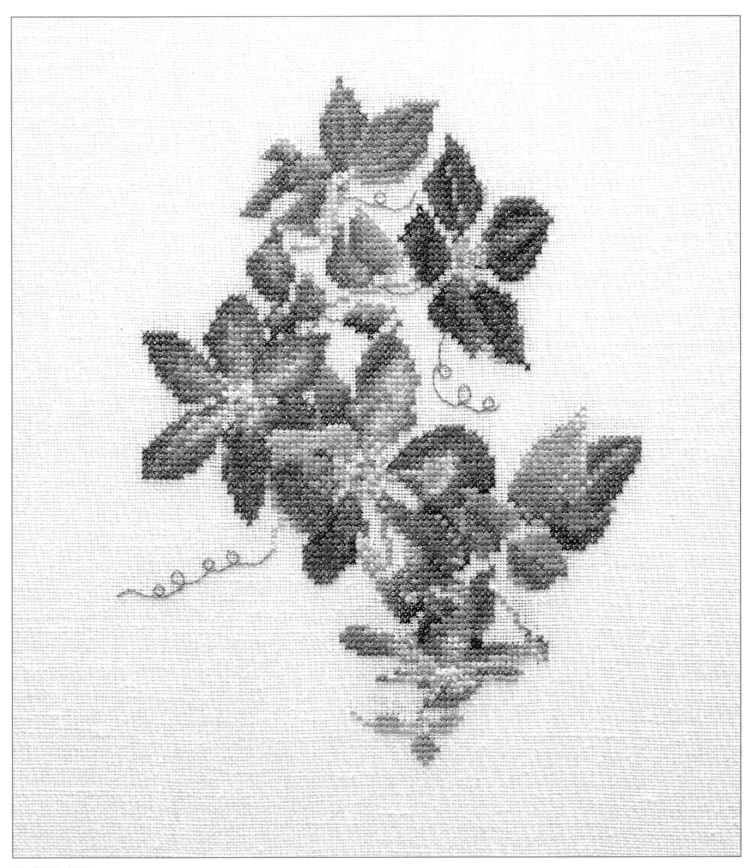

FINISHED SIZE
12.5 x 16cm (5 x 6¼in)

DMC	Anchor
772	259
3348	264
704	225
703	226
702	227
701	228
700	229
699	923
471	265
3747	120
341	117
340	118
3746	1030
333	119
792	941
791	178
746	275
676	891
729	890
3829	9012
554	96
550	99
224	839
223	894
3721	1027
221	896
371	887
611	898
3052	844
890	212

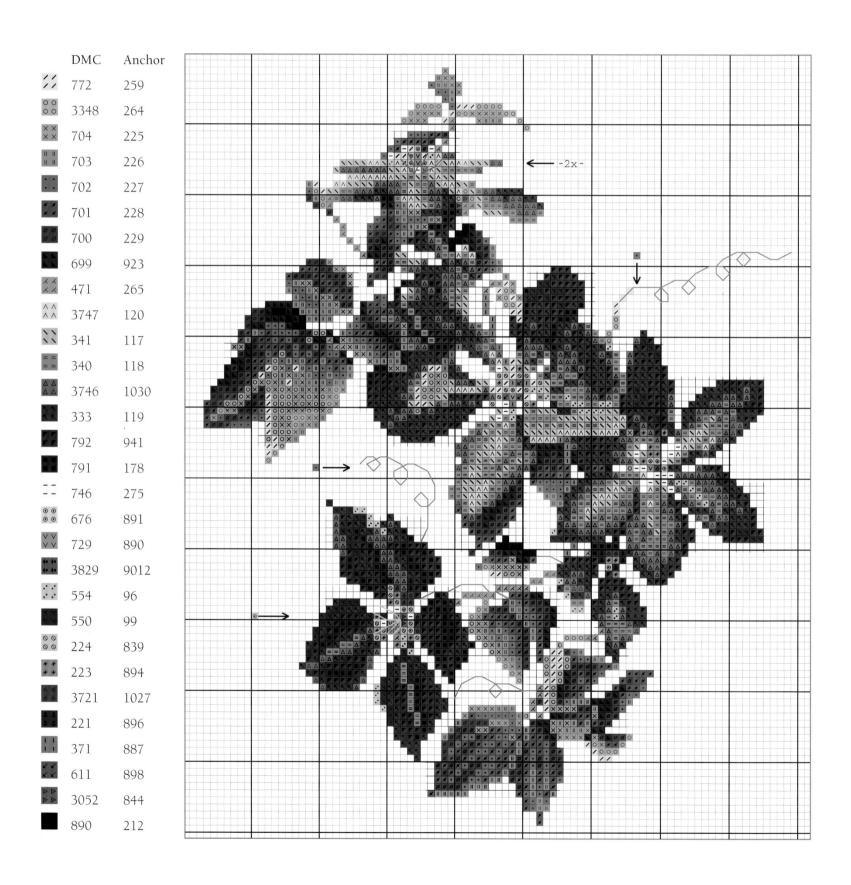

-2x-

Orchid

Flamboyant and exotic, orchids are prized for their unusual flowers, but can be difficult to grow. This cattleya orchid is named after William Cattley who discovered the dramatic-looking flower growing in moss in 1824.

I remember my father giving my mother a corsage made with a cattleya orchid in about 1950 when they went to a special festival. Later, this flower came to be regarded as old-fashioned, but these days orchids are popular again and this lovely purple flower with its yellow heart is admired anew.

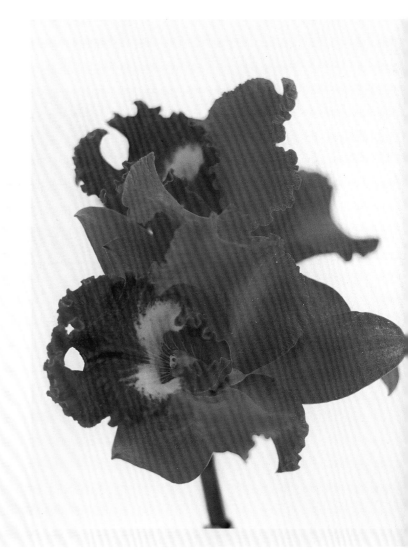

See pages 158–159 for cross stitch instructions.

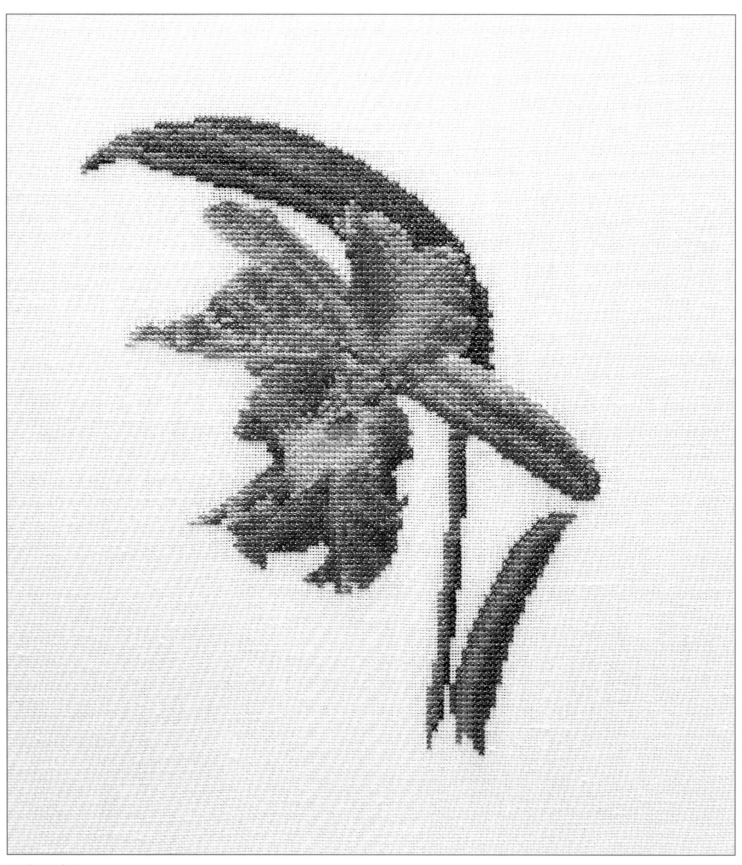

FINISHED SIZE
13.5 x 15.5cm (5¼ x 6¼in)

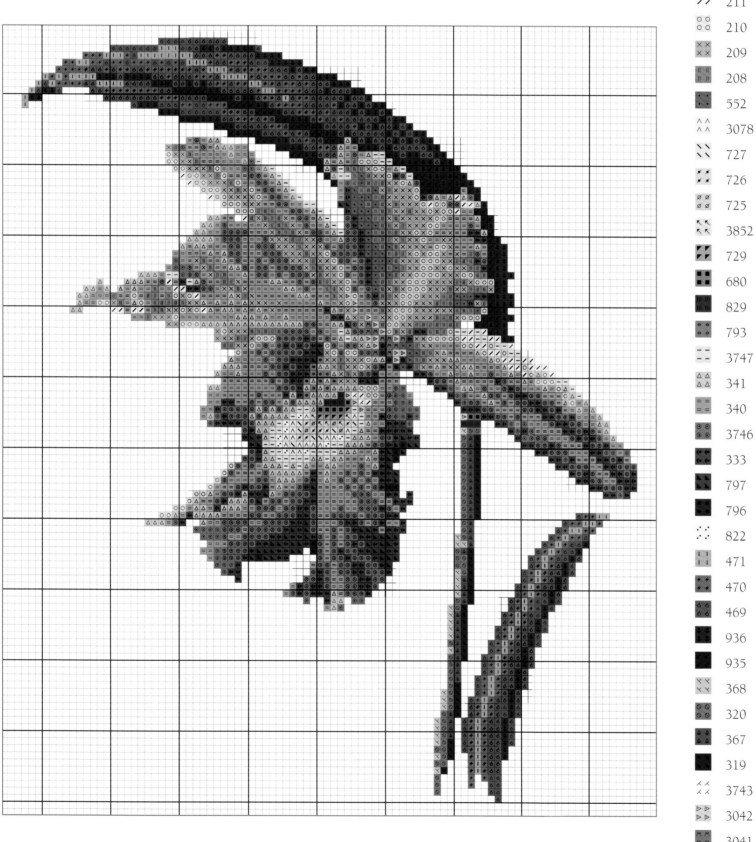

	DMC	Anchor
∕ ∕	211	342
○ ○	210	108
✕ ✕	209	109
‖ ‖	208	110
⬛	552	98
∧ ∧	3078	292
╲ ╲	727	293
⁄ ⁄	726	295
∅ ∅	725	305
↖ ↖	3852	307
◤ ◤	729	890
■ ■	680	820
▦	829	906
⊕	793	176
– –	3747	120
△ △	341	118
= =	340	117
⊘ ⊘	3746	1030
◀▶	333	119
◪	797	132
▣	796	133
⋰⋱	822	390
ǀ ǀ	471	265
⚡	470	266
◓ ◓	469	267
▥	936	846
◼	935	861
✕ ✕	368	214
◎	320	215
▲ ▲	367	216
◼	319	218
⋏ ⋏	3743	869
▷ ▷	3042	870
ᴍ ᴍ	3041	871
▨	3740	872

Thistle

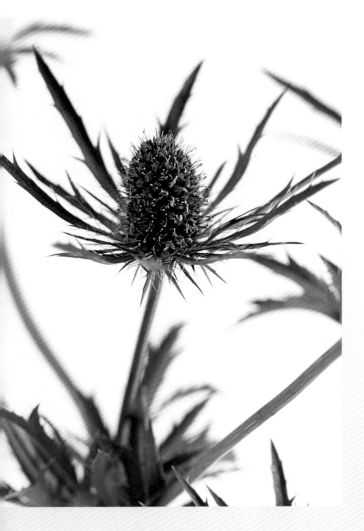

This decorative thistle is really a giant in the garden, growing very tall, and looks lovely in the flower bed. Known also as Miss Willmott's ghost, it produces cones of beautiful blue flowers surrounded by a silvery grey ruff of leaves.

The thistle self-seeds very easily, so it can spread throughout your garden if you do not take care! One long-lasting way to display it indoors is to cut and dry the flowers, then use them in dried flower arrangements.

See pages 158–159 for cross stitch instructions.

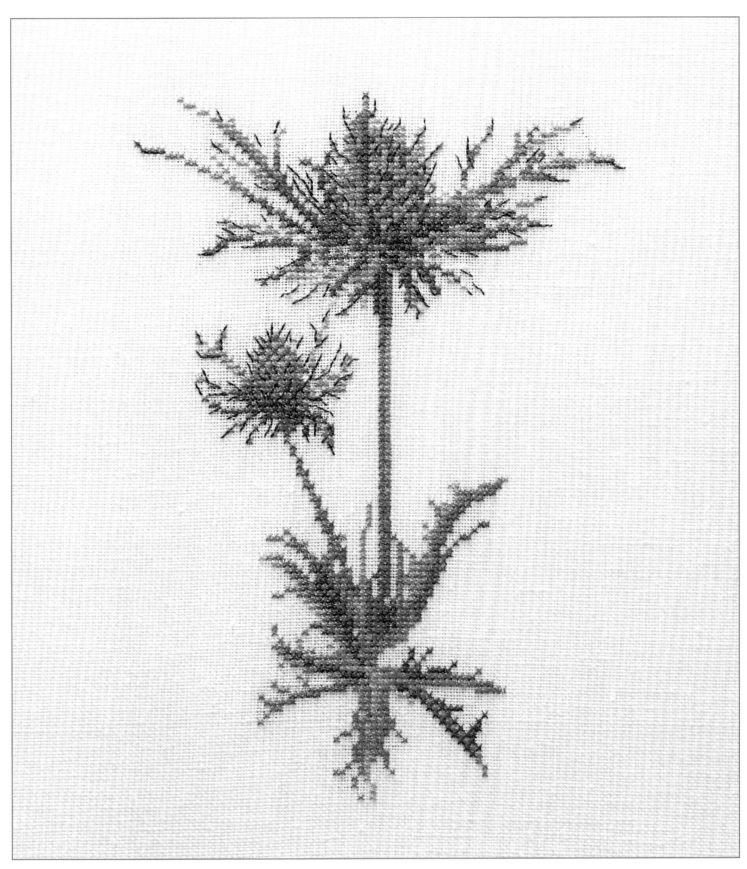

FINISHED SIZE
11.5 x 16cm (4½ x 6¼in)

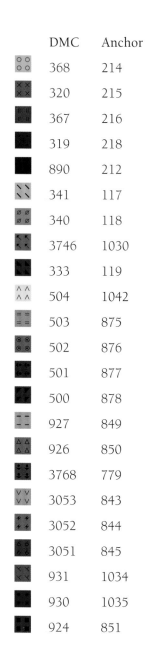

DMC	Anchor
368	214
320	215
367	216
319	218
890	212
341	117
340	118
3746	1030
333	119
504	1042
503	875
502	876
501	877
500	878
927	849
926	850
3768	779
3053	843
3052	844
3051	845
931	1034
930	1035
924	851

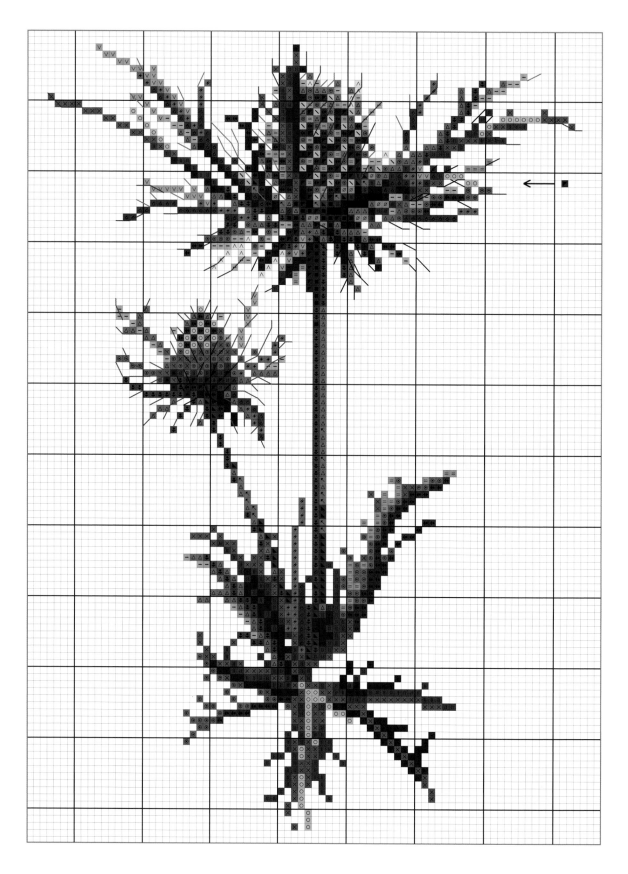

Iris

The iris is grown all over the world, and is said to be the most widely cultivated of all ornamental plants. The lavender-coloured variety featured in this panel has been associated with my family for a long time. Quite recently I was given some wonderful irises by my aunt who had transplanted them 50 years previously from my grandmother's garden, where they used to flower in abundance.

See pages 158–159 for cross stitch instructions.

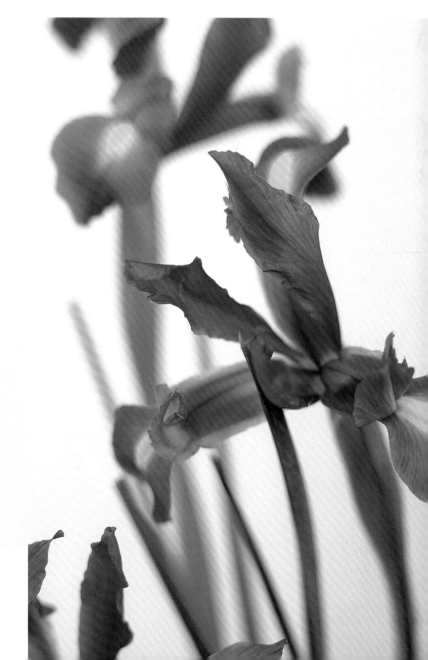

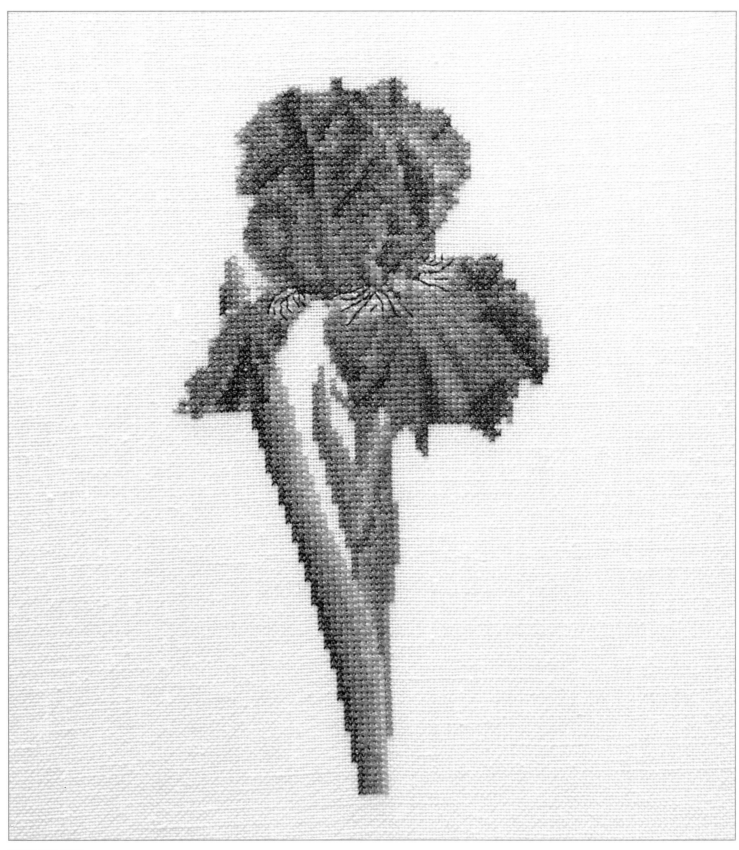

FINISHED SIZE
9 x 16.5cm (3½ x 6½in)

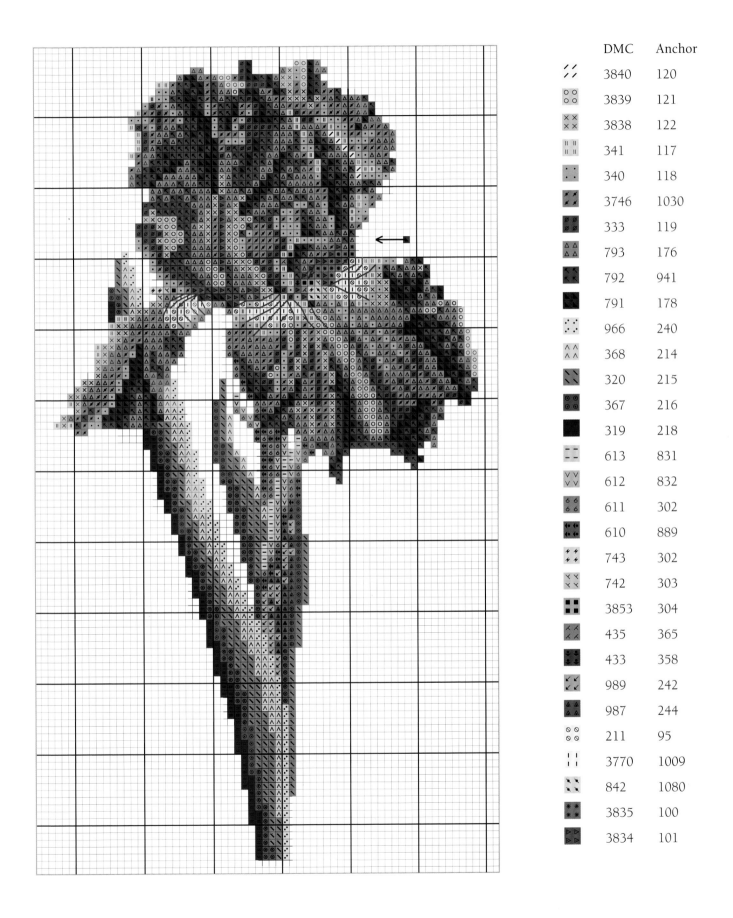

	DMC	Anchor
╱╱	3840	120
○○	3839	121
✕✕	3838	122
‖‖	341	117
∴∴	340	118
◹◿	3746	1030
∅∅	333	119
△△	793	176
◤◥	792	941
◼◼	791	178
⋰⋰	966	240
∧∧	368	214
╲╲	320	215
◉◉	367	216
◼	319	218
– –	613	831
∨∨	612	832
6 6	611	302
◀◀	610	889
⚡⚡	743	302
＜＜	742	303
◼◼	3853	304
✕✕	435	365
◥◥	433	358
↙↙	989	242
▲▲	987	244
○○	211	95
! !	3770	1009
↘↘	842	1080
✱✱	3835	100
▷▷	3834	101

Pansy

I love pansies, both the small ones and the large cultivated varieties, with or without faces, and in all colours. My garden would not be complete without some. They make lovely posies for special friends and can be used as pretty decorations indoors. Pansies have a number of common names, including love-in-idleness, heartsease, eyebright and lover's-thoughts, all of which suggest that the pansy is truly a flower of love and romance.

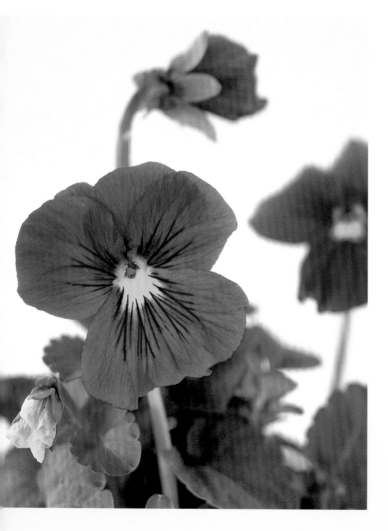

See pages 158–159 for cross stitch instructions.

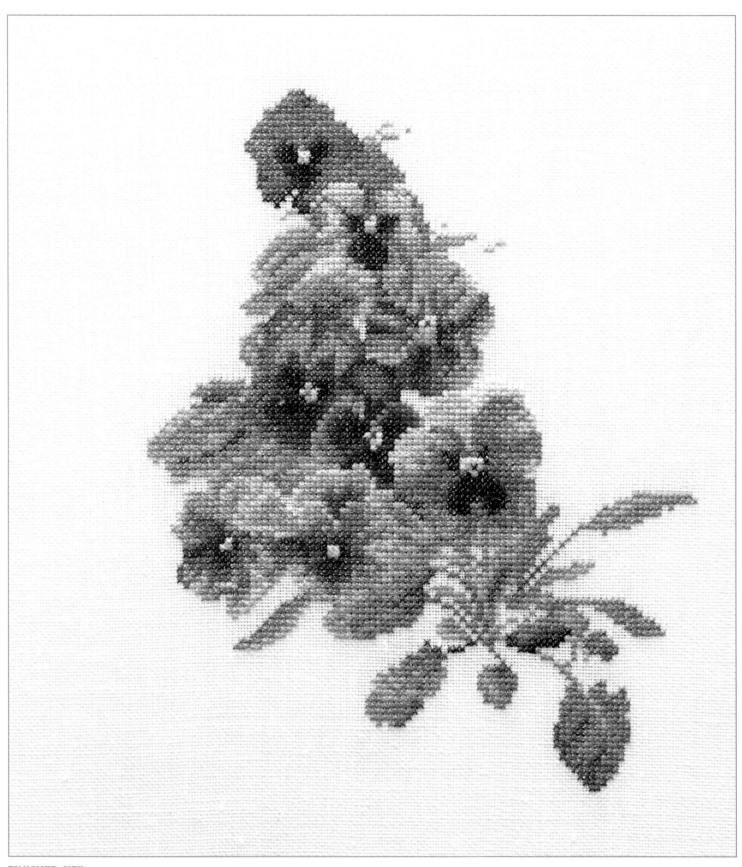

FINISHED SIZE
13.5 x 16.5cm (5¼ x 6½in)

	DMC	Anchor
∕∕	800	144
⊘⊘	809	130
✕✕	799	145
‖‖	798	146
⠿	797	132
■	820	134
╲╲	3747	120
∧∧	341	118
==	340	117
⌀⌀	3746	1030
✕✕	333	119
◀▶	552	98
▲▲	550	99
⠂⠂	772	259
— —	3348	264
∨∨	3347	261
ᕔᕔ	3346	262
▨	3345	263
■	895	1044
■	823	127
✕✕	743	302
✦✦	741	304
■	939	152
△△	833	874
✕✕	832	945
‖‖	831	888
▨	829	906
⊙⊙	746	275
<<	369	1043
▷▷	368	214
◥◥	320	215
▦	367	216
■	319	218
■	3371	382

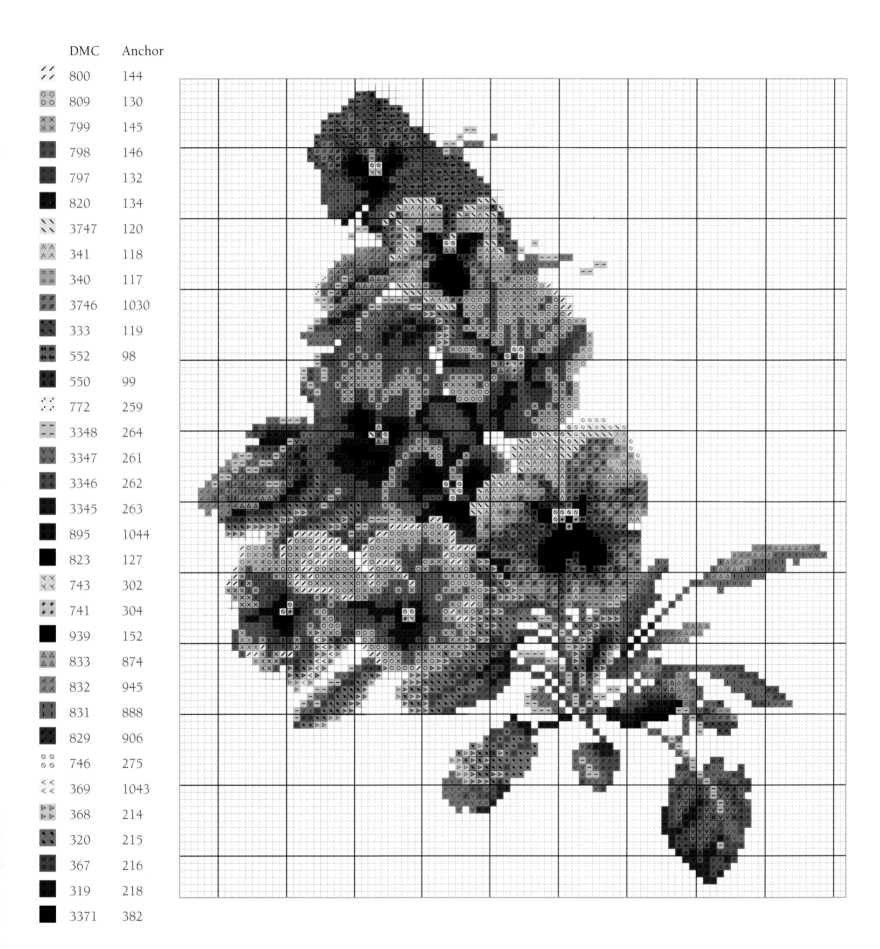

Hyacinth

These spring-flowering plants are often grown indoors in pots, where their many star-shaped flowers produce a fragrance that can fill the room. The name hyacinth comes from Hyakinthos, a figure from Greek mythology; when he was killed by Apollo, hyacinths started to grow at his feet.

In my youth, when there was a flower parade in town, we all used to make mosaics from hyacinths. They took hours to make, but looked beautiful; I remember my hands being impregnated with a lovely hyacinth perfume for days afterwards!

See pages 158–159 for cross stitch instructions.

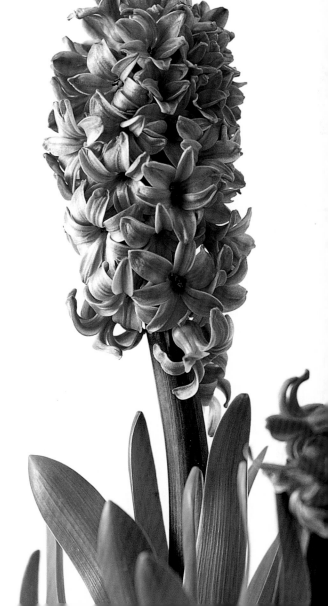

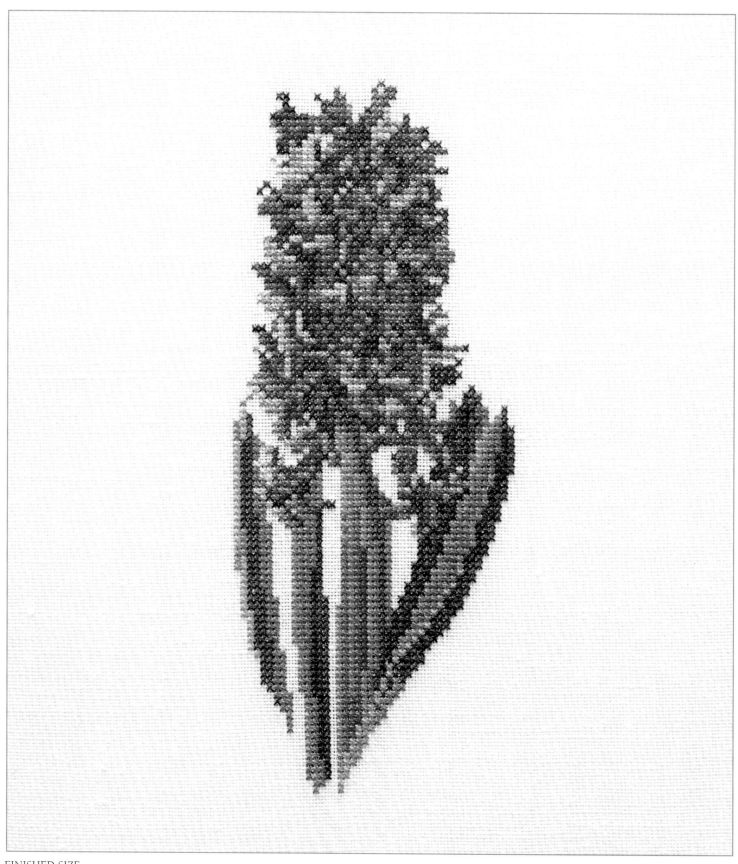

FINISHED SIZE
6.5 x 15.5cm (3½ x 6¼in)

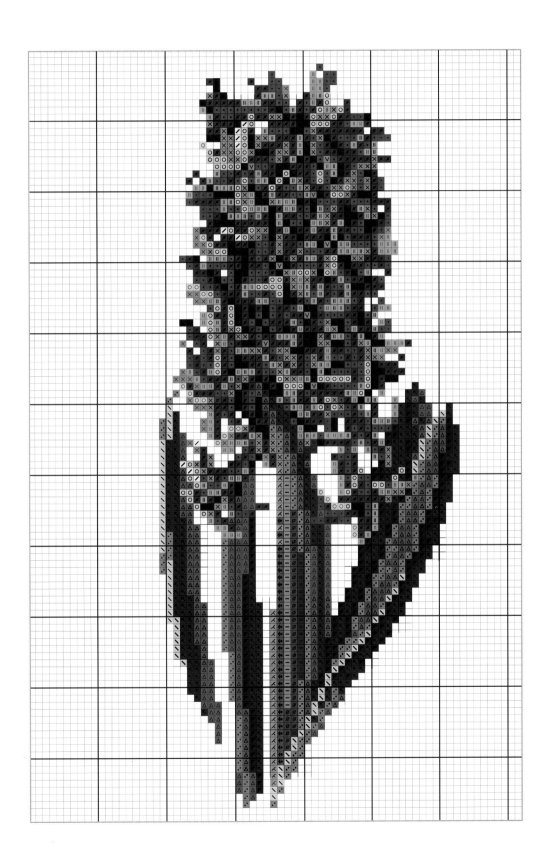

	DMC	Anchor
∕∕	800	144
○○	794	175
✕✕	793	176
‖‖	3807	122
∷	792	941
◢	791	178
■	823	152
▨	3740	872
＼＼	368	214
∴	320	215
△△	367	216
■	319	218
■	890	212
‑‑	3772	1007
■	902	897
∨∨	370	888
≺≺	3052	844
◀◀	3051	845

Agapanthus

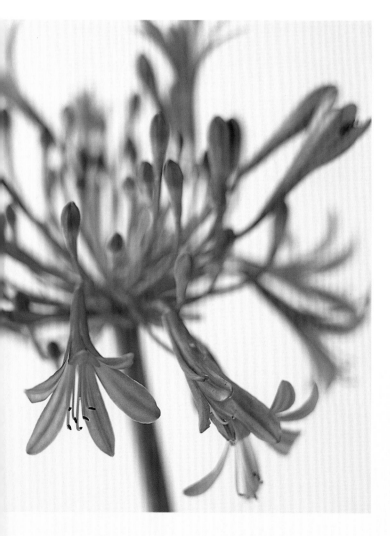

The meaning of agapanthus is 'love flower'. With their starry blue flowers on tall stems, these elegant plants look gorgeous in any border in late summer. On a recent trip to South Africa, where the agapanthus originates, I visited the botanical gardens near Capetown where there were some magnificent blue and white agapanthus flowering. In my own garden I was not so lucky; the plants grew to just half the size!

See pages 158–159 for cross stitch instructions.

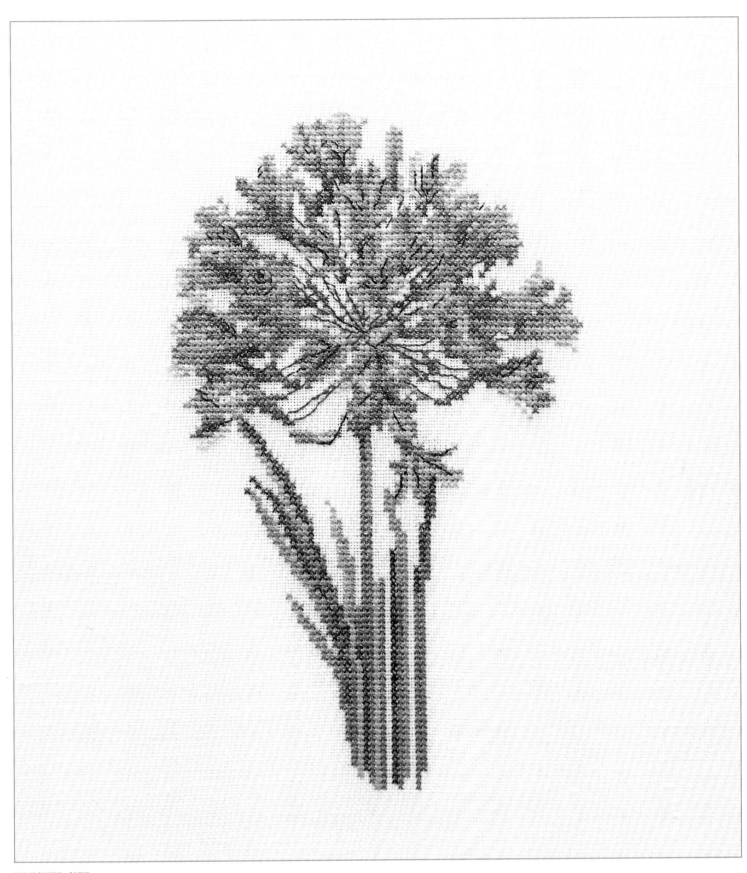

FINISHED SIZE
10.5 x 16.5cm (4¼ x 6½in)

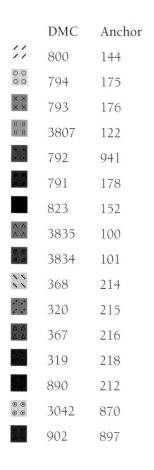

	DMC	Anchor
∕∕	800	144
○○	794	175
××	793	176
‖‖	3807	122
∴	792	941
▨	791	178
■	823	152
∧∧	3835	100
∅∅	3834	101
⧄	368	214
∴	320	215
△△	367	216
▨	319	218
▨	890	212
⊙⊙	3042	870
⊙⊙	902	897

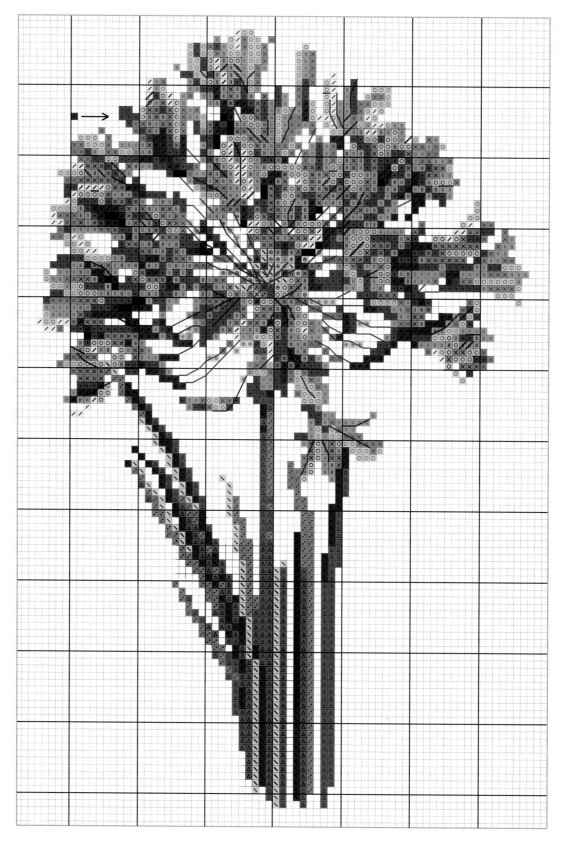

Morning glory

One of the most beautiful climbing plants, morning glory is also very quick-growing. Its large flowers and vine-like leaves will rapidly cover a wall, fence or arbour. There are many varieties of morning glory with different-coloured flowers, including crimson, rosy red, blue and white.

These flowers remind me of when I was about seven years old – I planted one in a pot and put it on a window sill outside my window. I watered it every day until it grew and grew right over the roof!

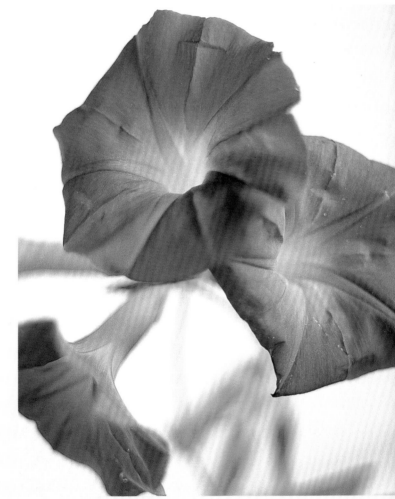

See pages 158–159 for cross stitch instructions.

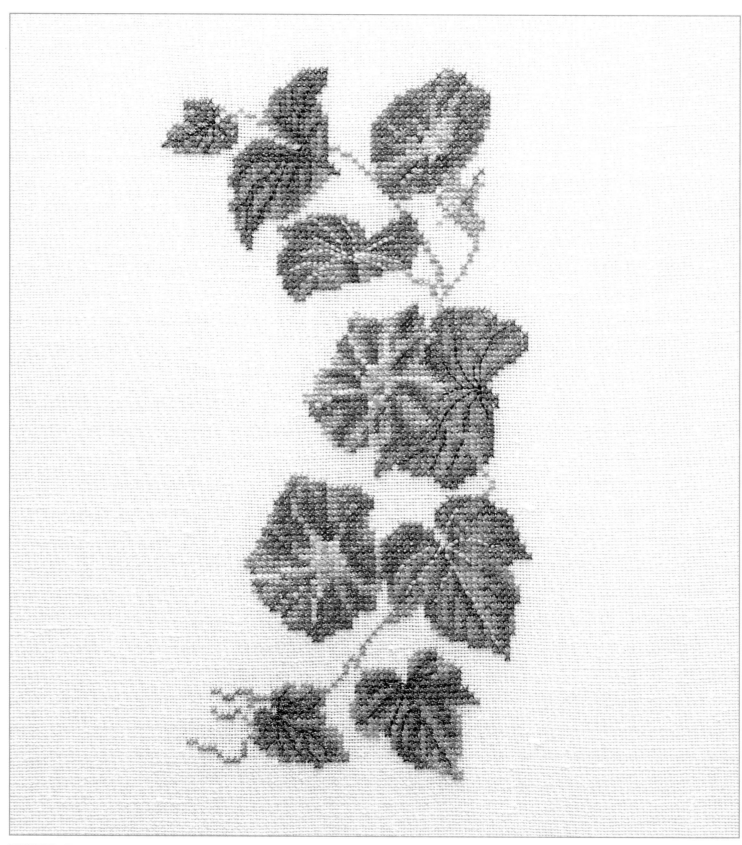

FINISHED SIZE
9 x 16.5cm (3½ x 6½in)

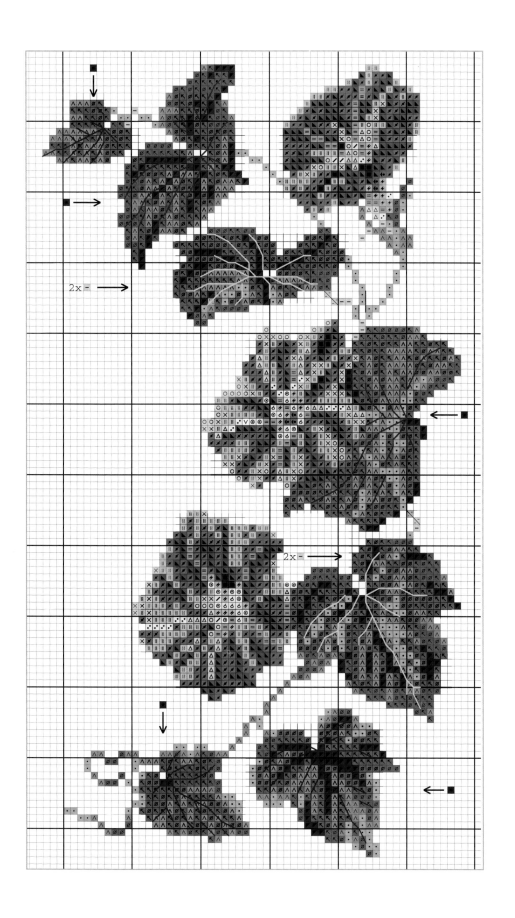

	DMC	Anchor
∕ ∕	3747	120
○ ○	341	117
✕ ✕	794	175
‖ ‖	799	145
◣ ◣	798	146
◣ ◣	797	132
■ ■	820	134
– –	3348	264
• •	989	242
∧ ∧	988	243
∅ ∅	987	244
◤ ◤	986	246
■ ■	319	218
■	934	862
⠿	225	1026
△ △	224	839
= =	223	894
∨ ∨	746	275
◉ ◉	677	300
6 6	3822	295
⚡ ⚡	436	363
◖ ◖	434	310

Scabious

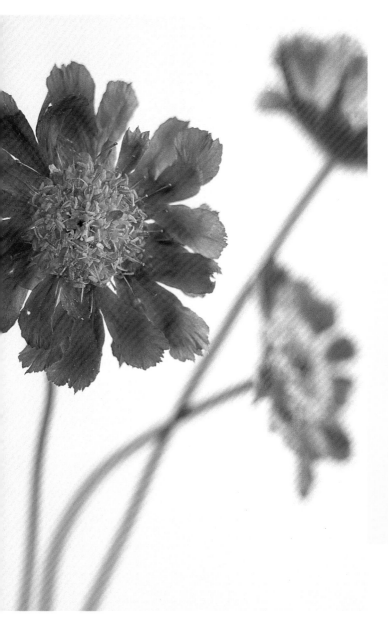

The scabious or pincushion flower is one of the most delightfully elegant plants for the garden, producing a long succession of blue, lavender or lemon-coloured flowers throughout the summer. It makes a good plant for the front of the border and is also excellent for cutting and displaying in bouquets and other arrangements.

The name scabious comes from the Latin word *scabiosus,* which means scabby; in ancient times, this plant was used as medicine to treat the skin condition scabies.

See pages 158–159 for cross stitch instructions.

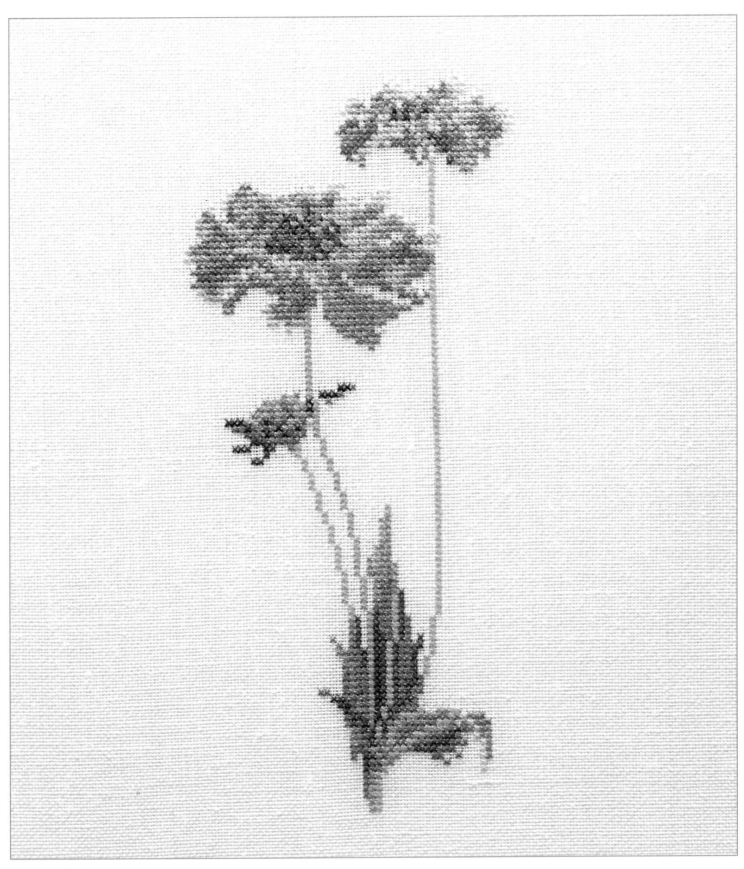

FINISHED SIZE
8 x 16.5cm (3¼ x 6½in)

	DMC	Anchor
✏✏	800	144
◦◦	794	175
✕✕	793	176
‖‖	3807	122
⦂⦂	792	941
◣◣	791	178
– –	369	1043
◥◥	368	214
⦂⦂	320	215
▲▲	367	216
■	319	218
■	890	212
ᐯᐯ	3348	264
◢◢	937	268
✦✦	471	265
✕✕	504	1042
‖‖	3813	875
66	503	876
⚓⚓	502	877
⊘⊘	3753	1031
◄◄	3752	1032
↙↙	932	1033
▲▲	931	1034

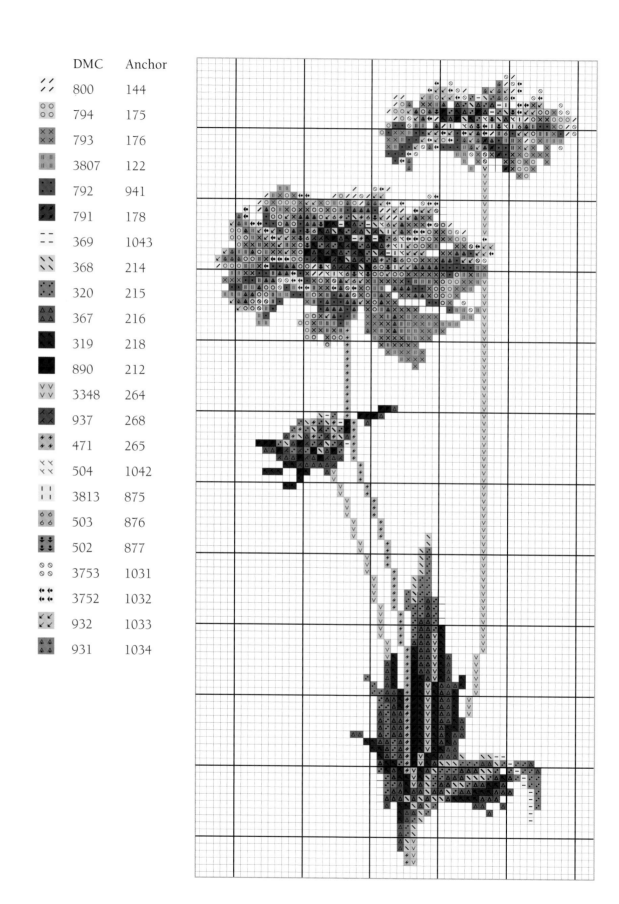

Bluebell

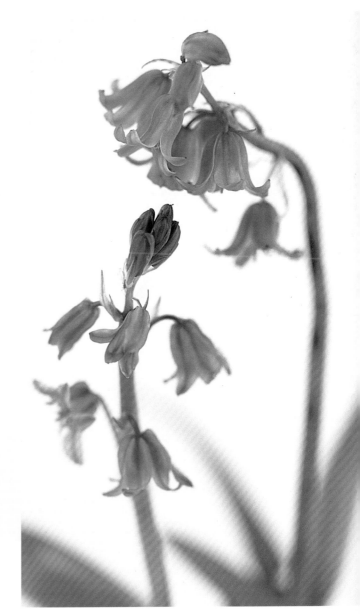

Bluebells are a lovely sight in spring – creating a beautiful luxurious carpet in woodlands and gardens. The pretty bell-shaped flowers grow in profusion, creating blankets of colour in shades of blue, violet and sometimes white.

Bluebells used to flower in profusion each spring beneath the pear blossom tree in my father's garden, and every year they would increase in number, spreading across the lawn. In the summer, we always had to be careful where we planted other flowers, so as not to damage the bluebell bulbs.

See pages 158–159 for cross stitch instructions.

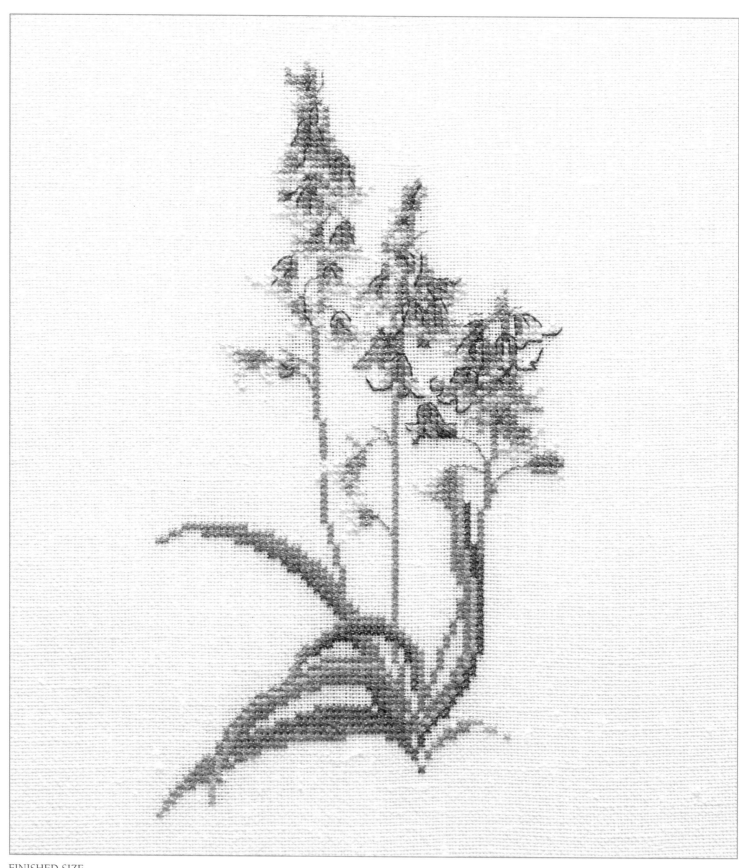

FINISHED SIZE
9 x 16cm (3½ x 6¼in)

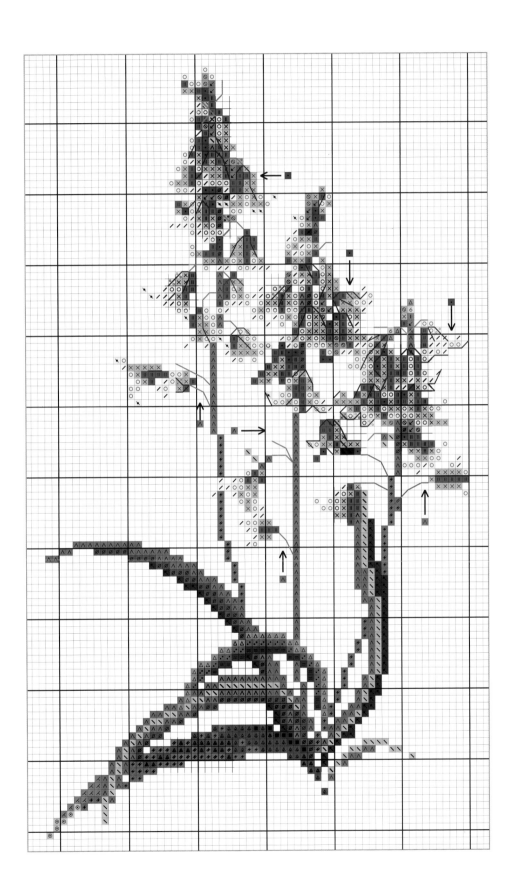

	DMC	Anchor
∕∕	775	128
∘∘	3840	120
××	3839	121
‖‖	3838	122
∷	797	132
▨	796	133
■	820	134
╲╲	3348	264
∧∧	3347	261
∅∅	3346	262
▨	3345	263
△△	3364	843
⁚⁚	3363	845
▬	3362	846
⊙⊙	422	372
ϐϐ	3042	870
‖‖	3041	871
⋋⋌	733	279
✦✦	581	281
‖‖	580	924
▦	937	268
⊙⊙	340	117
⤈⤈	3746	1030
⋰⋰	772	259

Nigella

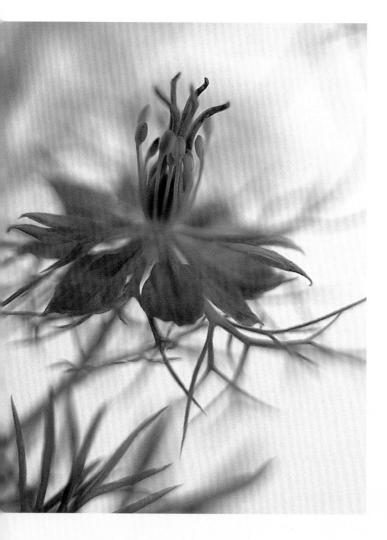

Also known as love-in-a-mist, the dainty ethereal blooms of this plant appear among fine, feathery foliage, producing a lovely misty show of pastel colour. It makes an ideal summer border plant, especially growing among pinks and poppies. The nigella does not live long, but the flowers are followed by pale green seed pods, which can be dried. If cut, the flower petals drop very quickly, but I can't resist bringing some indoors anyway.

See pages 158–159 for cross stitch instructions.

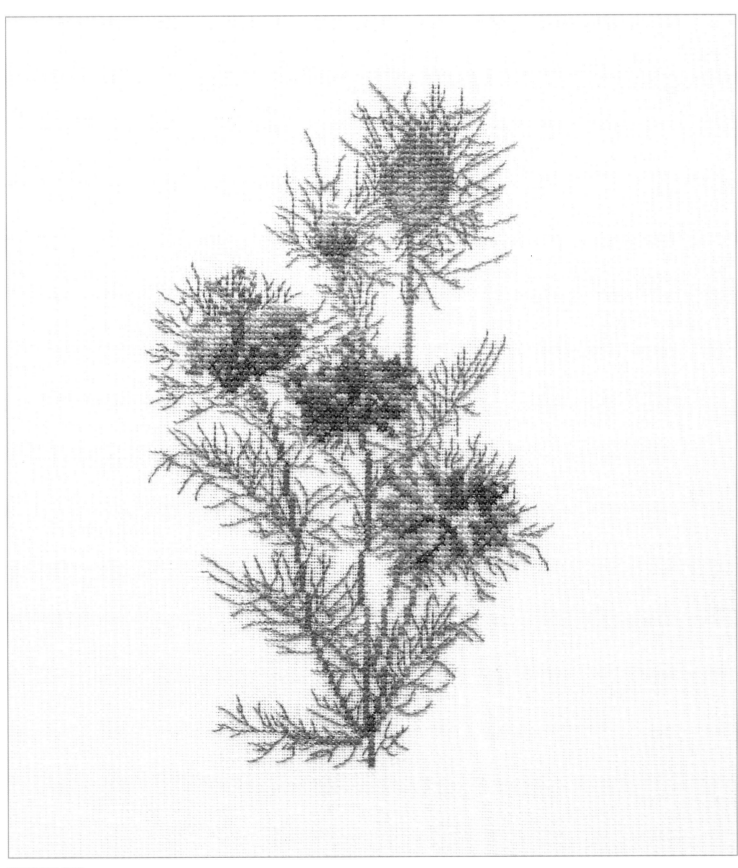

FINISHED SIZE
10 x 16.5cm (4 x 6½in)

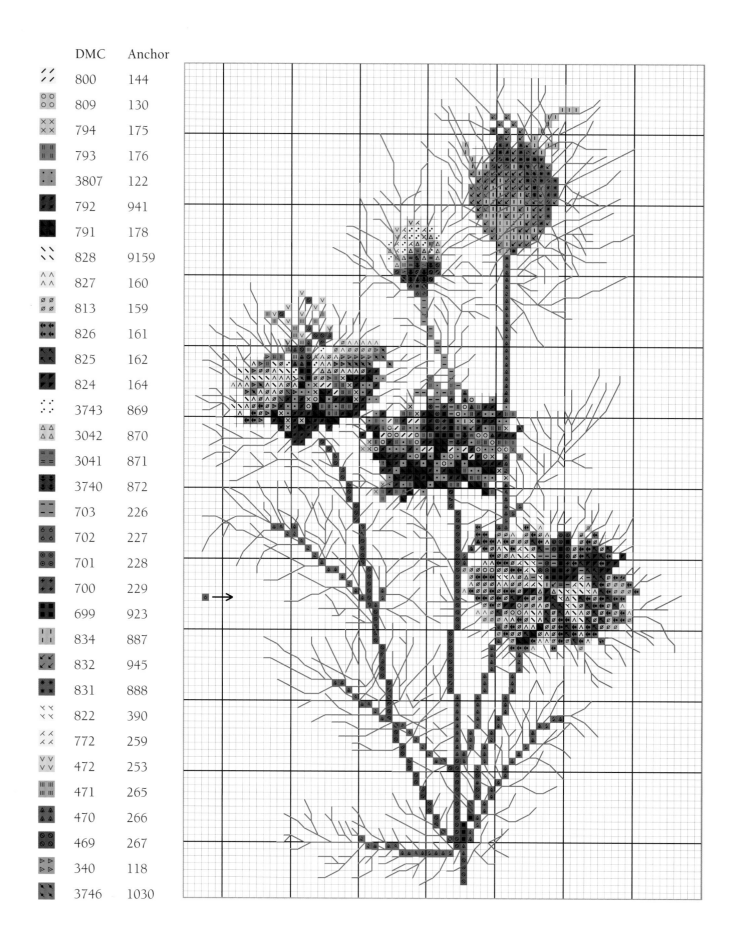

DMC	Anchor
800	144
809	130
794	175
793	176
3807	122
792	941
791	178
828	9159
827	160
813	159
826	161
825	162
824	164
3743	869
3042	870
3041	871
3740	872
703	226
702	227
701	228
700	229
699	923
834	887
832	945
831	888
822	390
772	259
472	253
471	265
470	266
469	267
340	118
3746	1030

Hydrangea

This is a popular garden plant with lovely big blue, white or pink flower heads lasting right through the summer. I like to pick a few stems of hydrangea in the summer and dry them, as they look lovely in the winter arranged in a vase.

Hydrangeas have a special meaning in our family. When a new baby was born, my mother was given a white hydrangea. My father planted these in the garden and when we moved to another house, the biggest plant moved with us; cuttings from this hydrangea still flower all over my garden today.

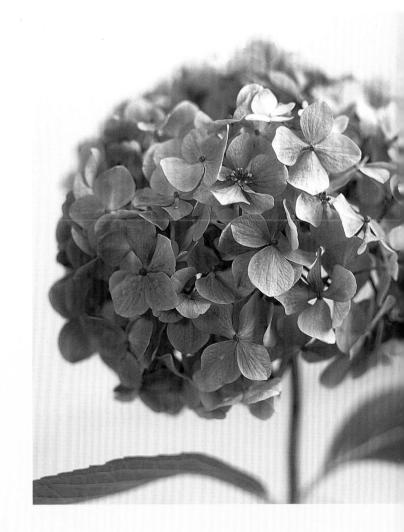

See pages 158–159 for cross stitch instructions.

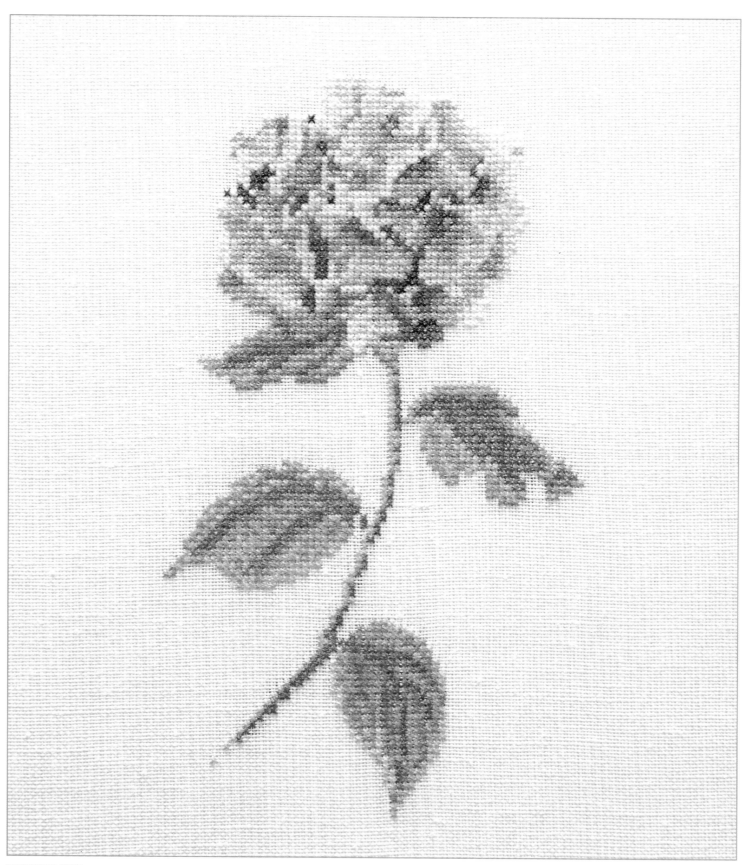

FINISHED SIZE
9.5 x 16cm (3¾ x 6¼in)

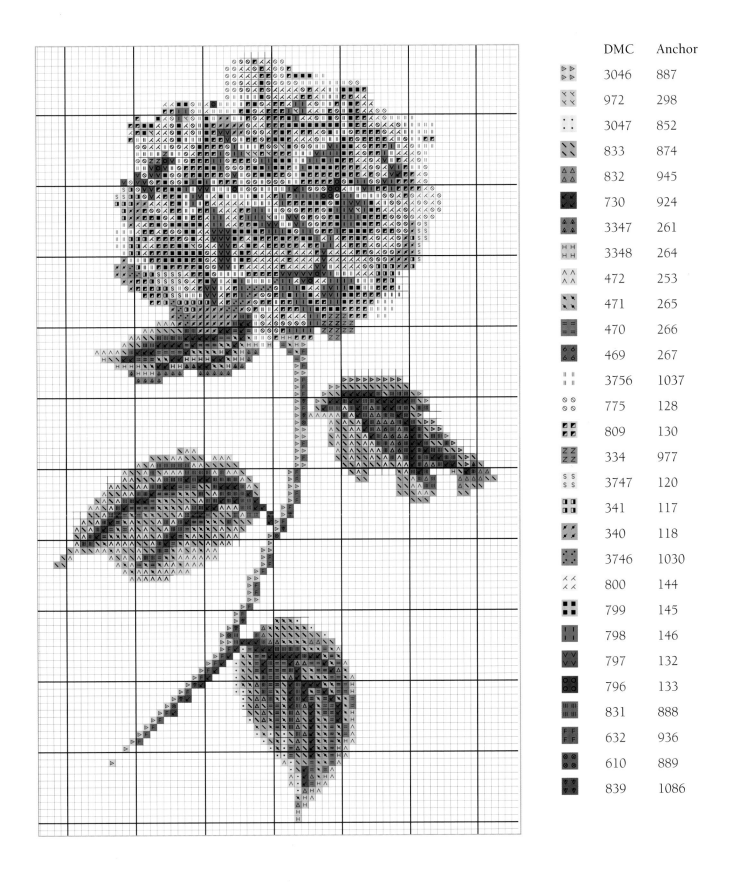

	DMC	Anchor		
▷ ▷ ▷ ▷	3046	887		
✗ ✗ ✗ ✗	972	298		
: :	3047	852		
╲ ╲	833	874		
△ △ △ △	832	945		
✗ ✗	730	924		
▲ ▲ ▲ ▲	3347	261		
H H H H	3348	264		
∧ ∧ ∧ ∧	472	253		
✘ ✘	471	265		
= = = =	470	266		
6 6 6 6	469	267		
‖ ‖ ‖ ‖	3756	1037		
⊘ ⊘	775	128		
◩ ◩ ◩ ◩	809	130		
Z Z Z	334	977		
S S S S	3747	120		
◧ ◧ ◧ ◧	341	117		
◿ ◿	340	118		
⠿ ⠿	3746	1030		
⤜ ⤜	800	144		
■ ■ ■ ■	799	145		
			798	146
V V V V	797	132		
⊙ ⊙ ⊙ ⊙	796	133		
‖‖ ‖‖	831	888		
F F F F	632	936		
⊗ ⊗ ⊗ ⊗	610	889		
▼ ▼ ▼ ▼	839	1086		

Basic skills

Before embarking on a project from this book, make sure that you have the tools and materials you require.

You will need

For each of the projects in this book, you will require the following materials:

36-count white linen, approx
 35 x 37.5cm (14 x 15in)
Stranded embroidery thread
 as given in the relevant key
No. 24 tapestry needle
Strong board or card
Strong thread for lacing
Mount and frame of your choice

Yarns

DMC embroidery threads are used throughout this book and will give you the same results. There are other brands of thread, such as Anchor, but the colours may not match the DMC colours exactly.

Preparing the fabric

The measurements for the fabric (above) allow for preparing the edges and stretching the fabric over card. Before stitching, oversew the edges of the fabric or bind them with masking tape to prevent fraying.

Fold the fabric in half both ways and crease along the fold lines. Open out the fabric and stitch basting stitches along the lines. Where the lines cross is the centre. The basting stitches can be removed later.

Using a hoop

It is advisable to use an embroidery hoop or frame when stitching as it keeps the fabric taut and does not let it stretch or distort, making stitching easier. A large hoop will be big enough for the whole of one of the flower designs. To stretch the piece of fabric in a hoop, place the area to be stitched over the inner ring, then press the outer ring over the fabric, with the tension screw released. When the fabric is taut and the weave is straight, tighten the tension screw. If the fabric creases, release the outer ring and repeat.

Using a frame

To stretch your fabric in a rectangular frame, baste a 12mm (½in) turning on the top and the bottom edges of the fabric and oversew strong tape to the other two sides.

Working from the centre outwards, oversew the top and bottom edges of the fabric to the tapes with strong thread. Fit the side pieces into the slots, roll any extra fabric on and insert the pegs or screws to secure the frame. Lace both edges of the fabric using a large-eyed

needle, threaded with strong thread; secure the ends around the intersections of the frame. Lace the webbing at 2.5cm (1in) intervals, stretching out the piece of fabric evenly.

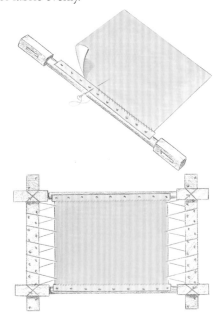

Preparing the threads

Cut a supply of 50cm (20in) lengths of the threads you will need for the project, separating them into strands, and putting them into a thread organizer – a piece of card with holes punched down each side. Each colour can be looped through a hole, and labelled with the colour number.

Stitching

Always start at the centre of the fabric and work outwards, as this ensures that the design will be placed centrally on the

fabric. Find the centre of the chart and mark it for your reference.

The projects in this book usually use one strand of thread over two threads of fabric, except where indicated.

When you begin, leave a long thread end at the back of the fabric, holding it with a finger initially, then catch the thread with the first few stitches to hold it secure. When finishing stitching, weave the thread end through the back of four or five nearby stitches, then trim.

If you are stitching a section that features several tiny areas of colour close together, you can work with a few needles at once. Keep them pinned to the fabric at one side or you may lose track of them.

Cross stitch

To make one cross stitch, think of the stitch area as a square. Bring the needle up through the hole in the bottom right of the square, then take it down through the hole in the top left. Then take the needle up through the bottom left hole and down into the top right.

For a row of cross stitches, work from right to left, completing the first row of evenly spaced diagonal stitches over the number of threads of fabric specified. Working from left to right, repeat the process to finish the stitches. Ensure that each cross stitch follows the same direction. For ease of working, you can rotate your work and stitch vertically, when required.

Back stitch

Back stitch is indicated on the chart by a bold line; the colour of the back stitch is denoted by a symbol, which is arrowed to the line. Use one or two strands of thread, as indicated in the chart. Bring the needle up from behind the work and down through the fabric, a stitch length behind the first point. Pass the needle under the fabric, and then up one stitch length ahead of the first point. Work each back stitch over the same number of threads as the cross stitch to form a continuous line.

Using charts

Each project has a chart detailing which colours to stitch where; each square of the chart represents one stitch. You might find that it is easier to photocopy, and enlarge, the chart before beginning to stitch.

Always start from the centre of the chart and work outwards. Some stitchers like to tick off the squares or colour them

in as they stitch to make it easier to follow the chart. Alternatively, you might prefer to use a ruler to aid your stitching, and move it down line by line as needed.

Finishing

After you have finished stitching, remove the frame and trim any straggly thread ends on the back of the fabric. If the embroidery is a bit dirty, wash it carefully in hand hot water. Use a gentle cleanser (not a detergent) and agitate gently.

Rinse, then place the embroidery face down on a towel. When nearly dry, press it lightly with a warm iron on the reverse side to smooth out any creases.

Mounting embroidery

Cut a piece of card to the size of the finished embroidery, with an extra amount added all round to allow for the recess in the frame. Mark the central vertical and horizontal lines on the card. Place the embroidery face down and centre the card on top so that the basted lines on the fabric and the lines on the card match.

Fold over the edges of the fabric on opposite sides, making mitred folds at the corners, and lace across, using strong thread. Repeat on the other two sides. Finally, pull up the stitches tightly to stretch the fabric firmly. Then overstitch the mitred corners to neaten.

Author's Acknowledgements

*I grew up surrounded by flowers and continue to live in a community in which flowers are both
a way of work and a way of life. I believe that this has made such a book possible.*

*I would like to thank all of the stitching ladies for producing the beautiful panels in this book,
as well as Murdoch Books UK for their co-operation throughout the project.*

General suppliers

For information on your
nearest stockist of stranded
cotton, contact the following:

DMC THREADS
UK
DMC Creative World Ltd
62 Pullman Road
Wigston
Leicester
LE8 2DY
tel: + 44 (0)1162 811 040

USA
The DMC Corporation
Port Kearny Building
10 South Kearny
NJ 07032
tel: + 1 (0)973 344 0299

AUSTRALIA
DMC Needlecraft Pty Ltd
PO Box 317
Earlwood
NSW 2206
tel: + 61 (0)2 9559 3088

ANCHOR THREADS
UK
Coats Crafts UK
PO Box 22
McMullen Road
Darlington
Co. Durham
DL1 1YQ
tel: + 44 (0)1325 394 394

USA
Coats North America
4135 South Stream Blvd
Charlotte
North Carolina 28217
tel: + 1 (0)704 329 5800

AUSTRALIA
Coats Paton Crafts
Level 1
382 Wellington Road
Mulgrave
Victoria 3170
tel: + 61 (0)3 9561 2288

KIT SUPPLIERS
Fa. Thea Gouverneur bv
Hoofdstraat 78a
2171 AV Sassenheim
The Netherlands
tel: + 31 (0)252 214 453
fax: + 31 (0)252 224 067

Michael Whitaker Fabrics
15/16 Midland Mills
Station Road
Crosshills
Keighley
West Yorkshire BD20 7DT
UK
tel: + 44 (0)1535 636 903

Interline Imports Inc
1050880 Ainsworth Crescent
Richmond BC 7A 3V6
Canada
tel: + 1 (0)604 271 8242

Potpourri Etc.
275 Church Street
Chillicote Street
Oh 45601
USA
tel: + 1 (0)740 779 9512

Ristal Threads
Heritage Village
Unit 11/12
2602 Watson Act
Australia
tel: + 61 (0)2 62 412 293

Margaret Barret
Distributors Ltd
19 Beasley Avenue
Penrose
Auckland
New Zealand

DL s.r.l
Via Piave 26
20016 Pero
Milan
Italy

Villanueva, S.L.
C/Rio Gargaliga 6
29002 Malaga
Spain

Paritys
23 Rue des Peupliers
Z.A. -BP 708
92007 Nanterre Cedex
France

Le Bonheur Des Dames
17 Avenue Jean Moulin
93100
Montreuil
France

Engbert J. Blok
Halsbekerstrasse 43
26655 Westerstede
Germany

RTO Ltd
Zjuzinskaya str. 6
Bldg 1, Floor 1
117418
Moscow
Russia
tel: 007 (0)95 331 2133

De Winn Co., Ltd
34–37 SamSoung-Dong
Gangnam-Gu
Seoul
Korea

Yuki Ltd
10-10-4-Bancho Karakuen
Nishinomiya City
622-0088
Japan
tel: + 81 (0)798 721 563

Mikza Agencies CC
P.O. Box 28791
6 Sunnyside
0132
Rep. of South Africa